EXECUTIVE ESCAPES

FAMILY

edited by Martin Nicholas Kunz

teNeues **manager magazin**
Wirtschaft aus erster Hand

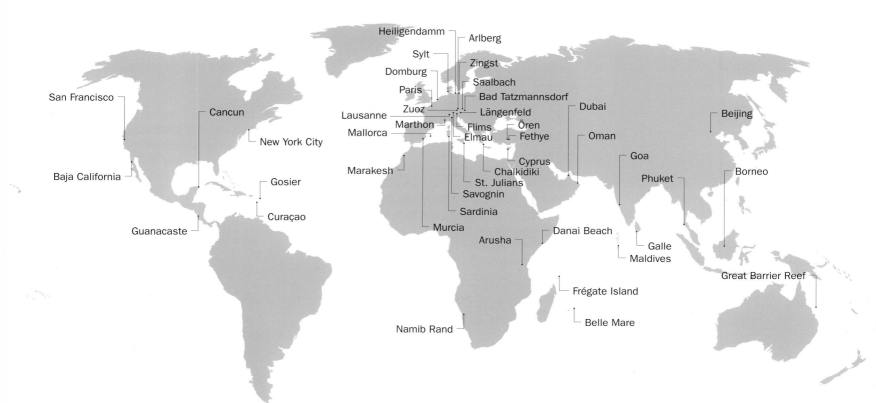

San Francisco

Cancun

New York City

Baja California

Gosier

Curaçao

Guanacaste

Heiligendamm

Arlberg

Sylt

Zingst

Domburg

Saalbach

Paris

Bad Tatzmannsdorf

Dubai

Beijing

Zuoz

Längenfeld

Lausanne

Ören

Marthon

Flims

Fethye

Oman

Mallorca

Elmau

Goa

Borneo

Cyprus

Phuket

Marakesh

Chalkidiki

St. Julians

Savognin

Sardinia

Danai Beach

Galle

Murcia

Arusha

Maldives

Frégate Island

Great Barrier Reef

Belle Mare

Namib Rand

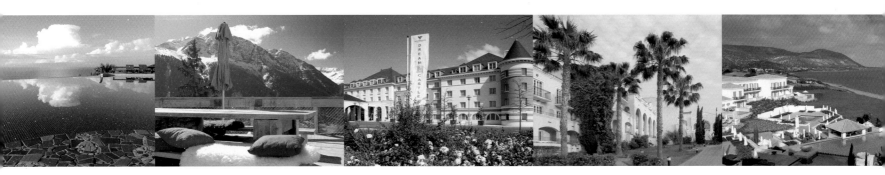

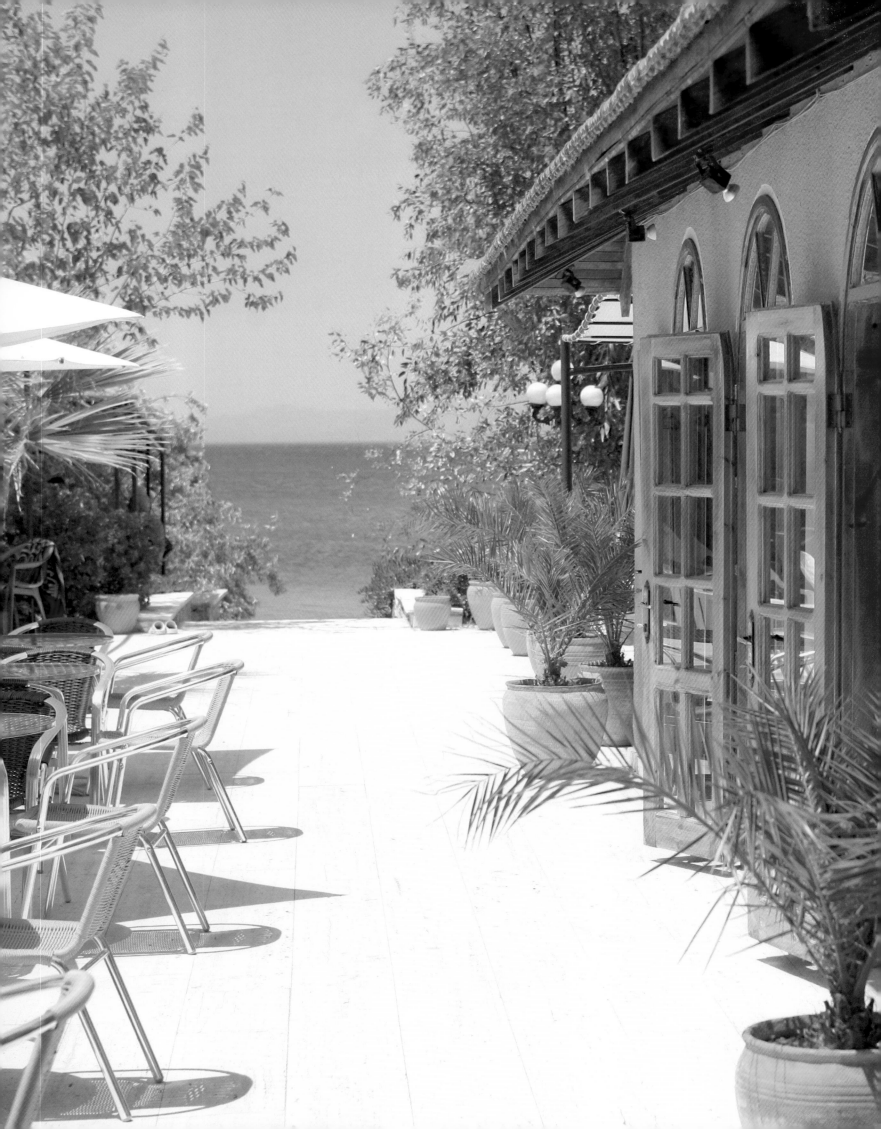

Introduction

Those who travel to far and unknown places collect a rich assortment of impressions and adventures: enthralling, varied, and always interesting. Traveling opens up new worlds, different, unique, and full of surprises, mysteries, and riddles—especially if children are part of the enterprise.

The right hotel in the right place is of absolute importance when it comes to a successful family holiday. This book introduces 47 hotels for parents wishing to enjoy the best days of the year with their children. Only exceptionally attractive locations were selected; good starting places from which to explore the surrounding countryside and its people in an unadulterated way. The list of hotels comprises idyllic country cottages, urban design hotels, romantic castles, lively holiday complexes, and luxury villas in pulsating cities or the calm countryside, in the mountains or by the sea, nearby or far away.

All of these hotels are marked by attentive service and excellent cuisine together with a comprehensive sports and leisure as well as health and fitness program for adults and children alike. While parents either take advantage of the sports facilities or simply relax, children can to indulge in fun and excitement: playing games, singing, arts and crafts, experimenting, listening to fairy tales, exploring nature, or letting off steam with new friends on the playground.

Even in the fast-paced, globalized world of today, some untouched spots remain. One should not fall into the trap of thinking that mass tourism has rendered futile the search for nature and true hospitality. The world is still big, and breathtaking beauty is still waiting to be discovered by those who go in search of it.

The joint discovery of new worlds beyond the stress of everyday life provides both parents and children with an enriching experience. This book caters for the special needs of family holidays. Those who look for an unforgettable holiday with their children need look no further.

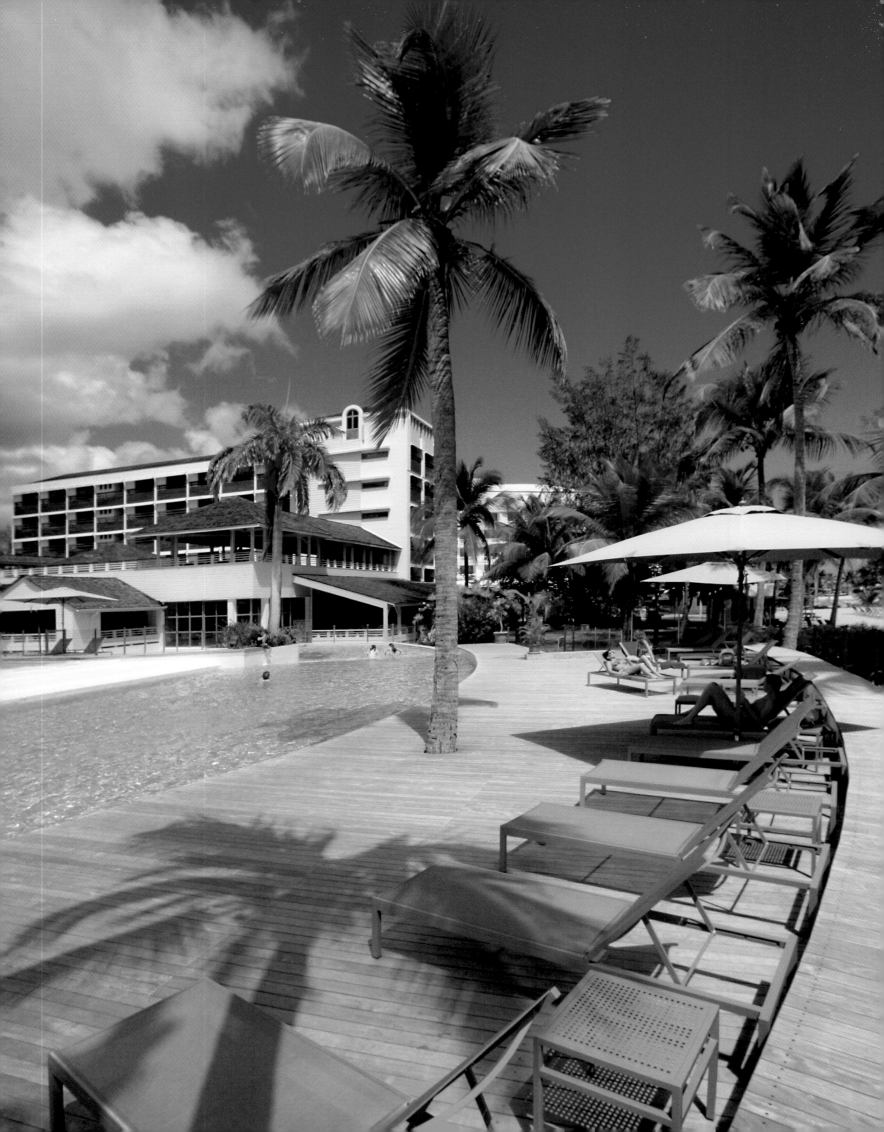

Einleitung

Wer auszieht, die unbekannte Ferne zu erkunden, sammelt eine reiche Fülle besonderer Eindrücke und Erlebnisse: spannend, abwechslungsreich und immer interessant. Reisen eröffnet Welten, fremd, einzigartig und voller Überraschungen, Geheimnisse und Rätsel – erst recht, wenn man mit Kindern unterwegs ist.

Für einen gelungenen Familienurlaub braucht es das richtige Hotel am richtigen Ort. In diesem Buch werden 47 Hotels für Eltern vorgestellt, die mit ihren Kindern die schönsten Tage des Jahres verbringen möchten. Es wurden Orte ausgewählt, die sich von ihrer besten Seite zeigen. Gute Adressen, um das jeweilige Land und die Menschen von einer unverfälschten Seite kennenzulernen. Es sind idyllische Landhäuser darunter, urbane Designhotels, romantische Schlösser, lebhafte Ferienanlagen und luxuriöse Villen. In pulsierenden Metropolen oder ruhigen Regionen, auf dem Land, in den Bergen oder am Meer, in weiter Ferne oder ganz nah.

Diese Hotels bringen aufmerksamen Service und hervorragendes Essen in Einklang mit einem großen Sport-, Freizeit- und Wellness-Angebot und einem umfangreichen Angebot für Kinder. Während die Eltern sich sportlich verausgaben oder einfach entspannen, gehören für die Kinder Spaß und Abenteuer zum Urlaubsprogramm: spielen, singen, basteln, experimentieren, Märchen lauschen, die Natur erforschen oder auf dem Spielplatz mit neuen Freunden toben.

Auch in der schnelllebigen, globalisierten Welt von heute gibt es auf der Erdkarte noch manche weiße Flecken. Man soll nicht glauben, dass die Suche nach ursprünglicher Natur und aufrichtiger Gastfreundschaft durch das Phänomen Massentourismus sinnlos geworden sei. Noch immer ist die Welt weit. Noch immer wartet das atemberaubend Schöne auf Menschen, die sich aufmachen, ihm zu begegnen.

Das gemeinsame Entdecken neuer Welten jenseits von Alltag und Hektik ist eine bereichernde Erfahrung für Eltern und Kinder. Dieses Buch geht auf die besonderen Bedürfnisse von Familien im Urlaub ein. Wer unvergessliche Ferien mit Kindern plant, wird hier fündig werden.

Introduction

Partir explorer l'inconnu lointain, c'est accumuler des expériences et des sensations, extraordinaires, captivantes, variées et toujours intéressantes. Si voyager donne accès à des mondes nouveaux, étrangers, uniques et pleins de surprises, de secrets et de mystères, cela est encore plus vrai lorsqu'on voyage avec des enfants.

Pour réussir ses vacances en famille, il faut trouver le bon hôtel au bon endroit. Dans cet ouvrage, nous vous présentons 47 hôtels pour parents désireux de passer les plus beaux jours de l'année avec leurs enfants. Autant de lieux choisis pour leur capacité à se montrer sous leur meilleur jour, et autant de bonnes adresses pour connaître le pays et les gens dans leur environnement : des maisons de campagne idylliques, des hôtels urbains design, des châteaux romantiques, des centres de vacances animés et de luxueuses villas, situés au cœur de métropoles bouillantes ou de régions tranquilles, à la campagne, à la montagne ou à la mer, dans des régions lointaines ou tout près de chez vous.

Ces hôtels, qui combinent personnel attentionné et excellente nourriture, offrent également aux parents et aux enfants un vaste choix d'activités sportives et récréatives, ainsi que des formules bien-être complètes. Tandis que les parents se dépensent en faisant du sport ou se détendent plus simplement, le plaisir et l'aventure sont au programme des vacances des enfants : jouer, chanter, bricoler, expérimenter, écouter des contes les oreilles grandes ouvertes, explorer la nature, ou encore se défouler avec de nouveaux copains sur l'aire de jeux.

Même à notre époque de mondialisation fiévreuse, celle-ci épargne encore de nombreux endroits sur la carte du monde. Il ne faut pas croire que rechercher la nature sauvage et l'hospitalité sincère à l'heure du tourisme de masse n'a plus de sens. Le monde est encore vaste, et des beautés époustouflantes attendent encore ceux qui sont prêts à partir à leur rencontre.

Découvrir ensemble de nouveaux mondes, au-delà du quotidien et du stress, constitue une expérience enrichissante, pour les parents comme pour les enfants. Ce livre a été conçu pour répondre aux besoins spécifiques des familles en vacances. Tous ceux qui envisagent de passer des vacances inoubliables avec leurs enfants y trouveront leur bonheur.

Hotel Diva

San Francisco, USA

An ideal starting point to experience San Francisco: the stylishly designed hotel with comfortable rooms topped by an elegant, modern atmosphere is only a stone's throw away from main sightseeing points, theaters, and shopping malls. Children have their separate check-in and colorful "Diva" suites with fancy dress chest, karaoke machine, children's videos, and CD player. The suites are big enough for two children and parents, who sleep in the adjoining room. The Hotel Diva is a non-smoking hotel.

Ein idealer Ausgangspunkt um San Francisco zu erleben: Das stilvolle Design-Hotel mit komfortablen Zimmern in eleganter, moderner Atmosphäre liegt in nächster Nähe von Sehenswürdigkeiten, Theatern und Einkaufsmeilen. Für Kinder gibt es einen separaten Check-in und farbenfrohe „Diva"-Suiten mit Verkleidungskiste, Karaoke-Gerät, Kinderfilmen und CD-Spieler. Die Suiten bieten Platz für zwei Kinder und ihre Eltern, die im angrenzenden Zimmer schlafen. Das Hotel Diva ist ein Nichtraucherhotel.

Un point de départ idéal pour découvrir San Francisco : cet hôtel design et de bon goût aux chambres confortables et au décor élégant et moderne est situé à proximité immédiate des attractions touristiques, des théâtres et des artères commerçantes. Pour les enfants, il existe un check-in séparé et des suites « Diva » aux couleurs gaies avec panoplies de déguisements différents, lecteurs karaoké, films de leur âge et lecteurs de CD. Les suites peuvent accueillir deux enfants et leurs parents, qui dorment dans la chambre attenante. L'Hotel Diva est un hôtel non-fumeur.

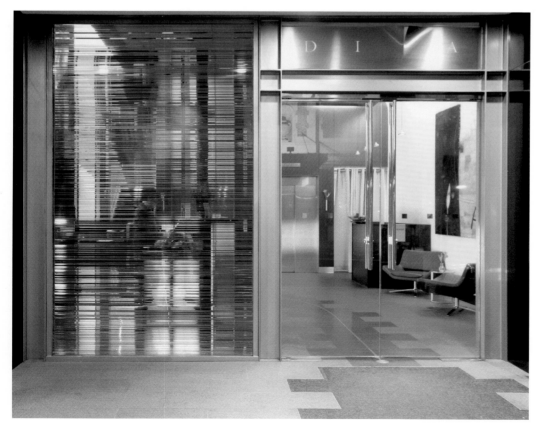

A welcoming, modern interior to make guests feel at home.

Ein einladendes, modernes Interieur erwartet den Gast.

Un intérieur engageant et moderne attend le client.

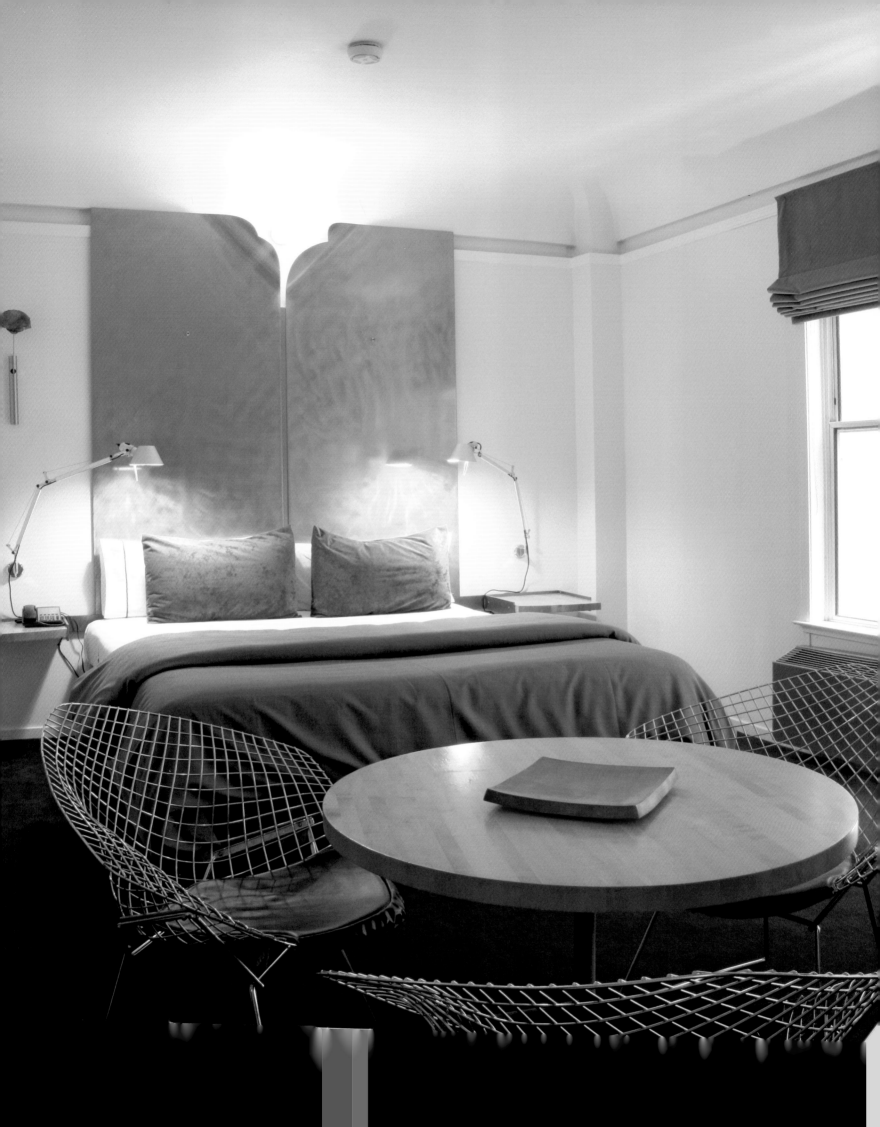

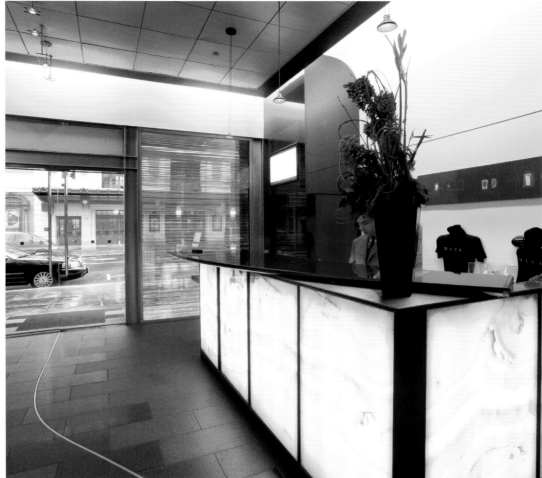

The colorful "Diva" suites are ideal for children.

Die farbenfrohen „Diva"-Suiten sind ideal für Kinder.

Les suites « Diva », aux couleurs vives et gaies, sont idéales pour les enfants.

Le Parker Méridien New York

New York City, USA

The luxury hotel in the center of Manhattan is literally around the corner from Central Park and such highlights as the Museum of Modern Art, Times Square, Broadway, and the Rockefeller Center. Elegant, comfy rooms offer all mod cons. There is a fitness center for parents, while children can look forward to the "Chocolate Brunch" in Seppi's restaurant during weekends. The rooftop swimming pool with a view over the whole city guarantees recuperation and enjoyment for the whole family, especially after a hard day's sightseeing.

Das Luxushotel im Herzen Manhattans ist nur einen Katzensprung vom Central Park und Sehenswürdigkeiten wie dem Museum of Modern Art, Times Square, Broadway und Rockefeller Center entfernt. Elegante, behagliche Zimmer bieten hohen Komfort. Für Eltern gibt es ein Fitness-center. Die Kinder wird der „Chocolate Brunch" im Restaurant Seppi's am Wochenende begeistern. Das Schwimmbad auf der Dachterrasse mit Ausblick über die ganze Stadt garantiert nach anstrengendem Sightseeing Erfrischung und Vergnügen für die ganze Familie.

Cet hôtel de luxe au cœur de Manhattan n'est qu'à deux pas de Central Park et d'attractions telles que le Museum of Modern Art, Times Square, Broadway et le Rockefeller Center. Des chambres élégantes, où l'on se sent à l'aise, offrent un haut niveau de confort. Les parents trouveront un centre de fitness, tandis que le « Chocolate Brunch » au Seppi's, le restaurant de l'hôtel, réjouira les enfants le week-end. La piscine sur le toit aménagé en terrasse avec vue sur toute la ville garantit rafraîchissement et plaisir pour toute la famille après une longue journée de tourisme.

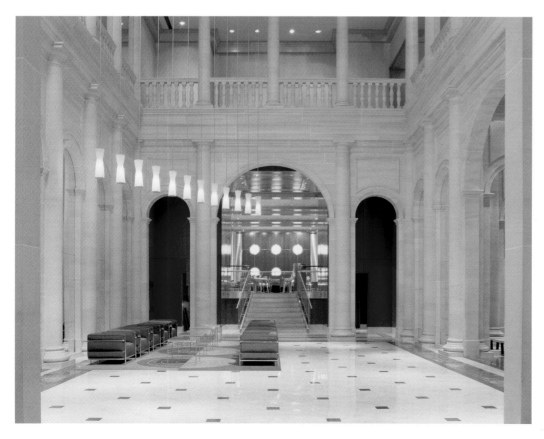

Rich in contrast: the hotel's elegant lobby and the rustic burger restaurant.

Kontrastreich: Die elegante Lobby und das rustikale Burger-Restaurant des Hotels.

En net contraste : l'élégant hall, et le restaurant à burgers rustique de l'hôtel.

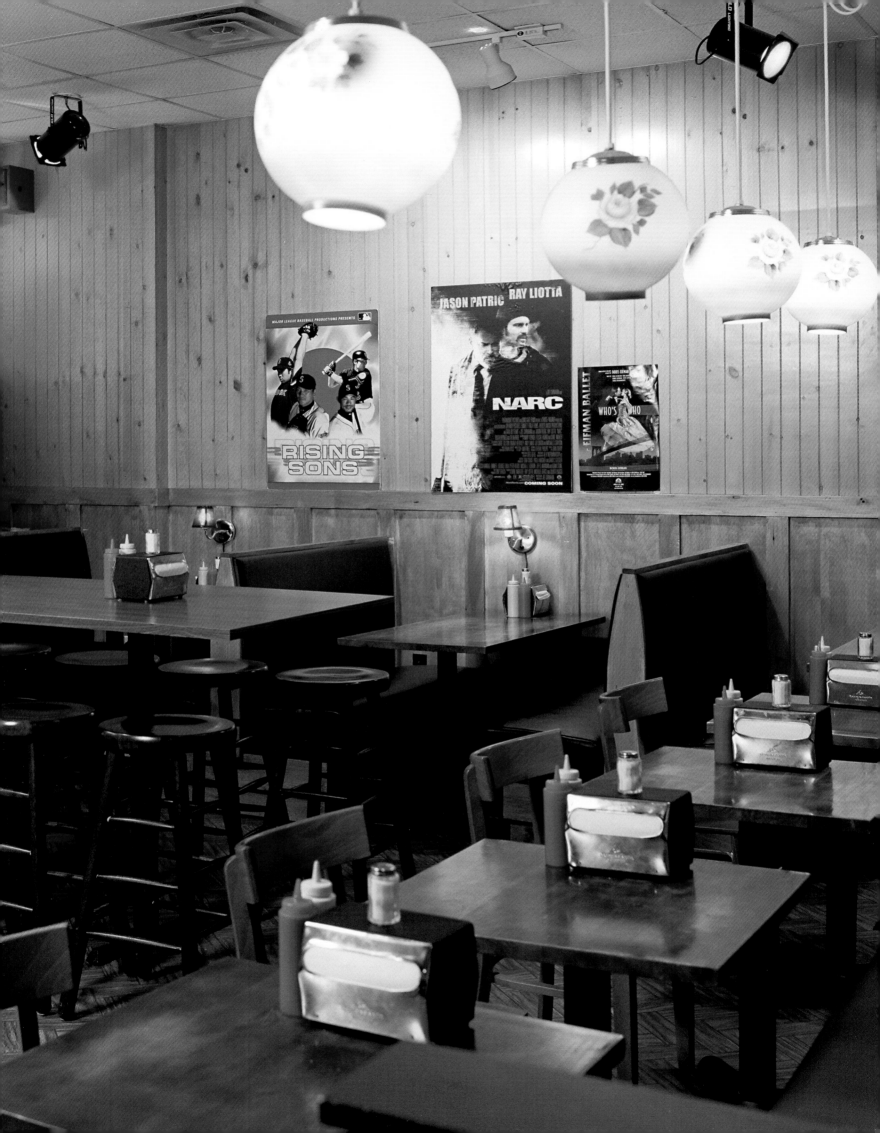

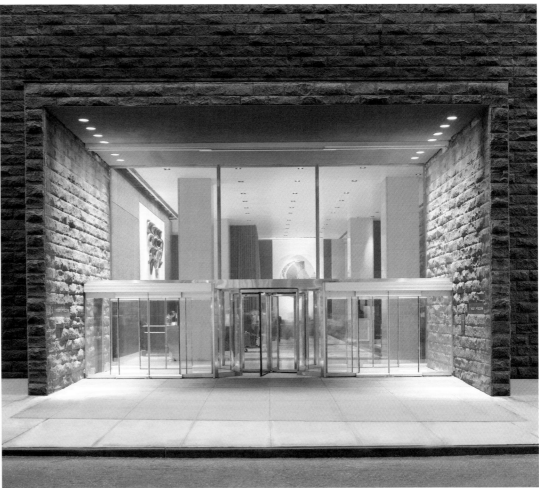

Natural stone, wood, and low key colors make for a comfy atmosphere.

Naturstein, viel Holz und dezente Farben sorgen für ein komfortables Wohngefühl.

De la pierre naturelle, beaucoup de bois et des couleurs douces pour rendre le séjour plus confortable.

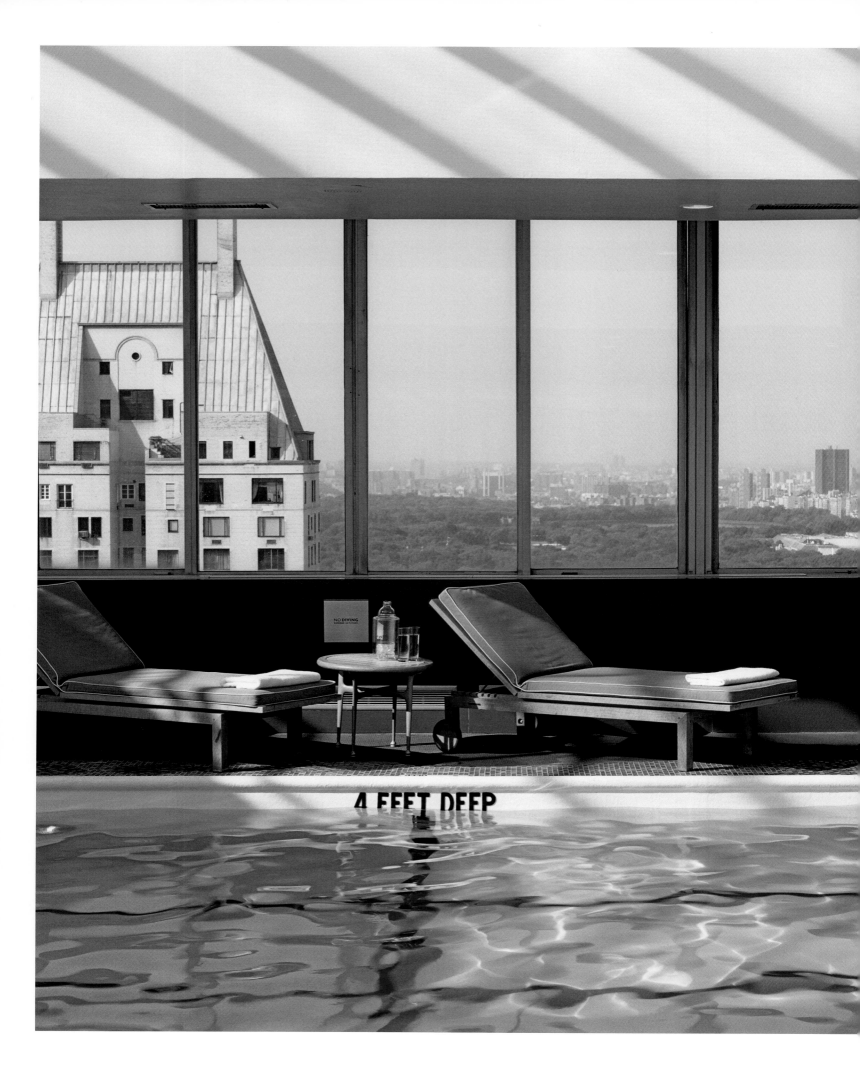

4 FEET DEEP

The pool with a view over Manhattan is one of the hotel's main attractions.

Der Pool mit Blick auf ganz Manhattan ist eine der Attraktionen des Hotels.

La piscine avec vue sur tout Manhattan est l'une des attractions de l'hôtel.

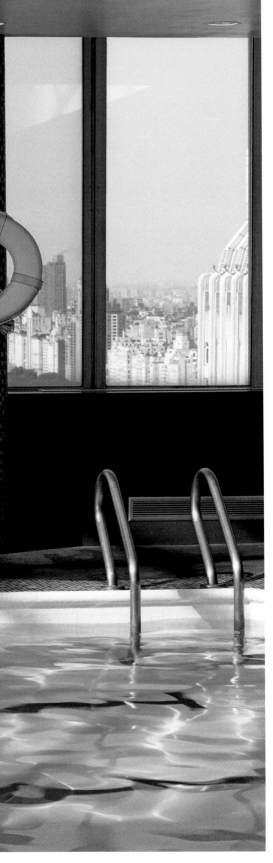

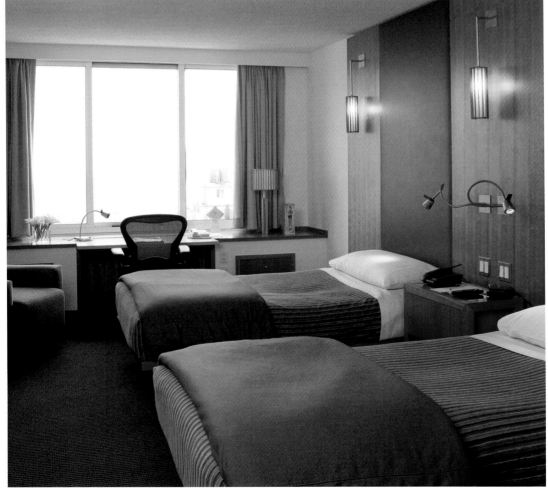

Hotel Punta Islita
Guanacaste, Costa Rica

This stylish hotel is situated between mango and lemon groves on the idyllic peninsula of Nicoya—a true retreat. Families adore the large pool, well tended gardens, and large rooms. Villas have two or three bedrooms; casitas boast their own pool. The hotel offers many family activities, including kayak tours, horseback riding, cross country drives, and tree-top tours. Afterwards, the hammocks on the terrace invite to relax while enjoying the view of the Pacific Ocean.

Zwischen den Mango- und Zitronenplantagen der idyllischen Halbinsel Nicoya liegt das stilvolle Hotel in einer abgeschiedenen Bucht – ideal für Ruhesuchende. Familien lieben das große Schwimmbad, den gepflegten Garten und die geräumigen Zimmer. Es gibt Villen mit zwei oder drei Schlafzimmern; die Casitas haben einen eigenen Pool. Für Familien bietet das Hotel vielfältige Aktivitäten von Kajaktouren bis zu Geländefahrten, Reiten und Baumwipfeltouren am Seilzug. Danach geht es in die Hängematten auf der Terrasse – zum entspannten Schaukeln mit Blick auf den Pazifik.

Situé au milieu des plantations de manguiers et de citronniers de l'idyllique presqu'île de Nicoya dans une baie retirée, cet élégant hôtel est idéal pour ceux et celles qui recherchent la tranquillité. Les familles adorent sa grande piscine, son jardin bien entretenu et ses chambres spacieuses. Il existe des villas de deux ou trois chambres à coucher, des casitas ayant chacune leur propre piscine. Pour les familles, l'hôtel propose des activités diverses et variées, du kayak au tour en 4x4 dans l'arrière-pays, en passant par l'équitation et le canopying (escalade et voltige dans les arbres), avant d'inviter à se balancer dans les hamacs de la terrasse et à se détendre en observant le Pacifique.

The restaurant affords a wonderful view of the bay.

Vom Restaurant hat man einen weiten Blick auf die Bucht.

Depuis le restaurant, on a une vue imprenable sur la baie.

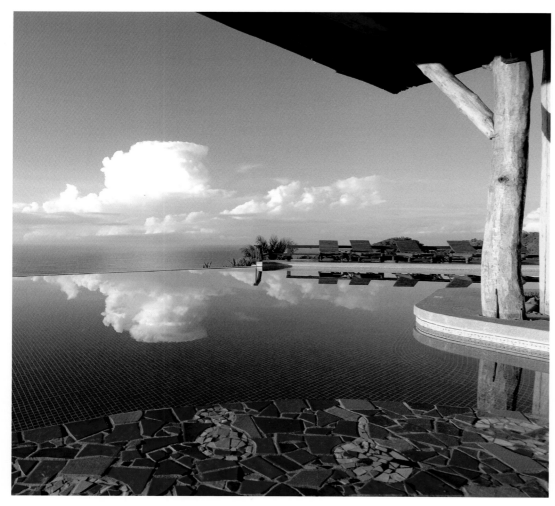

The generous rooms exude a rustic and comfortable atmosphere.

Die großen Unterkünfte sind rustikal und gemütlich eingerichtet.

Les grandes chambres sont d'un aménagement rustique, mais agréable.

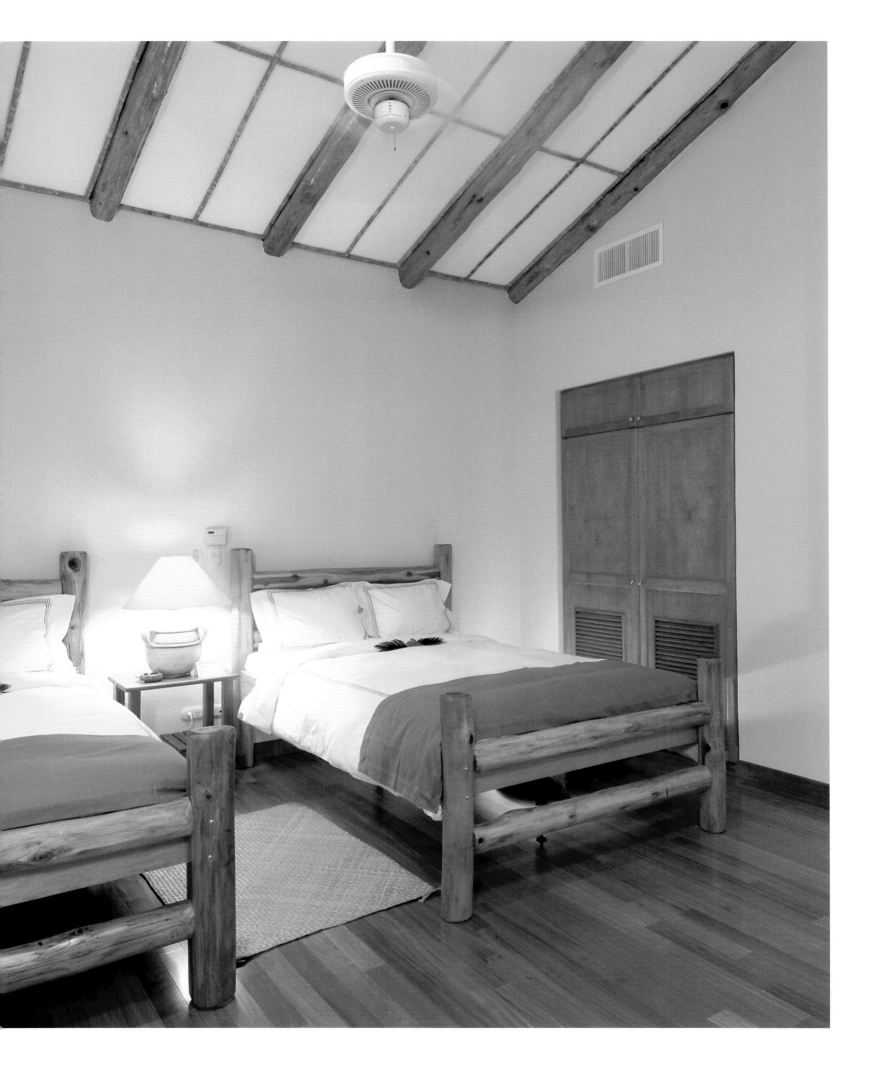

The Ritz-Carlton, Cancun

Cancun, Mexico

This prime location in Cancun provides guests with pure relaxation. The hotel on the white sandy beach is an ideal starting point for excursions to impressive Maya sites or the natural preserve of Yucatan. The supervised children's program ranges from a treasure hunt via baking, pottery, and water games right through to cave painting. At weekends there is an evening program, too, so that parents may enjoy a romantic dinner.

Erholung pur erwartet den Gast im ersten Haus am Platz in Cancun. Das Hotel am weißen Sandstrand ist ein guter Ausgangspunkt für Ausflüge zu den eindrucksvollen Maya-Stätten und Naturparks der Yucatan-Halbinsel. Für Kinder reicht das betreute Angebot von Schatzsuche über Backen, Töpfern und Wasserspiele bis hin zu Höhlenmalerei. Am Wochenende gibt es ein Abendprogramm für die Kleinen, damit die Eltern ein romantisches Abendessen genießen können.

Repos et détente à l'état pur attendent le client dans ce qui est le plus prestigieux bâtiment de Cancún. Cet hôtel, situé au bord d'une plage de sable blanc, est un bon point de départ pour des excursions vers les impressionnants sites mayas et parcs naturels de la presqu'île du Yucatán. L'éventail des activités (encadrées) proposées aux enfants va de la chasse au trésor à la peinture rupestre, en passant par la cuisine au four, la poterie et les jeux d'eau. Le week-end, il existe également un programme vespéral pour les petits, histoire de permettre aux parents de s'offrir un souper romantique.

The hotel boasts all kinds of toys and equipment for toddlers.

Das Hotel hält eine umfangreiche Ausstattung für Kleinkinder bereit.

L'hôtel tient des équipements complets à la disposition des petits enfants.

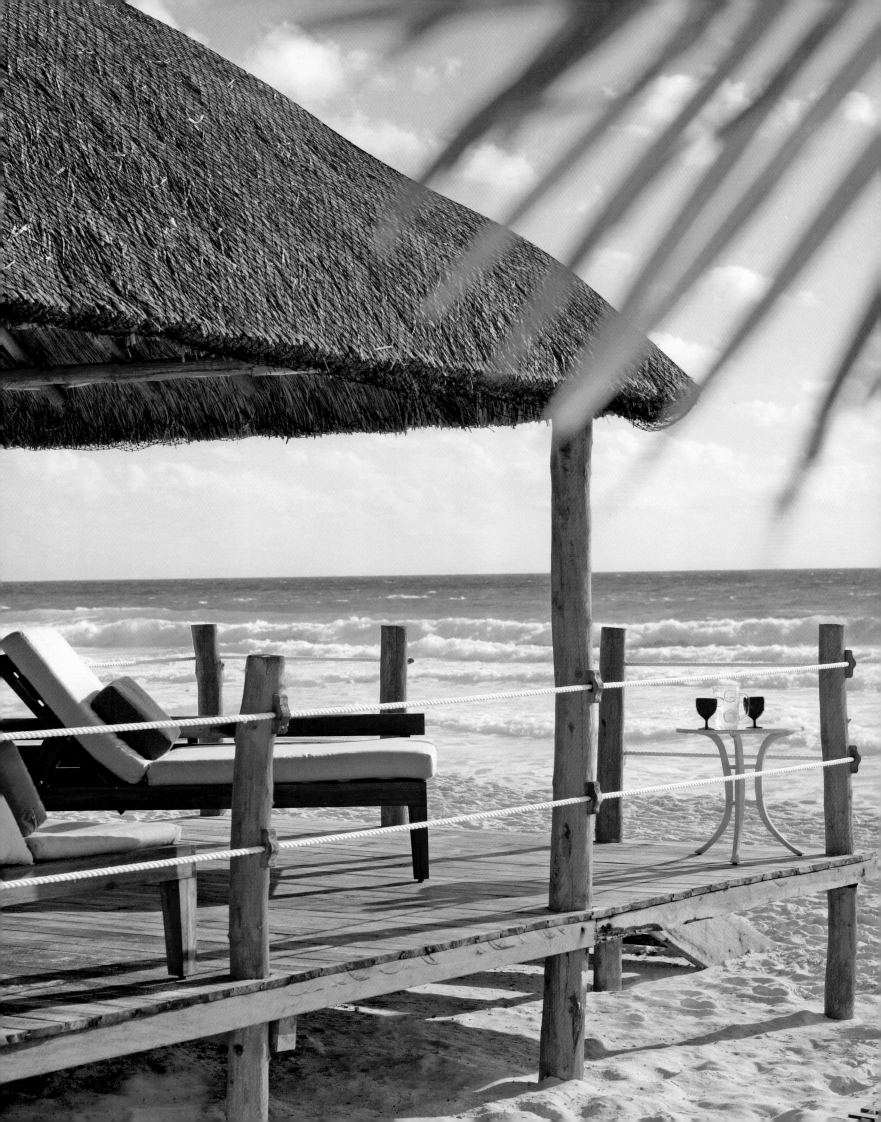

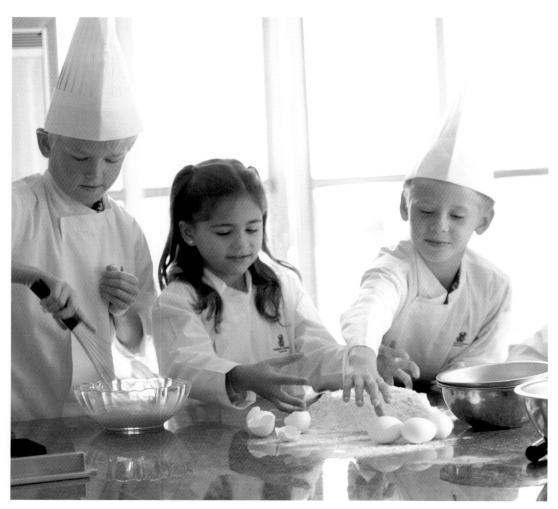

The modern site with two large pools is located right next to the beach.

Die moderne Anlage mit zwei großen Schwimmbädern liegt direkt am Meer.

Les installations, modernes, avec deux grandes piscines, donnent directement sur la mer.

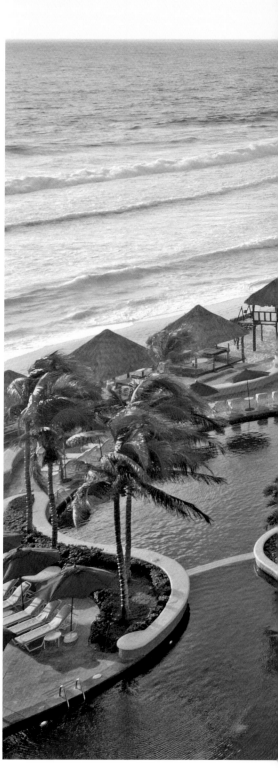

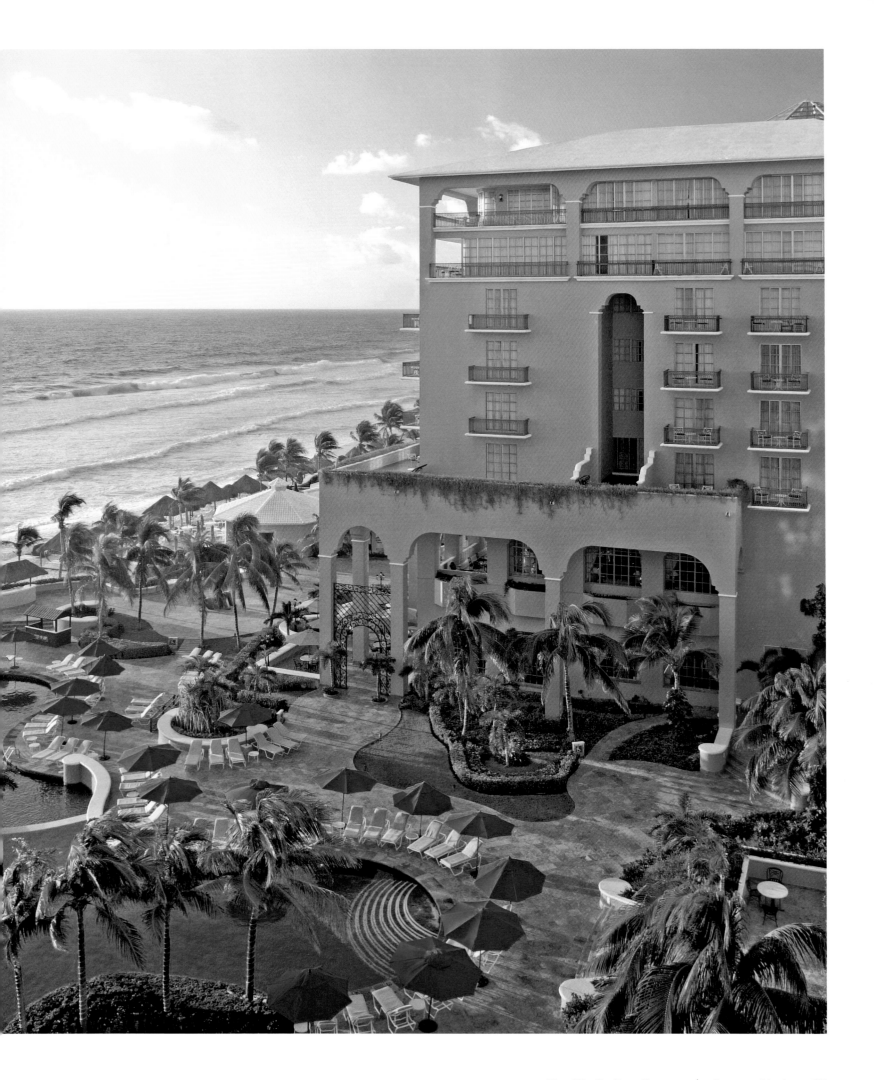

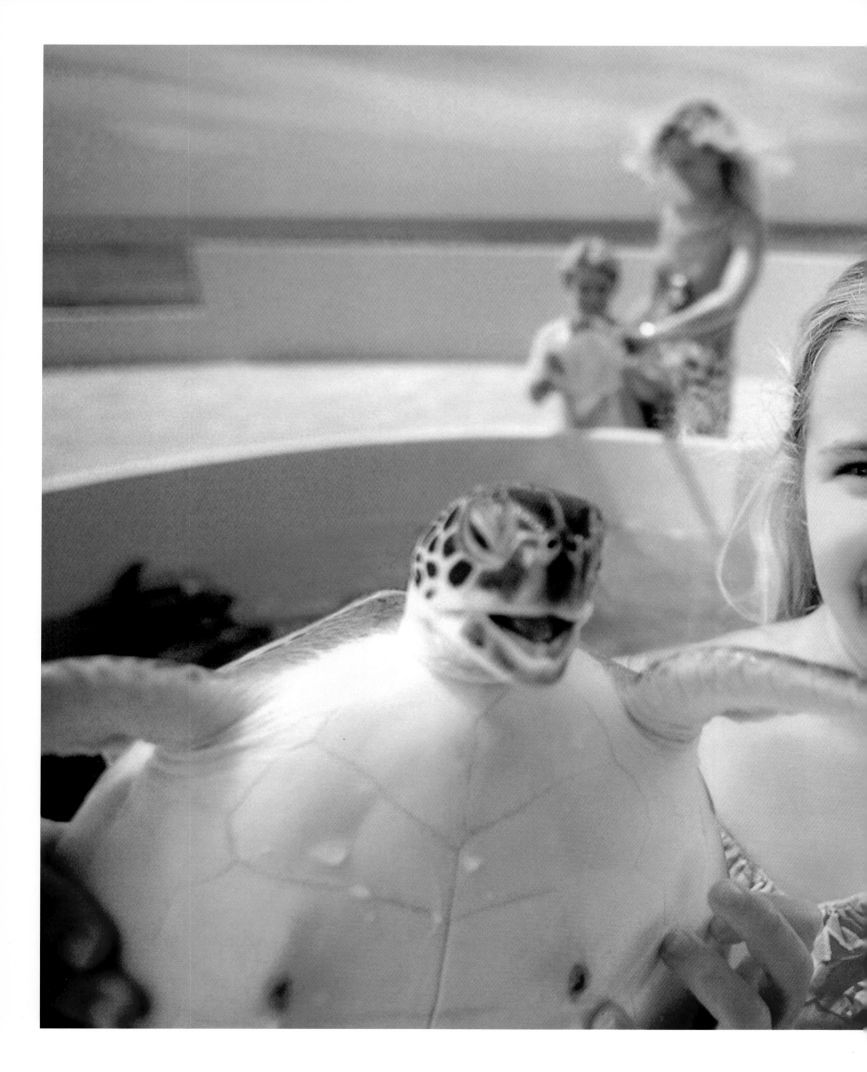

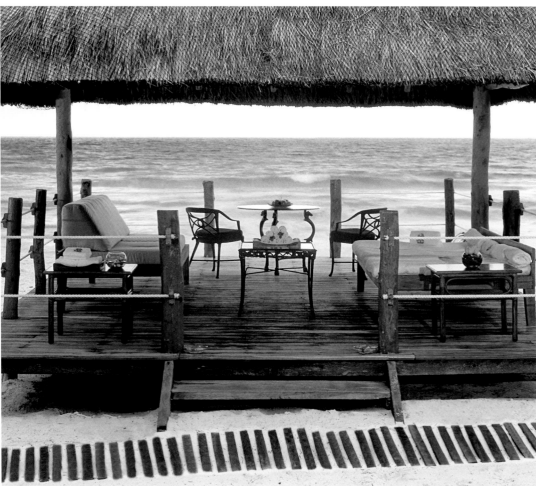

The supervised kids' club teaches children about the tropics.

Kinder machen im betreuten Kinderclub spannende Erfahrungen mit der tropischen Welt.

Les enfants feront de passionnantes expériences avec le monde tropical dans le cadre du club enfants.

One&Only Palmilla

Baja California, Mexico

The luxury resort designed in Mexican style is beautifully situated on the southernmost point of the Baja California peninsula, amidst a unique mountainscape. The spacious complex located right on the beach offers great sporting facilities, a lovely health and fitness area, and large, elegantly furnished rooms. Moreover, the complex features an alluring poolscape with a tropical oasis, waterfalls and kids' pool, a playground, and a supervised mini-club.

Das Luxusresort im mexikanischen Stil besticht durch seine Lage an der Südspitze der Halbinsel Baja California inmitten einzigartiger Berglandschaft: Direkt am feinsandigen Strand bietet die weitläufige Anlage vielfältige Sportmöglichkeiten, einen herrlichen Wellness-Bereich und große, elegant möblierte Zimmer. Außerdem locken eine Schwimmbadlandschaft mit tropischen Oasen, Wasserfällen und Kinderpool, ein Spielplatz und ein betreuter Miniclub.

Ce luxueux complexe de style mexicain séduit par sa situation à la pointe sud de la péninsule de Basse-Californie, au beau milieu d'un paysage de montagnes unique en son genre : érigée directement au bord d'une plage de sable fin, cette vaste station offre la possibilité de pratiquer de nombreux sports, mais aussi un magnifique espace bien-être et de grandes chambres élégamment meublées, sans parler de sa piscine paysagère, avec ses oasis tropicaux, ses chutes d'eau et son bassin enfants, de son aire de jeux et de son mini-club supervisé par des adultes.

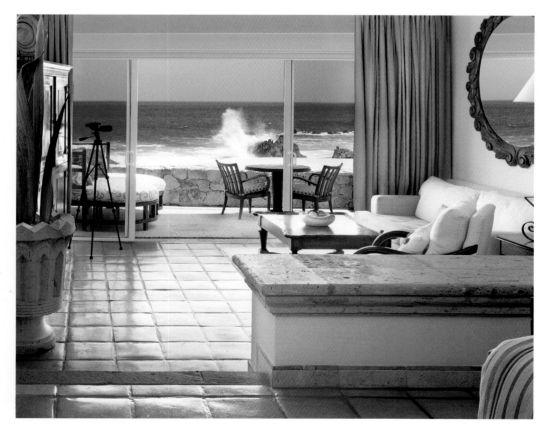

The elegantly furnished hotel offers quiet hideaways by the sea.

Das elegant eingerichtete Hotel bietet ruhige Rückzugsorte am Meer.

Cet hôtel, aménagé élégamment, propose des lieux de refuge tranquilles au bord de la mer.

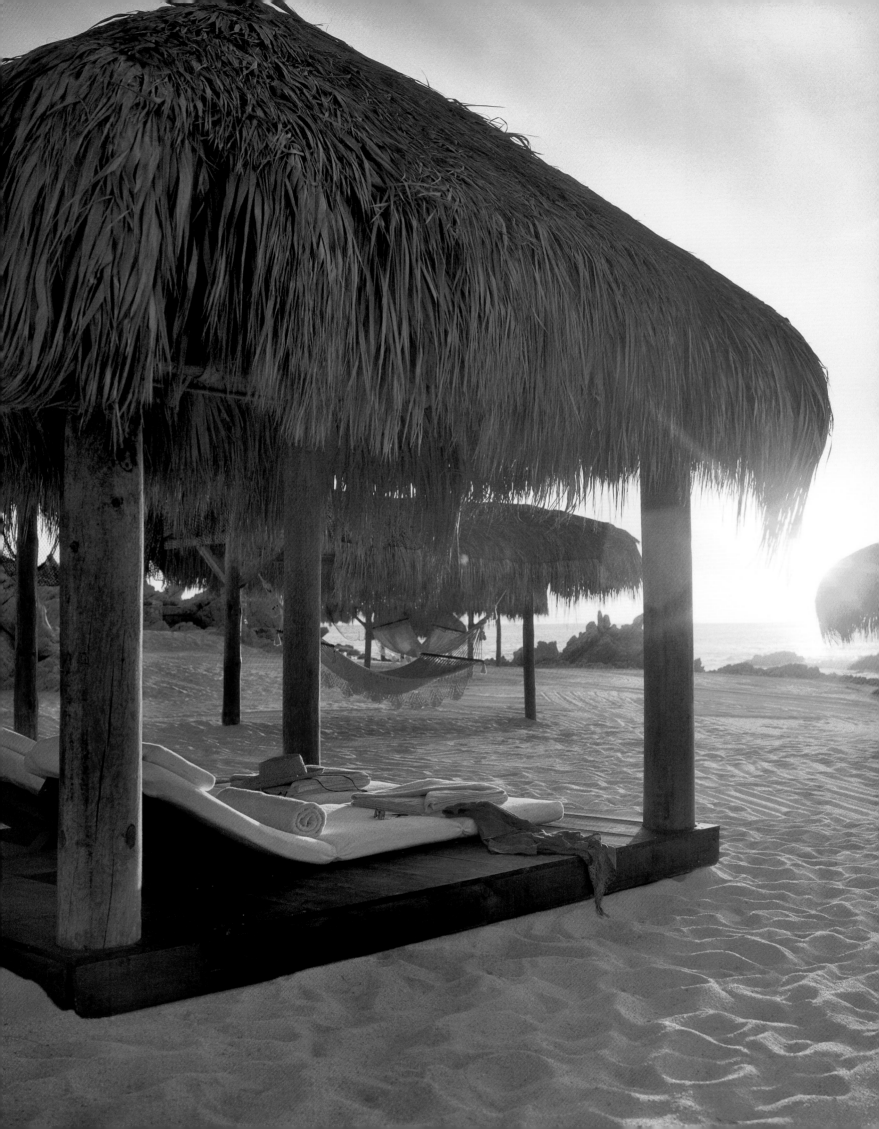

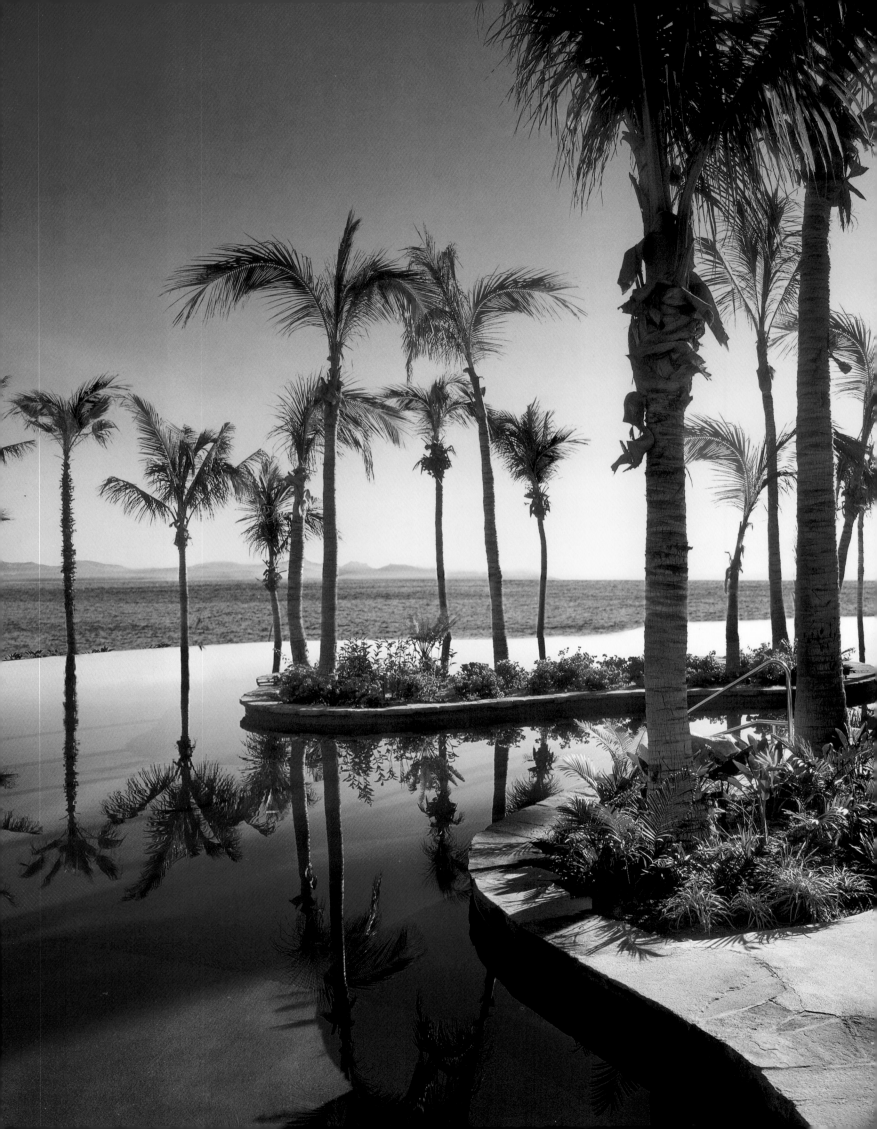

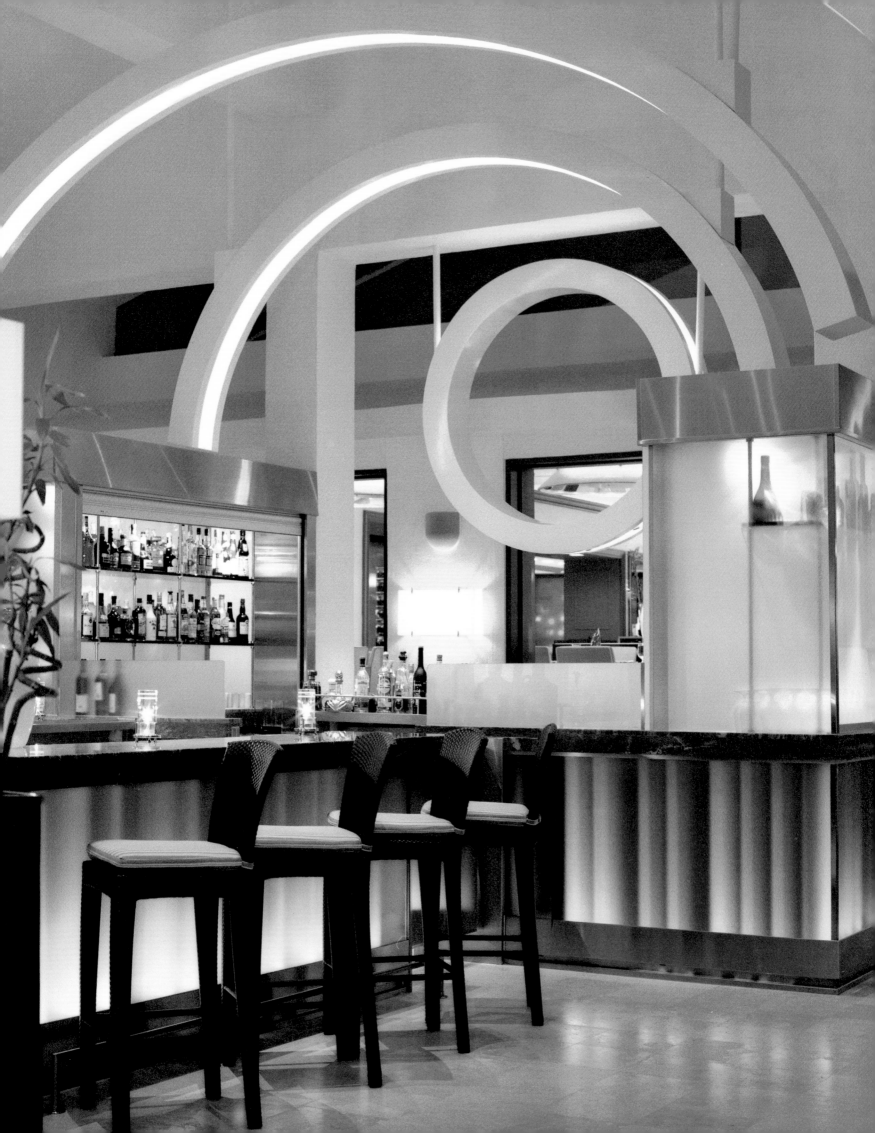

Floris Suite

Curaçao, Caribbean

The hotel exudes incredible charm with its modern and elegant design by Jan des Bouvrie, accentuated by interesting lighting, fine materials, and strong color contrasts. The larger suites come with a fully equipped kitchen. One can walk to the private beach or take the hotel shuttle—it only takes a few minutes in either case. Kids' pool and childcare make for an ideal place to spend a family holiday.

Das Hotel entfaltet seinen Charme schon beim Betreten: Modern und elegant zeigt sich das Design von Jan des Bouvrie, das durch interessante Beleuchtung, edle Materialien und starke Farbakzente besticht. Die größeren Suiten haben eine voll ausgestattete Küche. Den privaten Strand erreicht man zu Fuß oder mit dem hoteleigenen Shuttle in wenigen Minuten. Kinderschwimmbecken und Kinderbetreuung machen das Haus zum idealen Ort für einen gelungenen Familienurlaub.

Cet hôtel déploie son charme dès qu'on y entre : le design, moderne, élégant et signé Jan des Bouvrie, séduit par son éclairage intéressant, ses matériaux nobles et ses coloris marqués. Les plus grandes suites possèdent leur propre cuisine entièrement équipée. La plage (privée) est à quelques minutes : on peut y aller à pied, ou en empruntant la navette de l'hôtel. Le bassin de natation pour les enfants et la garderie font de cette maison le lieu idéal pour des vacances en famille réussies.

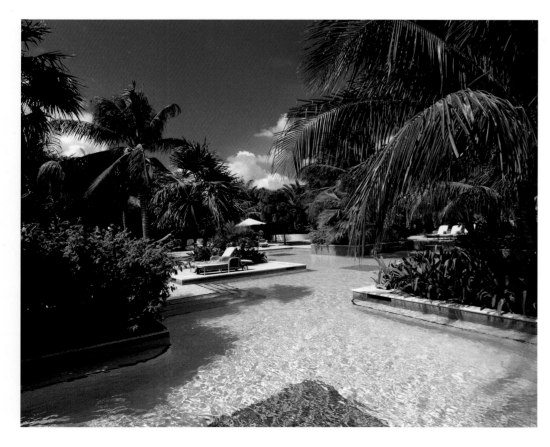

The large pool embedded in the tropical gardens.

Das große Schwimmbad liegt in einem tropischen Garten.

La grande piscine est située dans un jardin tropical.

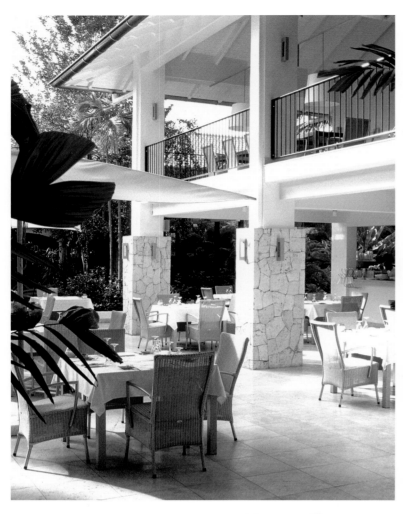
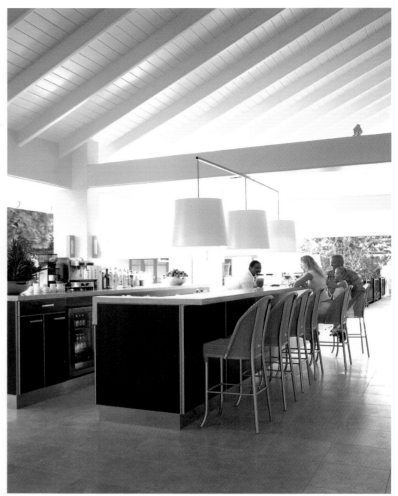
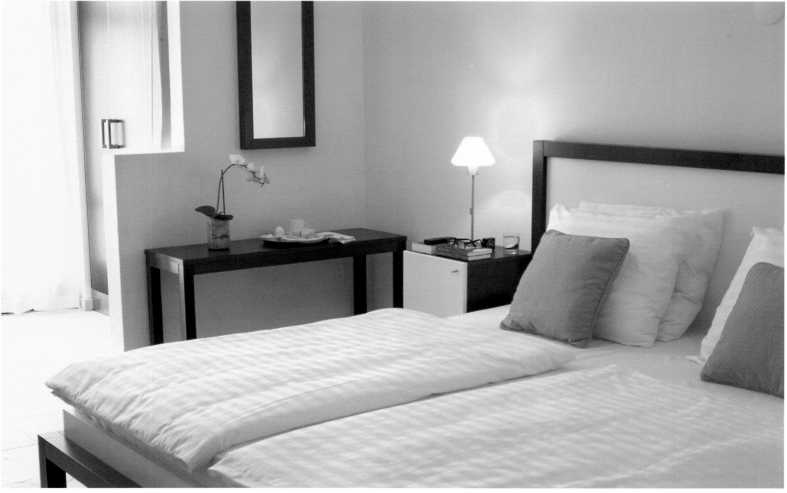

The little ones have plenty of space at the nearby beach.

Am nahen Strand haben kleine Gäste viel Platz zum Spielen.

Sur la plage, toute proche, les petits pensionnaires ont beaucoup de place pour jouer.

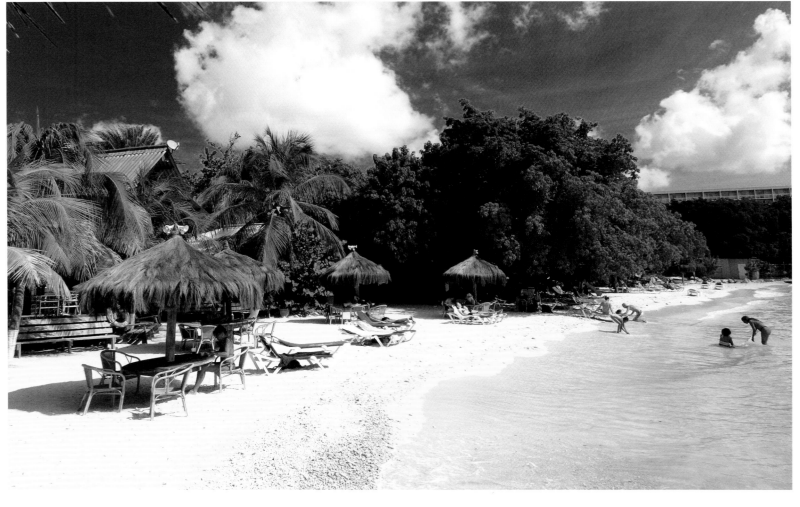

La Créole Beach Hôtel & Spa

Gosier, Guadeloupe, Caribbean

The large complex is located directly on the beach of Gosier amidst a generously sized garden with restaurants and three pools—one of which is reserved for kids. Guests from the age of four are expertly catered for in the kids' club Ti Moune: games, sports and a lot of activities such as painting, treasure hunt, riding, and a visit to the aquarium form part of the program. The club is opened only during French school holidays. Gosier is an ideal starting point to explore the fascinating world of the archipelago, its beaches, and the national preserve.

Die große Anlage liegt direkt am Sandstrand von Gosier in einem weitläufigen Garten mit mehreren Restaurants und drei Schwimmbädern – eines davon ist für die Kinder reserviert. Gäste ab vier Jahren sind im Kinderklub Ti Moune bestens aufgehoben: Spiele, Sport und viele Aktivitäten wie Zeichnen, Schatzsuche, Reiten und Aquariumbesuch stehen auf dem Programm. Der Club ist nur während der französischen Schulferien geöffnet. Gosier ist ein idealer Ausgangspunkt, um die faszinierende Welt des Archipels, seine Strände und den Nationalpark zu entdecken.

Ce grand complexe est situé directement au bord de la plage de sable du Gosier, dans un vaste jardin doté de plusieurs restaurants et de trois piscines, dont une réservée aux enfants. Les pensionnaires à partir de quatre ans sont en de très bonnes mains au club Ti Moune, où les jeux, le sport et de nombreuses activités sont au programme, telles que dessin, chasse au trésor, équitation et visite d'aquarium. Attention, ce club n'est ouvert que durant les congés scolaires français. Le Gosier est un point de départ idéal pour découvrir le monde fascinant de l'archipel, ses plages et son parc national.

There are plenty of sun loungers around the pool to relax on.

Für ein entspanntes Sonnenbad stehen viele Liegen am großen Pool bereit.

De nombreux transats se tiennent à disposition pour des bains de soleil détendus au bord de la grande piscine.

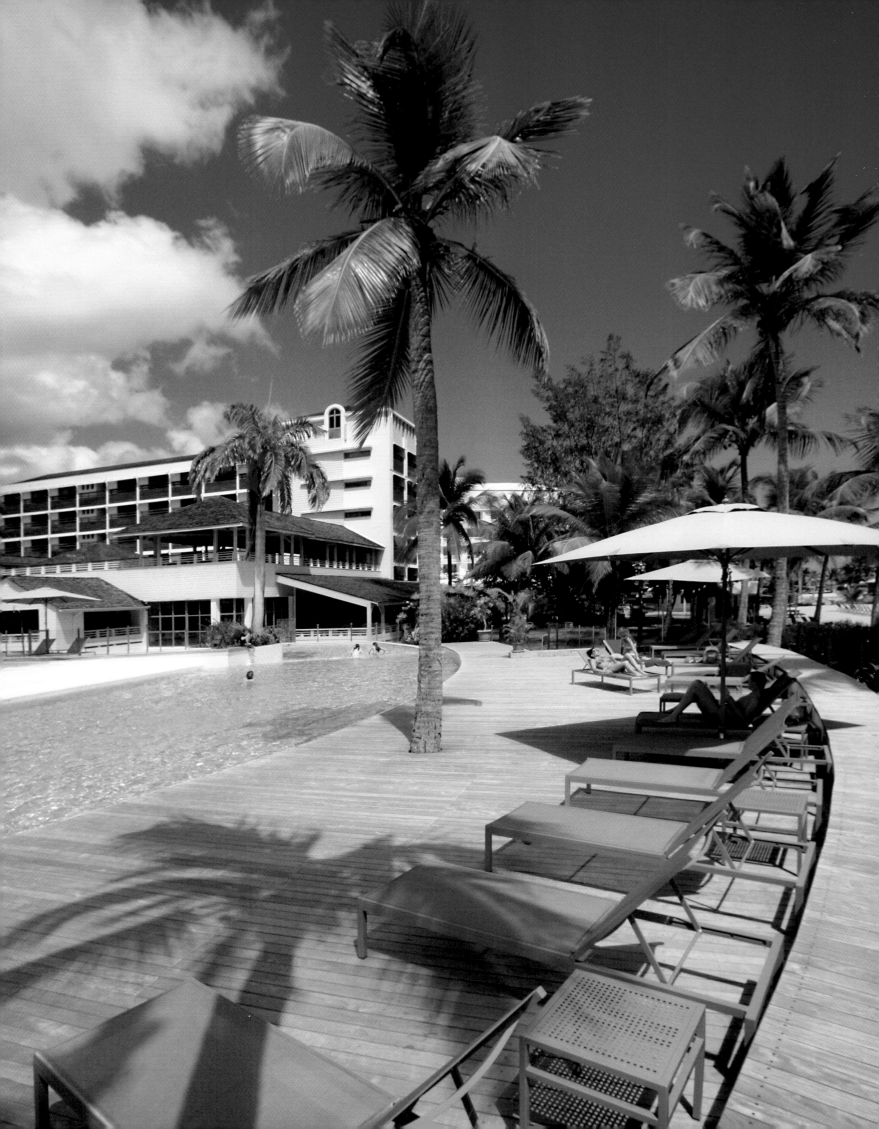

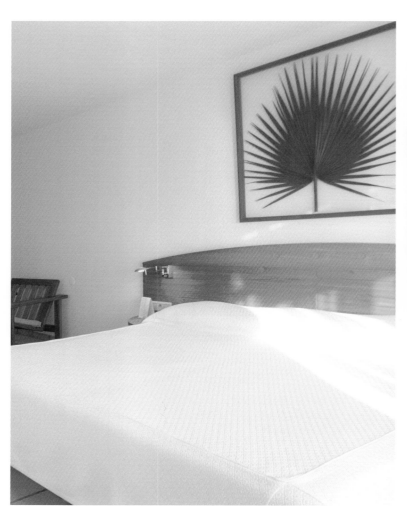

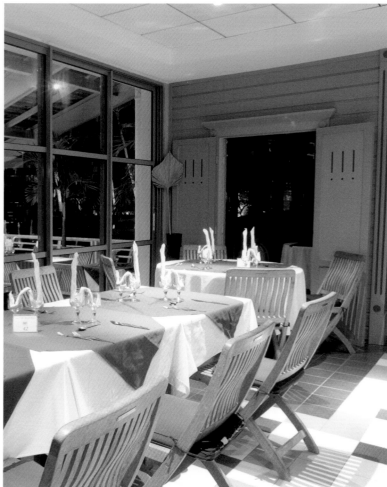

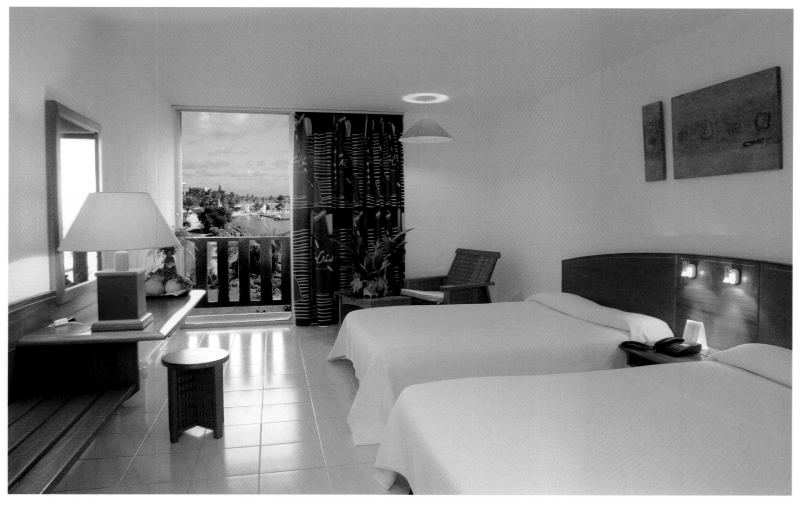

All rooms are bright and comfortable.

Alle Zimmer sind hell und gemütlich eingerichtet.

Toutes les chambres sont bien éclairées et confortables.

The sloping beach with great aquatic sports facilities is ideal for children.

Der flache Strand mit großem Wassersportangebot ist ideal für Kinder.

La plage artificielle, avec son grand choix de sport nautiques, est idéale pour les enfants.

Apparthotel Brommelje

Domburg, The Netherlands

Restrained luxury meets a comfortable atmosphere: the furnishings of restaurant, lounge, studios, and family suites are rustic yet modern. The beach and downtown Domburg are only minutes by foot. Bicycles can be rented from the hotel; horseback riding, hiking, and swimming facilities are all close by. The hotel also rents beach sheds and children's kits, which consist of a hand cart, bucket and shovel, arm floats and little chairs for babies. Those parents needing time to themselves can leave their children with the in-house babysitter.

Dezenter Luxus trifft hier auf gemütliche Atmosphäre: Die Einrichtung von Restaurant, Lounge, Studios und Familiensuiten ist rustikal und doch modern. Den Strand und die Innenstadt von Domburg erreicht man in wenigen Minuten zu Fuß. Fahrräder verleiht das Hotel; Reiten, Wandern und Schwimmen kann man ganz in der Nähe. Das Hotel vermietet Strandkabinen und Kinderpakete mit Bollerwagen, Schaufel und Eimer, Schwimmflügeln und Stühlchen für die Kleinsten. Wer Zeit für sich braucht, kann seine Kinder in der Obhut des hoteleigenen Babysitters lassen.

Mariage réussi de luxe discret et d'ambiance agréable, l'aménagement du restaurant, du salon, des studios et des suites familiales de cet hôtel est rustique, et pourtant moderne. La plage et le centre-ville de Domburg ne sont qu'à quelques minutes à pied. L'hôtel prête des vélos, tandis que l'on peut pratiquer l'équitation, la natation et partir en randonnée à proximité immédiate. L'hôtel loue également des cabines de plage, et des packs enfants comprenant petit chariot, pelles et seaux, brassards et petits sièges pour les plus petits. Ceux qui ont besoin de prendre du temps pour soi peuvent confier leurs enfants aux bons soins d'un(e) des baby-sitters de l'hôtel.

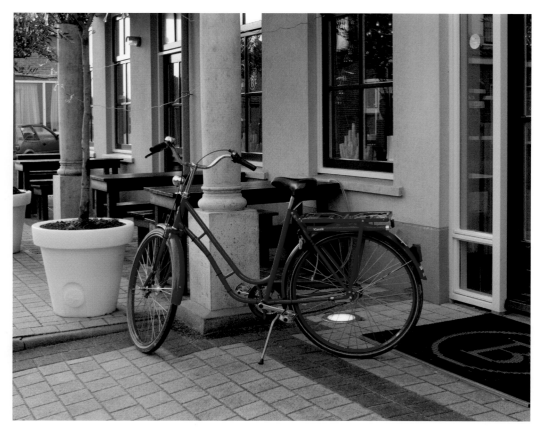

The modern hotel's restaurant is both bright and friendly.

Das Restaurant des modernen Hotels ist hell und freundlich gestaltet.

Le restaurant de cet hôtel moderne est accueillant et bien éclairé.

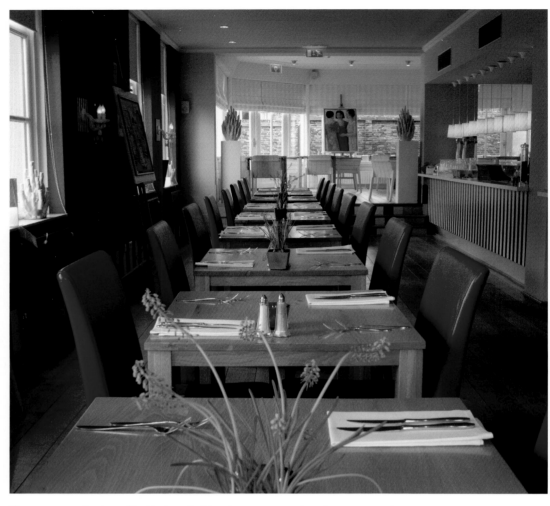

The rooms are dominated by black and white, the restaurant glows in a strong red.

Schwarz und Weiß geben in den Zimmern den Ton an, kräftiges Rot leuchtet im Restaurant.

Si le noir et blanc donne le ton dans les chambres, le rouge vif domine dans le restaurant.

Kempinski Grand Hotel Heiligendamm

Heiligendamm, Germany

The hotel's park on the Baltic coast harbors six neo-classical houses and a spa hotel with elegant rooms and suites. Children will love the different themes in the kids' villa—such as the "jungle world," the "western town" or the "space shuttle." A covered slide leads directly from the villa into the garden with swings, slides, and a sand pit. While parents play golf or relax in the spa, kids can enjoy a pirate's feast, pizza baking, pony or carriage rides, fairy tales, children's yoga, and readings in the supervised kids' club.

Zum Hotelpark am Ostseestrand gehören sechs Häuser im klassizistischen Stil mit einem Kurhaus und eleganten Zimmern und Suiten. Die Kinder werden die Erlebniswelten der Kindervilla begeistern, zum Beispiel „Dschungel", „Westernstadt" oder „Space Shuttle". Eine Röhrenrutsche führt aus der Villa direkt in den Garten mit Schaukeln, Rutsche und Sandkasten. Während die Eltern golfen oder im Spa entspannen, erleben die Kleinen im betreuten Club Piratenfest, Pizzabacken, Ponyreiten, Kutschfahrten, Märchenstunde, Kinderyoga und Lesungen.

Six bâtiments de style néoclassique aux chambres et suites élégantes composent ce parc hôtelier donnant sur la mer Baltique, et possédant son propre établissement thermal. Les thèmes de la villa des enfants (« Jungle », « Ville du Far-West » ou « Navette spatiale ») réjouiront les plus jeunes, quand ils ne seront pas en train d'emprunter le toboggan-tunnel qui, de la villa, mène directement au jardin, à ses balançoires, à son toboggan et à son bac à sable. Tandis que les parents font du golf ou se détendent au spa, les enfants pourront participer au banquet des pirates, faire des pizzas, chevaucher des poneys, faire des tours en calèche, écouter des contes et des lectures, ou encore pratiquer un yoga adapté, le tout sous la surveillance d'adultes.

The theme on the ground floor of the kids' villa is "Africa."

„Afrika" ist das Thema im Erdgeschoss der Kindervilla.

« L'Afrique » est le thème du rez-de-chaussée de la villa des enfants.

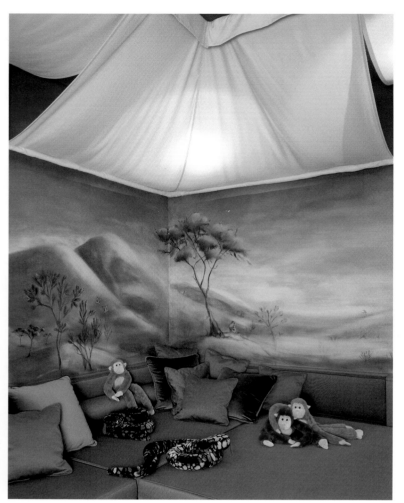

The luxurious hotel with four restaurants is situated directly on the Baltic coast.

Das luxuriöse Hotel mit vier Restaurants liegt direkt an der Ostsee.

Ce luxueux hôtel pourvu de quatre restaurants est situé directement au bord de la Baltique.

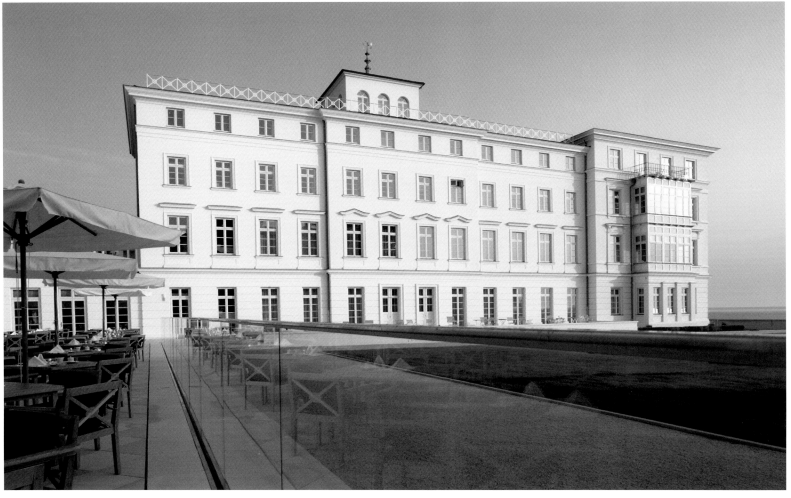

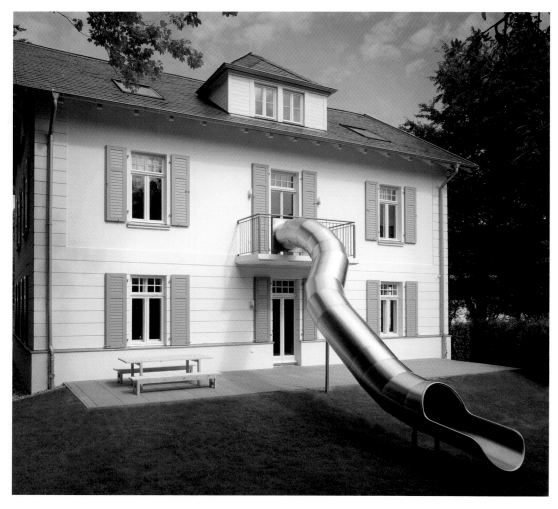

Kids can slide from the villa straight into the garden.

Aus der Kindervilla rutschen die Kleinen direkt in den Garten.

De la villa des enfants, les petits accèdent directement au jardin grâce à un toboggan.

Vier Jahreszeiten Zingst

Zingst, Germany

Pleasure and relaxation for parents, fun, and adventure for the kids in the Vorpommersche Boddenlandschaft National Park by the Baltic Sea: the beauty and fitness family hotel with its mod cons, attentive service, great spa facilities, and excellent food guarantees a successful holiday. The supervised kids' program is comprehensive: playroom with tabletop soccer, inflatable castle, and playground with climbing tower provide all sorts of fun. But that is not all: board games, books, drawing and painting, playstation, and crazy golf provide further entertainment.

Genuss und Erholung für Eltern, Spaß und Abenteuer für Kinder im Nationalpark Vorpommersche Boddenlandschaft an der Ostsee: Das Wellness- und Familienhotel sorgt mit Wohnkomfort, aufmerksamem Service, großem Spa-Angebot und ausgezeichnetem Essen für ein gelungenes Urlaubserlebnis. Das betreute Kinderprogramm ist umfangreich: Spielzimmer mit Tischfußball und Hüpfburg und ein Spielplatz mit Kletterturm garantieren Spaß und Abwechslung. Zudem gibt es Brettspiele, Bücher, Malvorlagen, Playstation und einen Minigolfplatz.

Plaisir et détente pour les parents, amusement et aventures pour les enfants au parc national de la « Vorpommersche Boddenlandschaft », au bord de la mer Baltique : le confort, le service prévenant, la formule spa étendue et l'excellente nourriture de cet hôtel orienté familles et bien-être feront de vos vacances une réussite. L'éventail des activités encadrées pour les enfants est large : des pièces de jeux avec baby-foot et château gonflable et une plaine de jeux dotée d'une tour d'escalade veilleront à ce que les plus jeunes ne s'ennuient jamais, sans parler des jeux de plateaux, des livres, des cahiers de coloriages, de la Playstation et du mini-golf.

All hotel rooms are generously sized, bright, and modern.

Alle Räume des Hotels sind großzügig, hell und modern eingerichtet.

Toutes les pièces de l'hôtel sont spacieuses, bien éclairées et modernes.

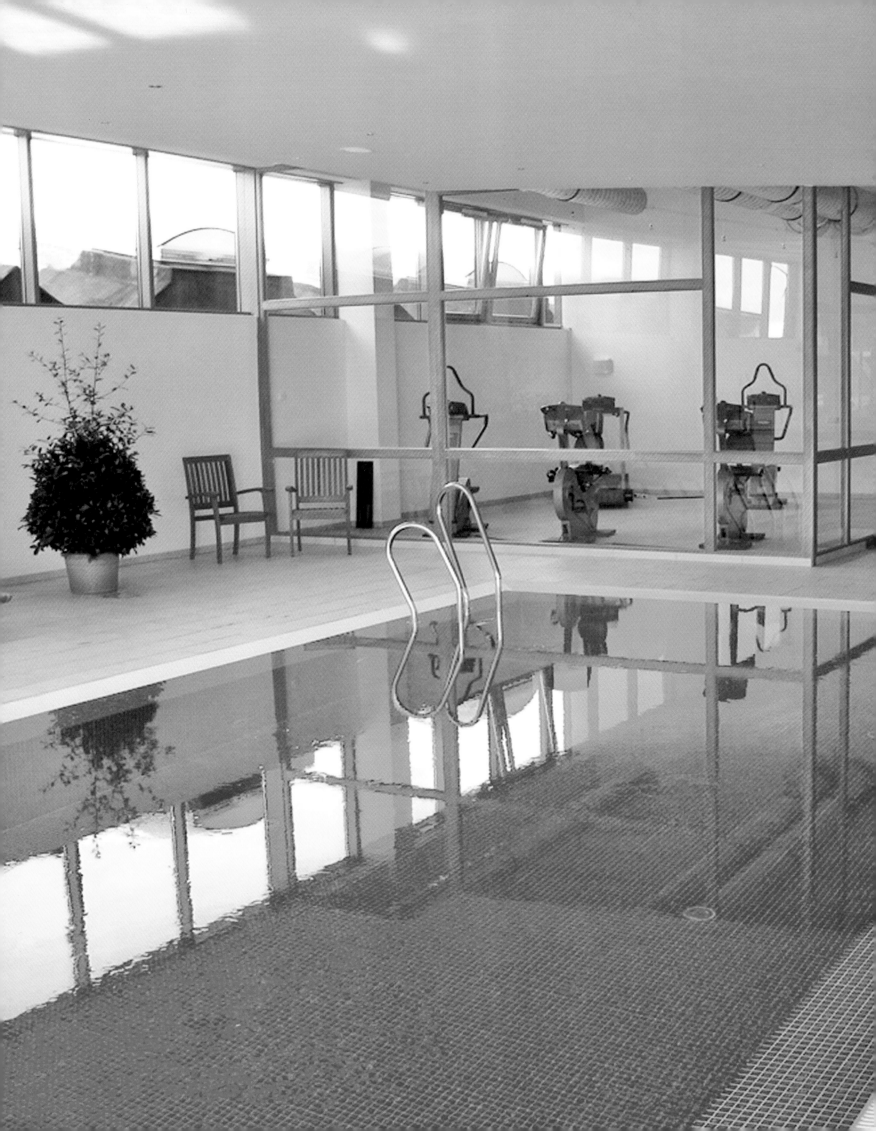

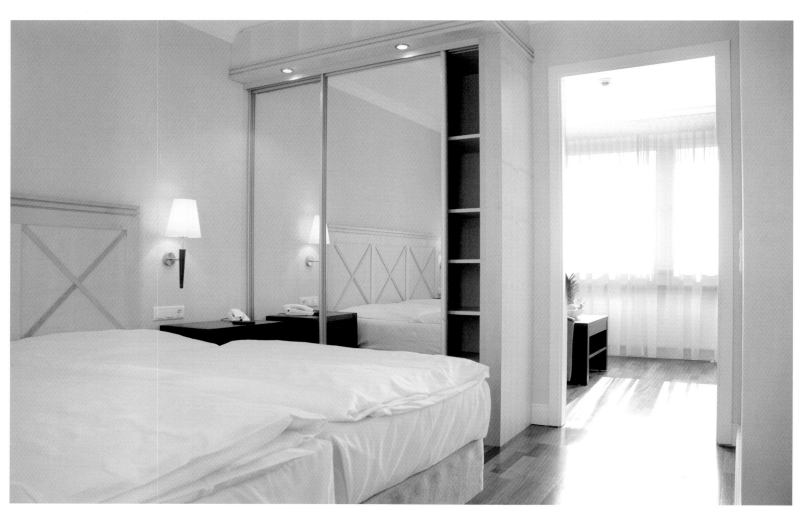

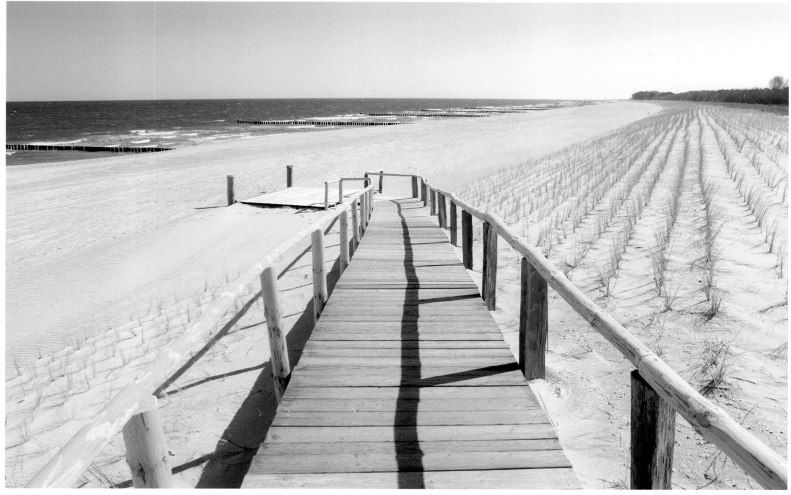

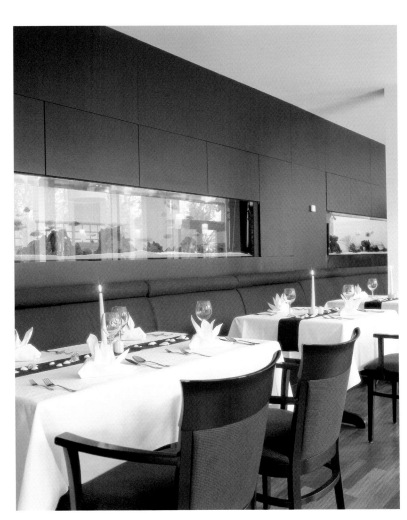

Families will find a multitude of leisure facilities in the national park and along the Baltic coast.

An der Ostsee und im Nationalpark finden Familien ein großes Freizeitangebot.

Au bord de la Baltique et au parc national, les familles auront un vaste choix d'activités de loisirs.

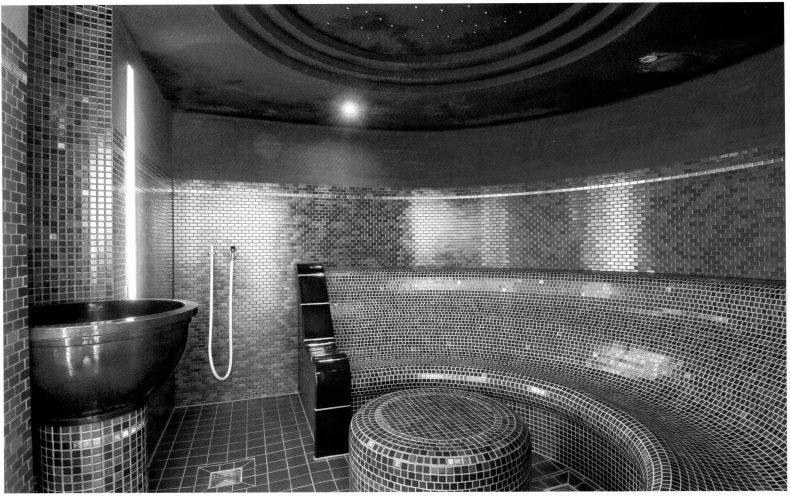

Hotel Fährhaus Sylt

Sylt, Germany

The former ferry house dating from the 19th century offers wonderful views over the tidelands as well as elegant, comfy rooms and culinary delights. Hospitality and comfort of the highest degree are complemented by fantastic health and beauty facilities. Kids await a kids' corner in the library and a playground in the gardens. The hotel is happy to provide a babysitter. Nature lovers will find a multitude of things to do from horseback riding to sailing and guided tideland walks for the whole family.

Das ehemalige Fährhaus aus dem 19. Jahrhundert bietet nicht nur herrliche Ausblicke auf das Wattenmeer. Hier findet man auch elegante, behagliche Zimmer und kulinarische Genüsse. Zu Gastlichkeit und Wohnkomfort auf höchstem Niveau kommt ein großes Verwöhnprogramm. Kleine Gäste vergnügen sich in der Spielecke der Bibliothek oder auf dem Spielplatz im Garten. Das Hotel kümmert sich gerne um einen Babysitter. Naturverbundene finden ein vielfältiges Freizeitangebot von Reiten über Segeln bis zu geführten Wattwanderungen für die ganze Familie.

Cette ancienne gare maritime du XIXéme siècle offre non seulement une vue splendide sur l'estran, mais aussi d'élégantes et confortables chambres et de véritables délices culinaires. Un vaste choix d'activités de détente et de soins, veille à maintenir l'hospitalité et le confort des lieux au plus haut niveau. Un coin jeux dans la bibliothèque et une plaine de jeux dans le jardin attendent les petits pensionnaires, pour lesquels l'hôtel peut se charger de trouver un(e) baby-sitter. Ceux et celles qui sont restés proches de la nature trouveront un large éventail d'activités de loisirs variées pour toute la famille, de l'équitation aux randonnées avec guide sur l'estran, en passant par la voile.

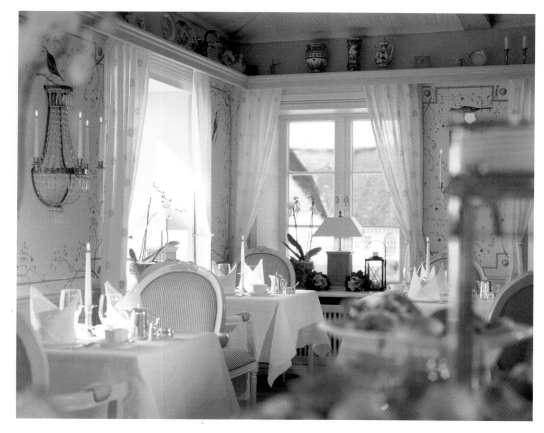

The historic ferry house with its modern extension is very cozy.

Das historische Fährhaus mit modernem Anbau ist gemütlich eingerichtet.

L'intérieur de cette ancienne gare maritime avec annexe moderne est agréable.

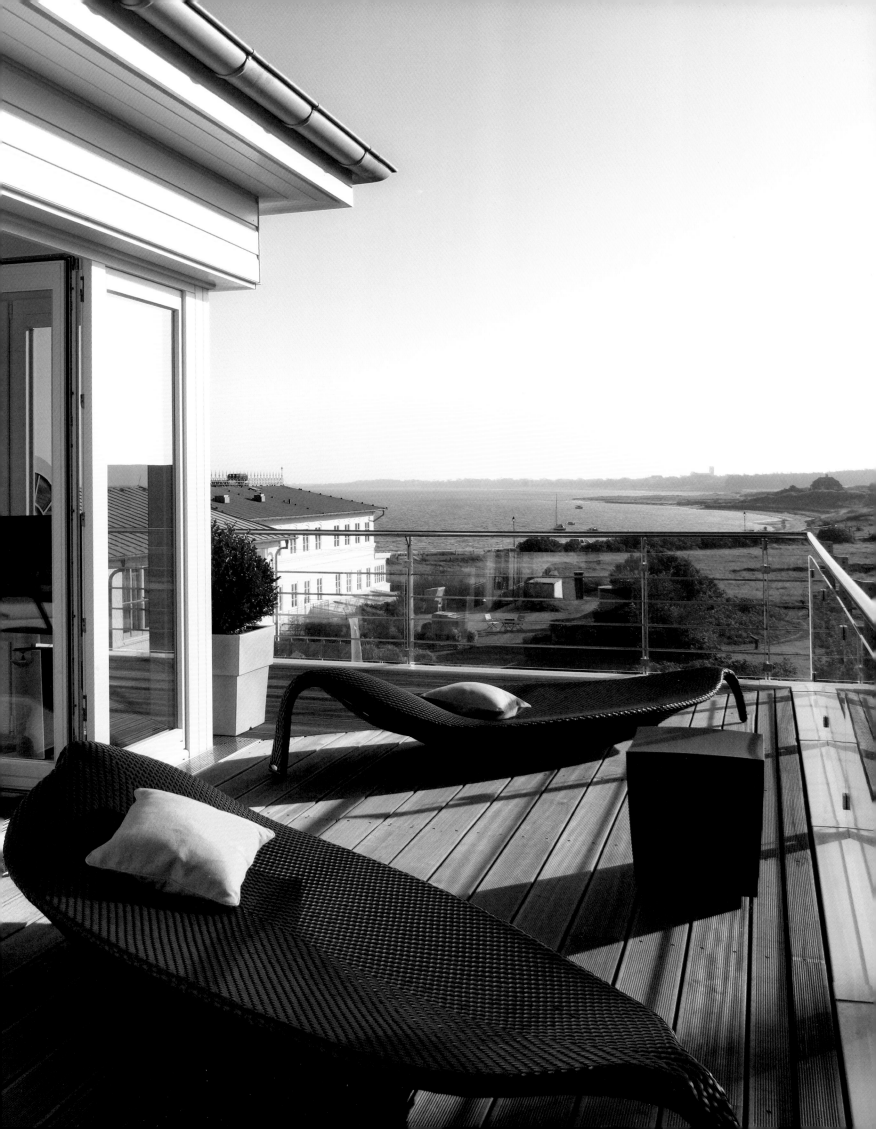

The hotel exudes stylish living and a colorful ambiance.

Stilvoller Wohnkomfort und ein farbenfrohes Ambiente zeichnen das Hotel aus.

Bon goût, confort et atmosphère colorée caractérisent l'hôtel.

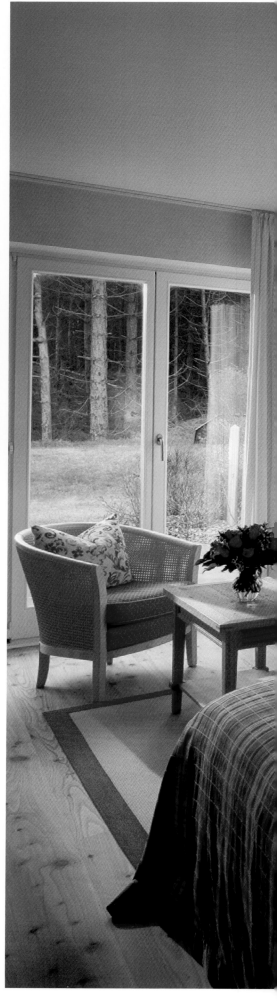

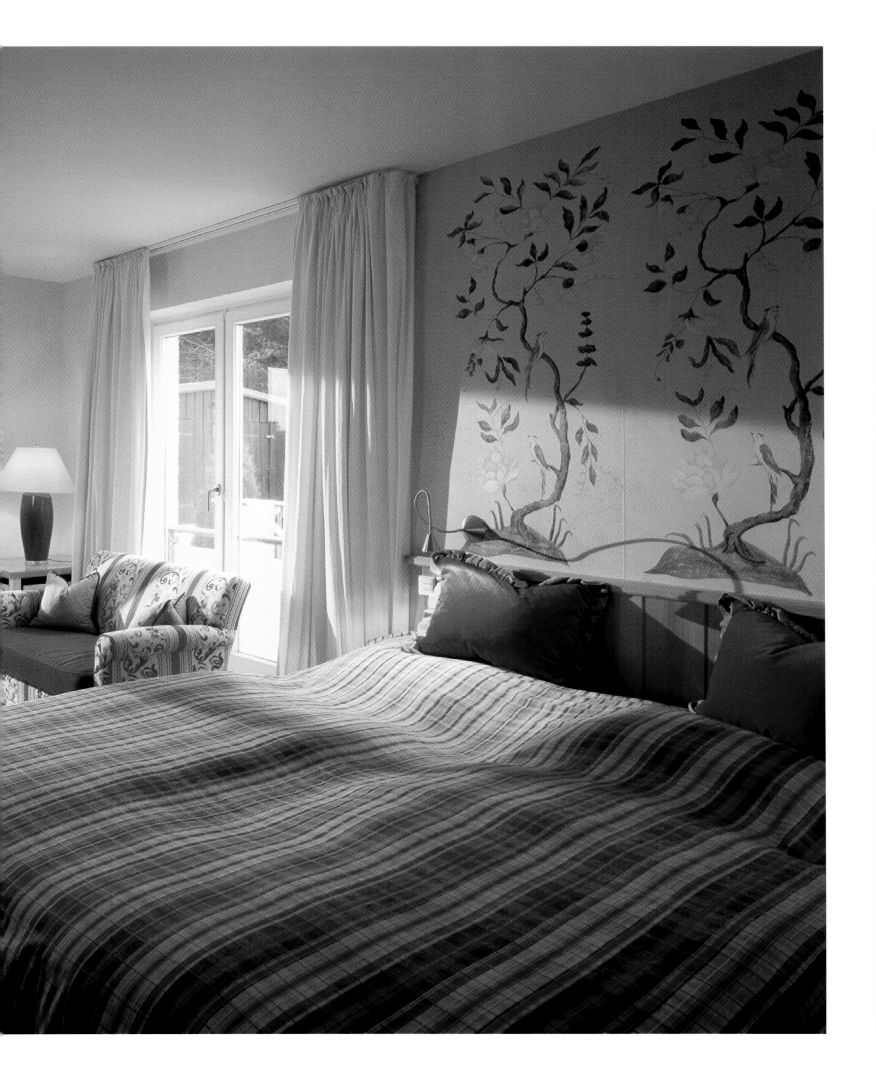

Schloss Elmau
Cultural Hideaway & Luxury Spas
Elmau, Germany

Elegant ambiance, three luxurious spa areas plus a huge natural spa, an excellent cuisine, and perfect service crowned by a breathtaking scenery—that is Schloss Elmau. The luxury hotel is synonymous for quality cultural events, varied recreational fun, and an exciting kids' program: adventure holidays, children's literature days, musical weeks, and nature experiments along the mountain creek form only a small part of what is on offer. Then there is the private family spa and two large playgrounds with climbing park. But the greatest luxury: endless space.

Elegantes Ambiente, drei luxuriöse Spa-Bereiche und ein riesiges Natur-Spa, hervorragende Küche und perfekter Service, gekrönt von eindrucksvoller Landschaft – das ist Schloss Elmau. Das Luxushotel steht für ausgesuchte Kulturevents, abwechslungsreichen Freizeitspaß und spannendes Kinderprogramm: Abenteuerferien, Kinderliteraturtage, Musikwoche und Naturexperimente am Bergbach sind nur ein Teil des umfangreichen Angebots. Außerdem warten ein eigenes Familien-Spa und zwei große Kinderspielplätze mit Klettergarten. Der größte Luxus: unendlich viel Platz.

Atmosphère distinguée, trois luxueux spas et un gigantesque spa en pleine nature, excellente cuisine et service impeccable, et pour couronner le tout un paysage enivrant – voilà ce qui résume le château d'Elmau, hôtel de luxe synonyme d'événements culturels sélectionnés, d'activités de loisirs variées et de programme enfants captivant. En effet, les vacances-aventures, les journées de la littérature enfantine, les semaines de la musique et les expériences en milieu naturel ne sont qu'une partie de la gigantesque palette des services offerts. On notera également l'existence d'un spa privé réservé aux familles et de deux grandes plaines de jeux avec jardin d'escalade. Mais le plus grand luxe, c'est la place immense dont on dispose.

Fascinating nature all around—the castle hotel is an ideal family destination.

Rundum faszinierende Natur macht das Schlosshotel zum idealen Familienziel.

La nature environnante, fascinante, fait de l'hôtel une destination de vacances idéale pour les familles.

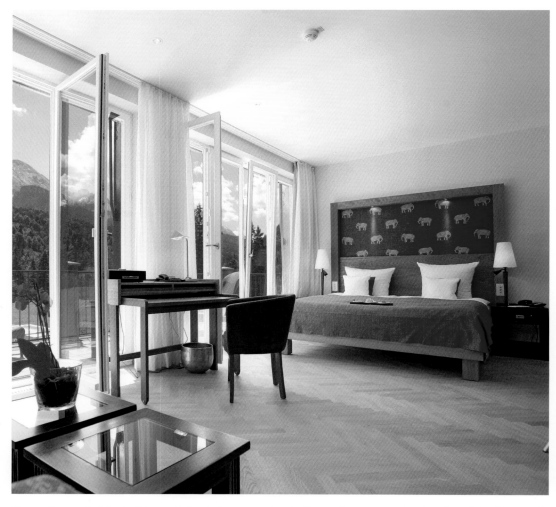

The rooftop pool of the bathhouse is heated year-round and offers swimmers an extensive view of the Wetterstein mountains.

Vom ganzjährig beheizten Pool auf dem Dach des Badehauses haben Schwimmer eine weite Aussicht auf das Wetterstein-Gebirge.

Depuis la piscine, chauffée toute l'année et située directement au-dessus de l'établissement thermal, les nageurs ont une belle vue sur le massif du Wetterstein.

Arlberg Hospiz Hotel
St. Christoph/Arlberg, Austria

The health and fitness hotel offers pure recreation right in the Alps. Located next to the slopes, the glamorous building with its generous rooms and suites exudes exclusive hospitality of the highest level. Adults can relax in the extensive beauty, pool, and fitness area, while the offspring is taken good care of in the Hospizerl kids' club, and they have fun learning skiing and snowboarding in the ski school nearby.

Erholung pur verspricht das auf Sport und Wellness ausgerichtete Hotel mitten in den Alpen. Direkt an der Skipiste gelegen, steht das mondäne Haus mit seinen großzügigen Zimmern und Suiten für gemütlichen Komfort und exklusive Gastlichkeit, die höchsten Ansprüchen gerecht werden. Erwachsene finden Erholung im großen Beauty-, Bäder- und Fitnessbereich. Der Nachwuchs ist im Hospizerl Kinderclub gut aufgehoben und lernt in der benachbarten Skischule spielerisch Skifahren und Snowboarden.

Cet hôtel, orienté sport et bien-être et situé au cœur des Alpes, offre du repos à l'état pur. Donnant directement sur la piste de ski, cette maison bourgeoise aux chambres et aux suites spacieuses est synonyme de confort agréable et d'hospitalité sélect satisfaisant même les plus exigeants. Les adultes trouveront le repos dans la vaste aire beauté, bains et fitness, leur progéniture étant en de bonnes mains au club enfants Hospizerl et elle apprendra le ski et le snowboard de manière ludique en hiver dans l'école de ski avoisinante.

The large hotel lies 6,000 feet above sea level on the Arlberg pass.

Das große Hotel liegt in einer Höhe von 1800 Metern über dem Meeresspiegel direkt am Arlberg.

Ce grand hôtel est situé à 1800 mètres d'altitude, et donne directement sur le massif de l'Arlberg.

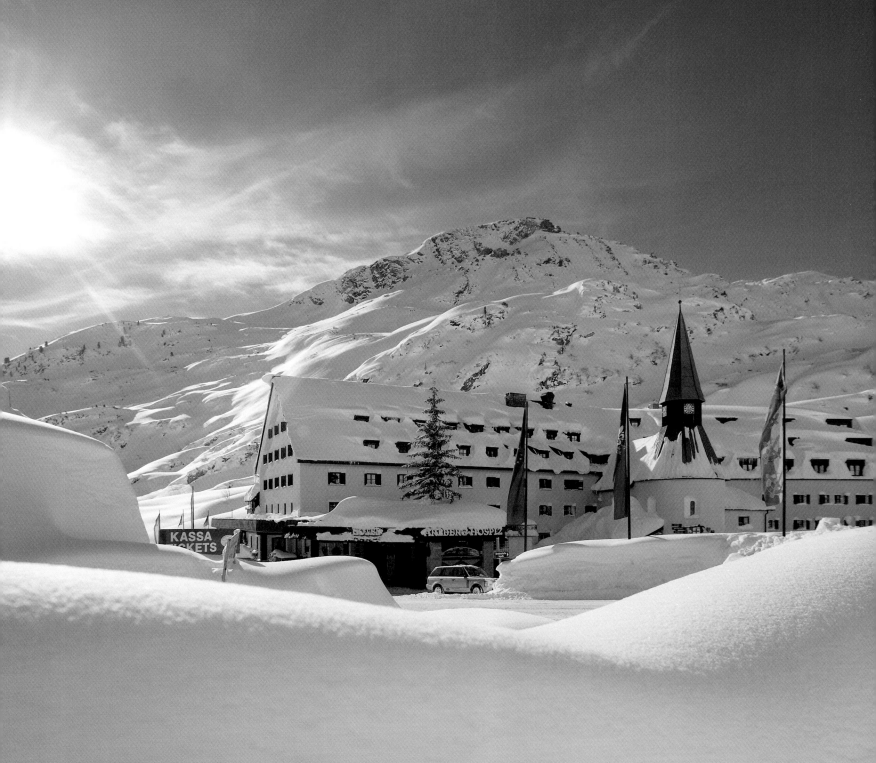

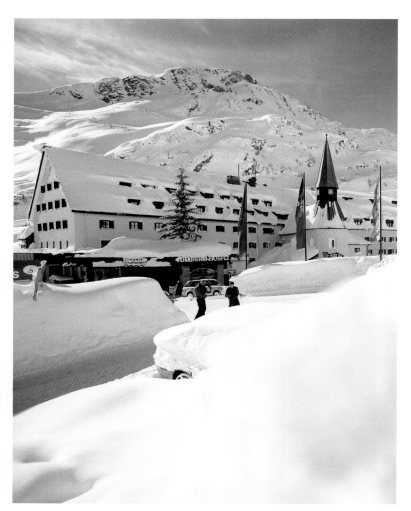

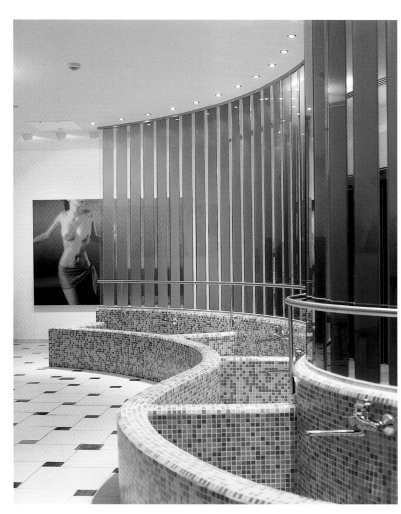

Elegant rooms and a large pool complex welcome the guest.

Elegante Zimmer und ein großer Bäderbereich erwarten die Urlauber.

D'élégantes chambres et un grand espace thermal attendent les vacanciers.

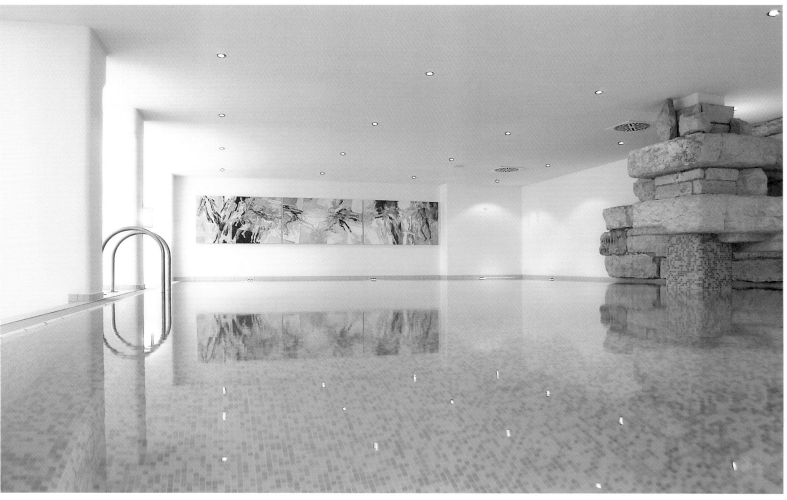

Naturhotel Waldklause
Längenfeld, Austria

The hotel with its clear lines, a lot of wood and comfortable rooms proffers views of the Ötztal Alps. The low-energy house is built almost exclusively from environmentally compatible timber, stone, and glass and offers health & beauty and relaxation facilities as well as peace and quiet. The family rooms come equipped with a kitchenette, a space for playing and an outside playground. From mountain biking—the hotel provides bicycles—to climbing, hiking, skiing, or tobogganing, active families can draw on rich resources. Guests have free entry to the neighboring spa with its extensive kids' area.

Klare Linien, viel Holz und gemütliche Räume prägen das Hotel mit Blick auf die Ötztaler Berge. Das Niedrigenergiehaus, das fast ausschließlich aus schadstofffreiem Holz, Stein und Glas erbaut wurde, bietet Wellness, Ruhe und Harmonie pur. Für Familien gibt es Zimmer mit Kochnische, einen Raum zum Spielen und einen Spielplatz vor der Tür. Ob Mountainbiken – Räder stellt das Hotel –, Klettern, Spazieren, Skifahren oder Rodeln – aktive Familien werden hier sicher fündig. Gäste haben freien Eintritt in die benachbarte Therme mit großem Kinderbereich.

Des lignes claires, du bois en abondance et des pièces agréables caractérisent cet hôtel avec vue sur les montagnes de l'Ötztal. Cette maison basse énergie, construite presque exclusivement en bois non polluant, en pierre et en verre, offre bien-être, calme et harmonie à l'état pur. Pour les familles, on trouve des chambres avec coin-cuisine, un espace pour jouer et une plaine de jeux juste en face, une aire de jeux. VTT – prêtés par l'hôtel –, escalade, promenades, ski, luge … Les familles actives trouveront sûrement leur bonheur. Les pensionnaires ont accès gratuit aux thermes voisins, dotés d'un vaste espace enfants.

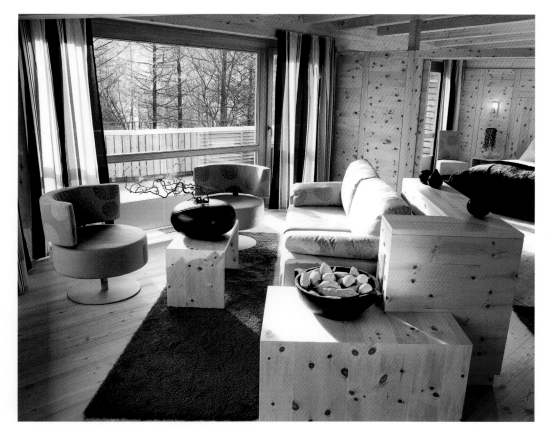

Whether inside or out: this nature hotel has wood everywhere.

Ob drinnen oder draußen: Holz spielt die Hauptrolle im Naturhotel.

À l'intérieur comme à l'extérieur, le bois est à l'honneur au Naturhotel.

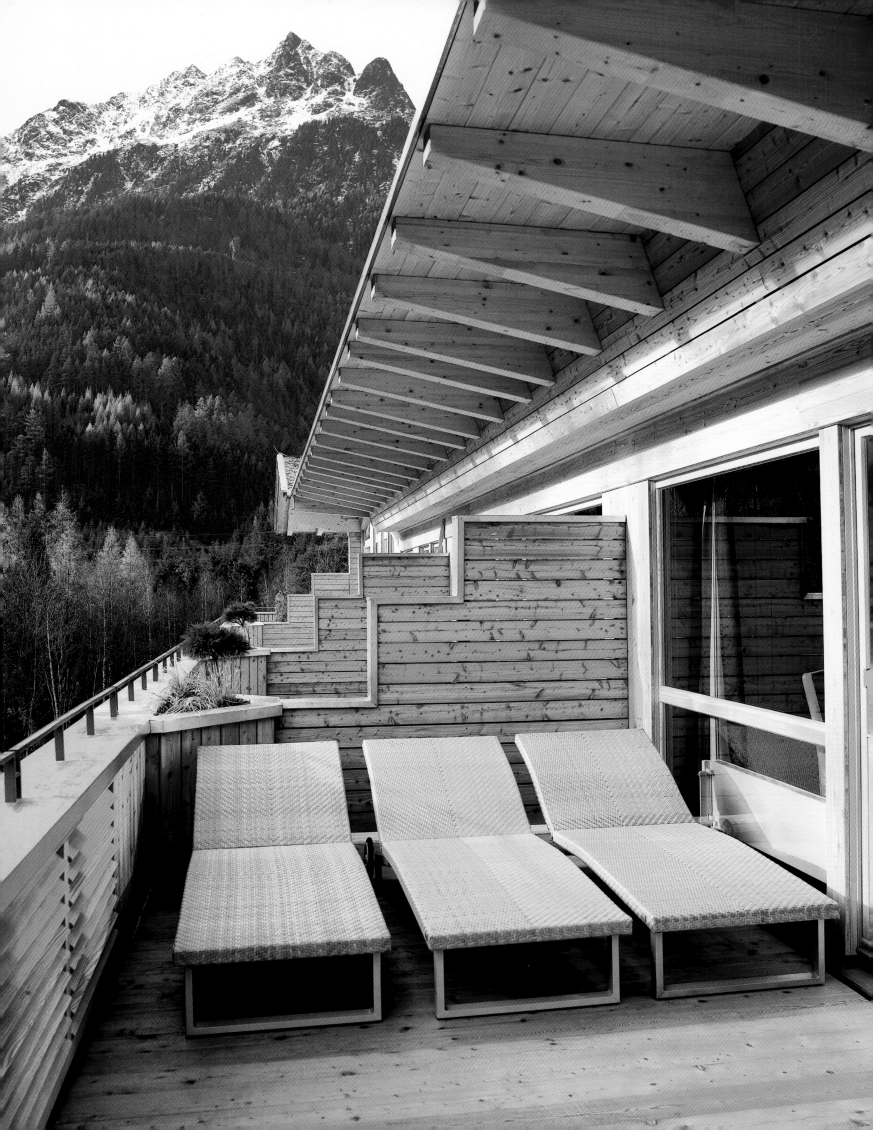

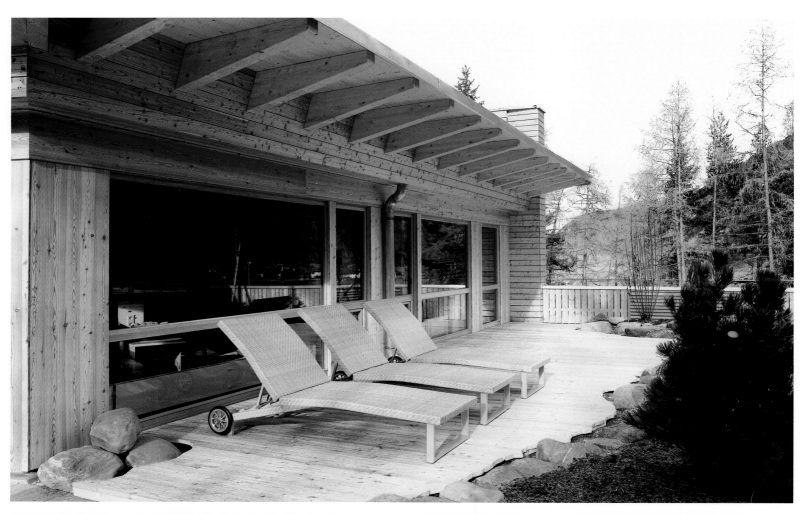

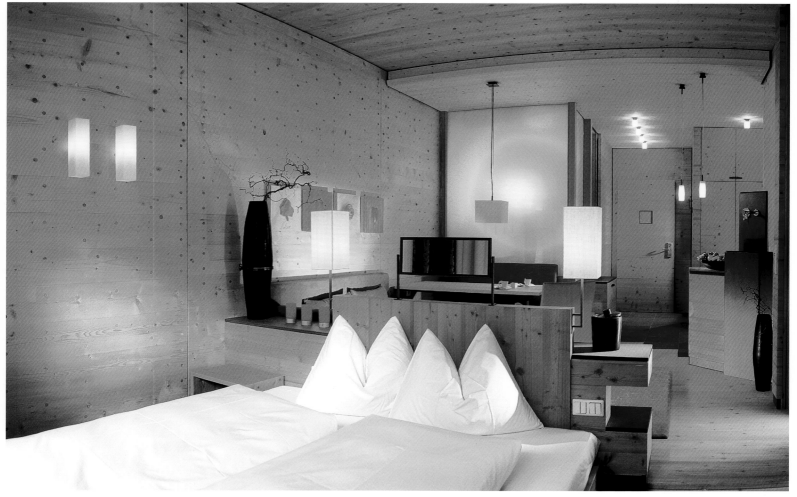

Lighting effects, strong colors, and a lot of timber give the rooms a warm touch.

Lichteffekte, kräftige Farben und viel Holz geben den Räumen eine warme Note.

Effets de lumière, couleurs chatoyantes et bois en abondance confèrent aux pièces une note chaleureuse.

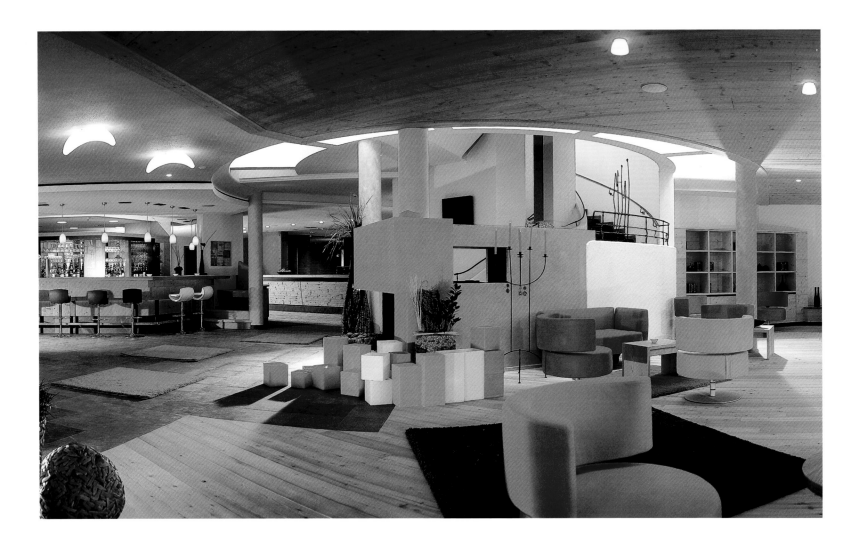

Avance Hotel
Reiter's Burgenland Resort
Bad Tatzmannsdorf, Austria

The all-inclusive resort with comfortable family rooms boasts a spa, two golf courses, horseback riding, yoga, fitness, and health & beauty facilities. Small guests can enjoy climbing, moonwalking, a games room, and a kids' spa. The supervised program for toddlers from six months and for older children is comprehensive: gymnastics, circus, golf, and tennis courses, a tepee, and campfires as well as having a closer look at the hotel's ponies, donkeys, and goats. And to top it off, kids have a whole water park reserved for them—romping is a must. The hotel also provides for your baby's requirements, ranging from potty to stroller.

Das All-inclusive-Resort mit gemütlichen Familienzimmern bietet eine Therme, zwei Golfplätze, Reiten, Yoga, Fitness und Wellness. Auf die kleinen Gäste warten Kletterlandschaft, Hüpfburg, Spielzimmer und ein Kinder-Spa. Das betreute Programm für Kinder ab einem Alter von sechs Monaten aufwärts ist umfangreich: Turnen, Zirkus, Golf- und Tennisstunden, Lagerfeuer am Tipi-Zelt und Besuche bei den hoteleigenen Ponys, Eseln und Ziegen. Außerdem ist eine ganze Badelandschaft nur für Kinder reserviert – toben ausdrücklich erwünscht. Das Hotel verleiht Babyausstattung vom Töpfchen bis zum Buggy.

Cet hôtel-club all-inclusive aux chambres familiales confortables offre des thermes et deux parcours de golf, une salle de fitness et de bien-être, on peut pratiquer l'équitation et le yoga. Un site d'escalade, un château gonflable, des salles de jeux et un spa enfants attendent les petits. L'éventail des activités encadrées pour les enfants (à partir de six mois) est large : gymnastique, cirque, leçons de golf et de tennis, feux de camp avec tipi et visites aux poneys, aux ânes et aux chèvres de l'hôtel. Il existe en outre un espace baignade exclusivement réservé aux enfants, où le défoulement est non seulement permis, mais encouragé. L'hôtel prête également des équipements pour bébé, du pot à la poussette pliable.

The modern hotel in southern Burgenland boasts its own spa.

Das moderne Hotel im südlichen Burgenland hat eine eigene Therme.

Cet hôtel moderne, situé dans le sud du Burgenland, possède ses propres thermes.

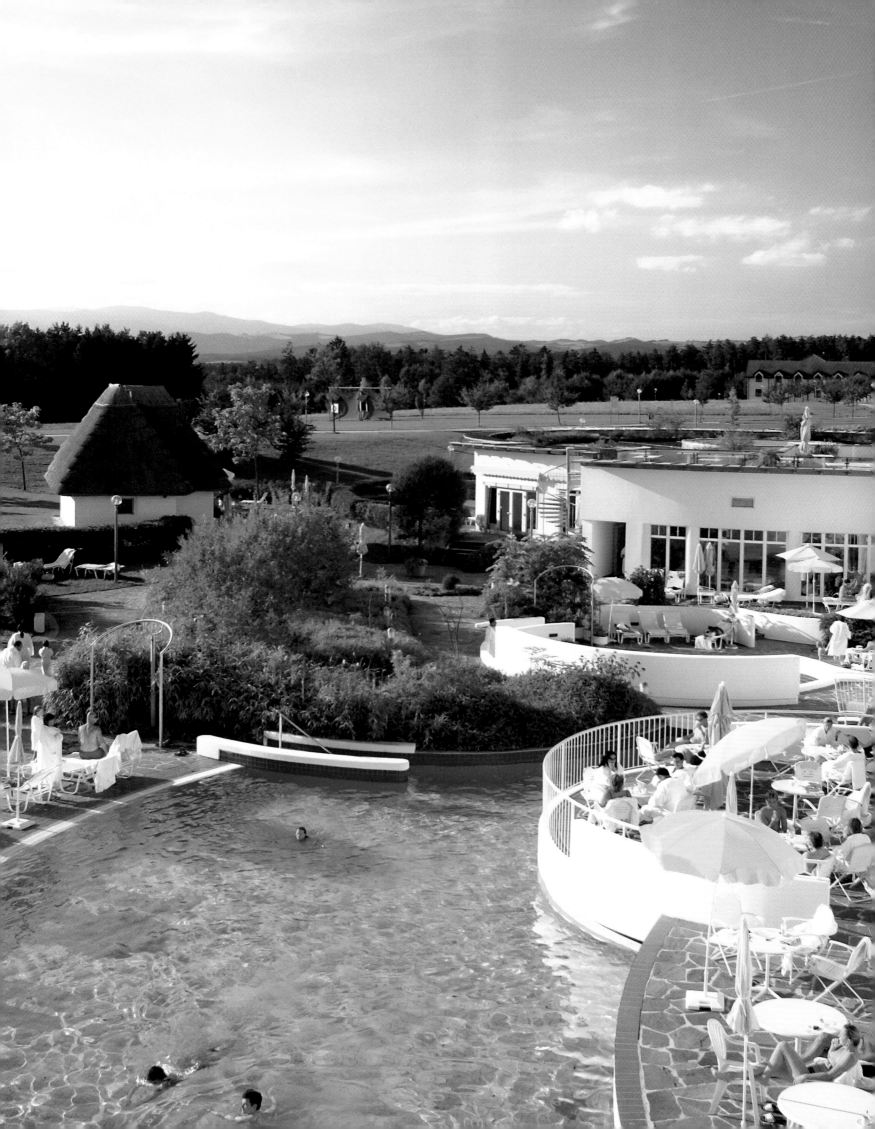

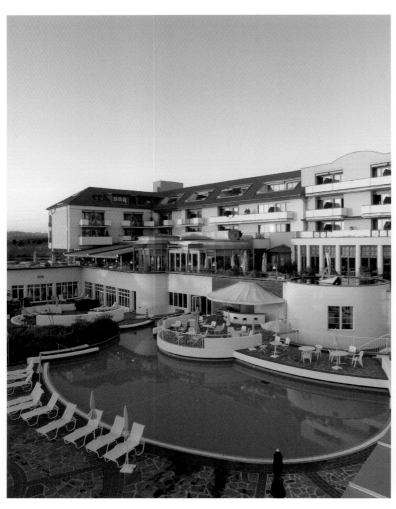

Golf, pony rides, and campfires form part of the kids' program.

Golf, Ponyreiten und Lagerfeuer gehören zu den Attraktionen für Kinder.

Golf, promenades à dos de poneys et feux de camp font partie des attractions réservées aux enfants.

Unterschwarzachhof

Saalbach-Hinterglemm, Austria

Comfortable rooms, an extensive health & beauty program, and manifold leisure possibilities including horseback riding, climbing, and skiing are on offer. The hotel has its own organic farm. Kids have their own pool, a playground, and a games room with a climbing wall, a workbench, and a children's kitchen. The supervised club offers something for everybody: pony rides, animal feeding, and making butter for the small guests, campfire evenings and mountain bike tours for the older ones. The hotel provides bicycles, baby equipment, laundry, and a baby kitchenette.

Gemütliche Zimmer, großes Wellness-Programm und vielfältige Freizeitmöglichkeiten mit Reiten, Klettern und Skifahren erwarten den Gast in diesem Hotel mit eigenem Bio-Bauernhof. Für Kinder gibt es einen eigenen Pool, einen Spielplatz und ein Spielzimmer mit Kletterwand, Werkbank und Kinderküche. Im betreuten Club ist für jedes Alter etwas dabei: Ponyreiten, Tiere füttern und Butter herstellen für die Kleinen, Lagerfeuerabende und Mountainbike-Touren für die Größeren. Für Familien stehen Fahrräder, Babyausstattung, Waschküche und Baby-Kochecke bereit.

D'agréables chambres, un vaste programme bien-être et des activités récréatives variées comme l'équitation, l'escalade et le ski, voilà ce qui attend le client dans cet hôtel et sa propre ferme biologique. Les enfants y trouveront une piscine privée, une aire de jeux et une pièce de jeux avec mur d'escalade, établi et cuisinette. Quant au club enfants, il offre à tous les âges des activités sous surveillance : promenades à dos de poneys, alimentation des animaux et fabrication de beurre pour les petits, soirées feux de camp et excursions en VTT pour les plus grands. Des vélos, des équipements pour bébés, une buanderie et un coin-cuisine pour nourrir les bébés sont également à la disposition des familles.

The spa boasts an indoor and outdoor pool, kids' pool, whirlpool, and a sauna.

Zum Spa gehören Hallen- und Freibad, Kinderbecken, Whirlpool und Sauna.

Le spa comprend une piscine couverte et une autre en plein air, un bassin enfants, un bain à remous et un sauna.

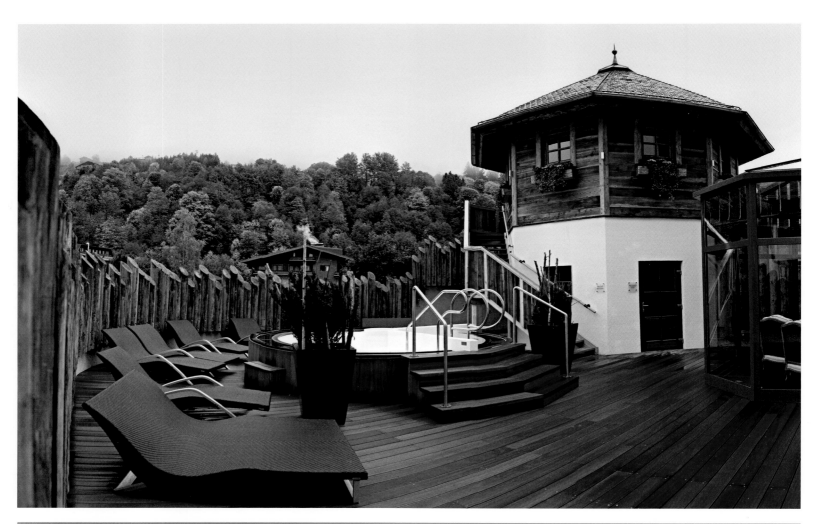

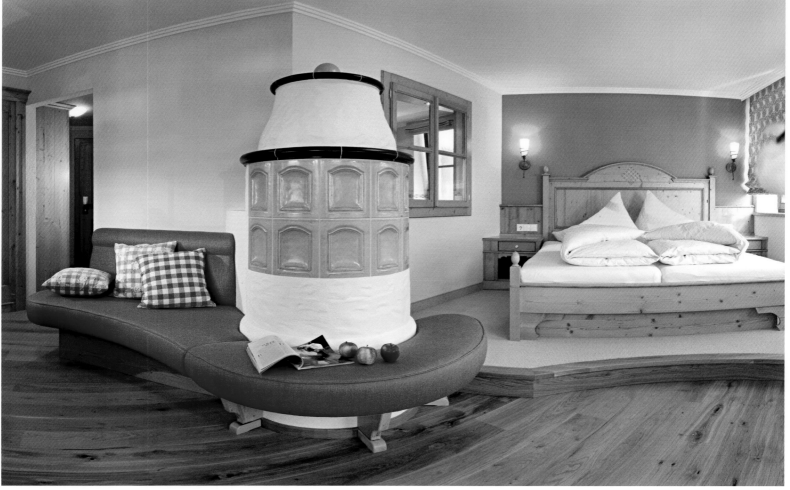

Children can feed the animals on the hotel's organic farm.

Die Kinder versorgen die Tiere auf dem hoteleigenen Mini-Bauernhof.

Les enfants peuvent nourrir les animaux à la mini-ferme de l'hôtel.

CUBE Savognin

Savognin, Switzerland

Are you sporty, a nature freak, and looking for adventure? Then this sport hotel is the right place for you. With its impressive mountainous backdrop, it offers a combination of urban design and a varied sports and recreational program. The family hotel is all concrete, glass, and interesting lighting effects, boasting an in-house climbing wall, fitness areas, tabletop soccer, table tennis, billiard, and a multitude of sporty excursions. There is something for every age group, whatever the weather.

Sportbegeistert, abenteuerlustig und naturverbunden? Dann sind Sie in diesem modernen Sporthotel gut aufgehoben. Vor beeindruckender Bergkulisse schafft das Haus eine interessante Verbindung von urbanem Design und abwechslungsreichem Sport- und Freizeitangebot. Glas, Beton und interessante Lichteffekte prägen das Haus, das auch besonders auf Familien ausgerichtet ist. Dafür sorgen die hauseigene Kletterwand, Fitnessbereiche, Tischfußball, Tischtennis, Billard und viele Möglichkeiten für sportliche Ausflüge. Bei jedem Wetter und für jedes Alter ist etwas dabei.

Fondus de sport, aventuriers et proches de la nature ? Alors vous êtes en de bonnes mains dans cet hôtel moderne, doté d'un complexe sportif. Sur fond de montagnes impressionnantes, cette maison combine de façon intéressante design urbain et activités sportives et de loisirs variées. Béton, verre et effets de lumière intéressants caractérisent cette maison, qui n'en reste pas moins particulièrement ouverte aux familles. En témoignent le mur d'escalade de l'hôtel, les espaces fitness, le baby-foot, le tennis de table, le billard et les nombreuses possibilités d'excursions sportives. Quels que soient le temps et l'âge, il y aura toujours quelque chose à faire.

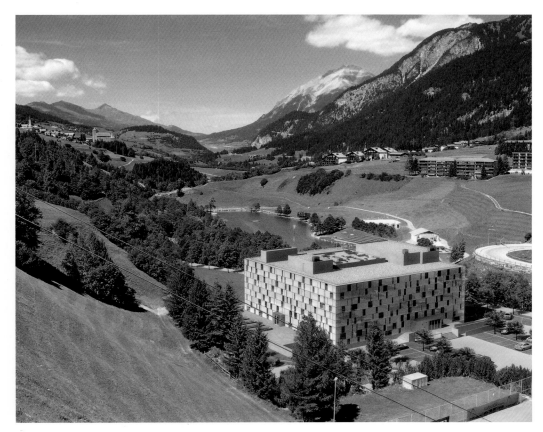

Modern architecture and a clear design silhouetted against Alpine idyll.

Moderne Architektur und klares Design heben sich von alpenländischer Idylle ab.

L'architecture moderne et le design pur se détachent d'un décor alpin idyllique.

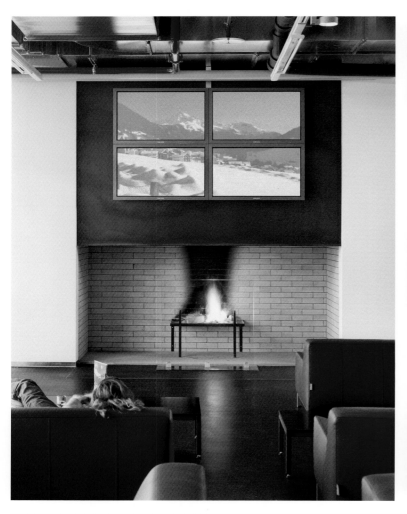

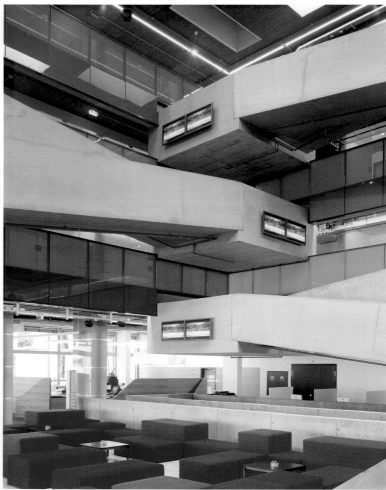

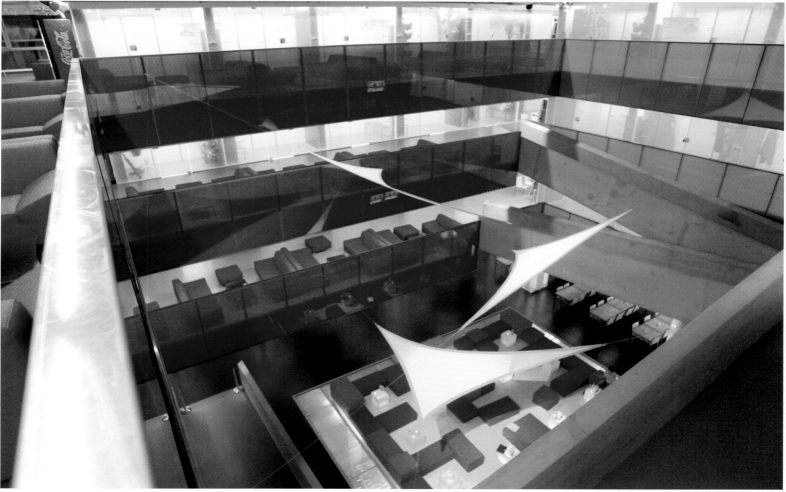

Furnishings reflect the functional design, reduced shapes, and strong colors.

Reduzierte Formen, kräftige Farben und funktionale Details prägen die Einrichtung.

Formes aux proportions réduites, couleurs vives et détails fonctionnels caractérisent l'aménagement de l'hôtel.

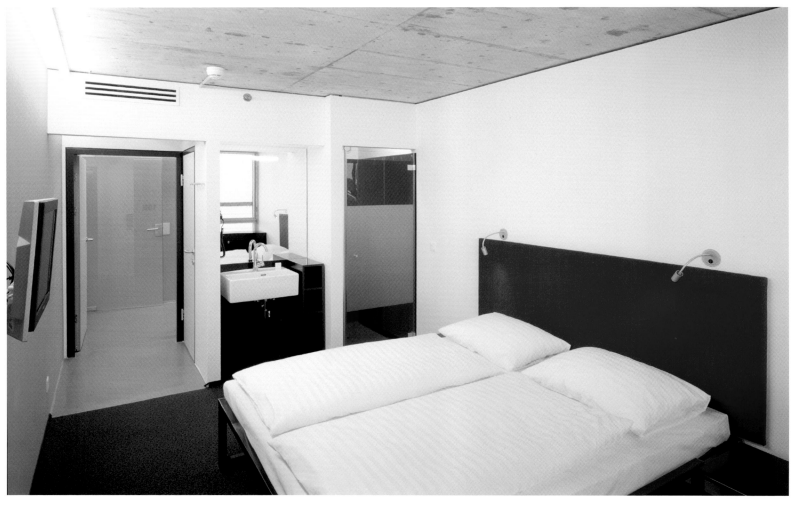

Waldhaus Flims
Mountain Resort & Spa

Flims, Switzerland

The resort with its great kids' program and many sports facilities is an ideal destination for families looking for relaxation and entertainment. Modern equipment, true hospitality, consummate service, and an excellent cuisine combine to form a balanced whole. Adults can enjoy the comprehensive beauty and fitness program while kids can explore the petting zoo, playroom, kid's club, cyber room with PlayStation, and a number of youth camps throughout the year. The fabulous park harbors an ecological swimming pond.

Mit einem tollen Unterhaltungsangebot für Kinder und vielen Sportmöglichkeiten ist das Resort ein idealer Urlaubsort für Familien, die Entspannung und Vergnügen suchen. Moderner Komfort, herzliche Gastfreundschaft, vollendeter Service und ausgezeichnete Küche fügen sich zu einem harmonischen Ganzen. Die Großen genießen ein umfangreiches Wellness-Angebot, auf den Nachwuchs warten Streichelzoo, Spielzimmer, Kids' Club, Cyber Room mit PlayStation sowie mehrmals im Jahr Jugendcamps. Im märchenhaften Park liegt ein Bio-Schwimmteich.

Un formidable choix d'activités de divertissement pour les enfants et la possibilité de pratiquer de nombreux sports font de ce complexe un lieu de vacances idéal pour les familles en quête de détente et d'amusement. Confort moderne, hospitalité chaleureuse, service irréprochable et excellente cuisine se fondent en un tout harmonieux. Les grands profitent d'un large éventail de soins et d'ateliers de remise en forme, tandis qu'une mini-ferme, des pièces de jeux, un club juniors, une cyber-room avec PlayStation et, plusieurs fois par an, des camps de jeunesse attendent leur progéniture. Le parc, féerique, abrite un étang biologique où l'on peut aller nager.

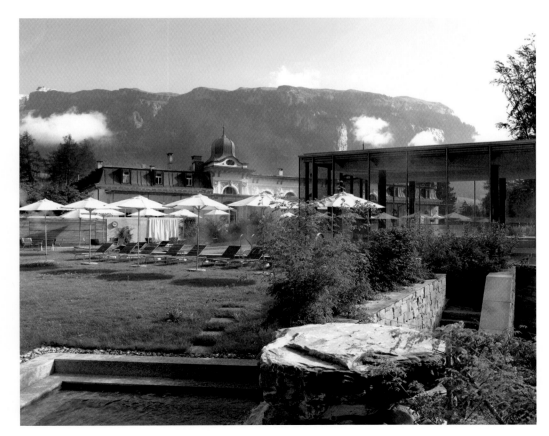

The colorful kids' restaurant offers lots of choices from the buffet.

Im farbenfrohen Kinder-Restaurant erwartet die Kleinen ein reichhaltiges Buffet.

Un buffet riche et varié attend les petits au restaurant des enfants, aux couleurs vives et gaies.

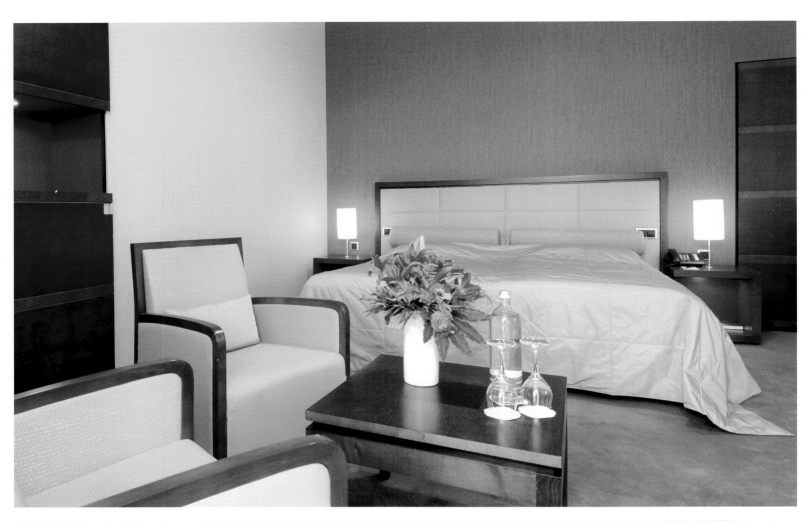

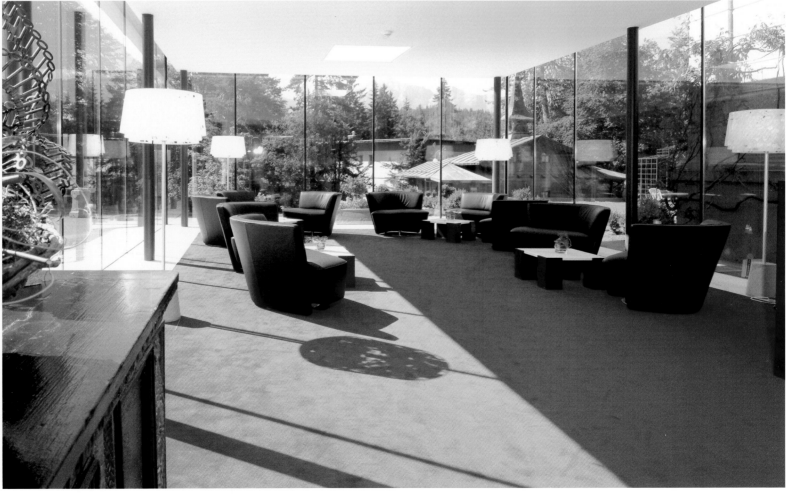

Opulent materials and strong colors make you feel welcome.

Edle Materialien und starke Farbakzente sorgen für Wohnkomfort.

Matériaux nobles et couleurs marquantes veillent au confort des hôtes.

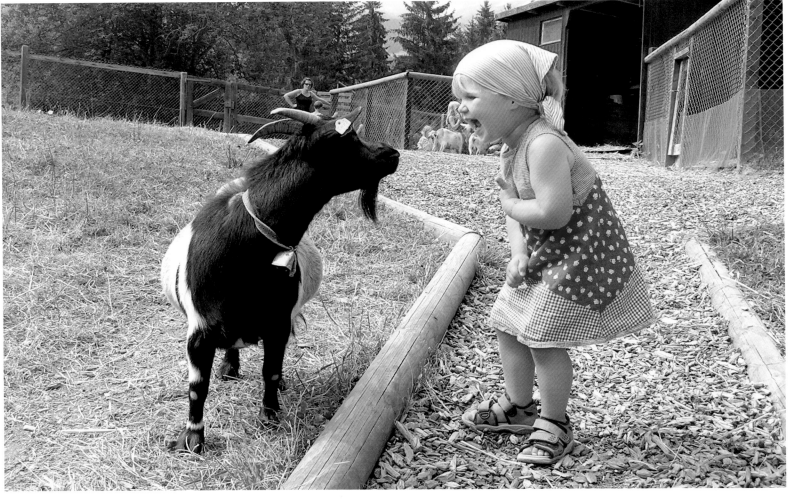

Hotel Castell

Zuoz, Switzerland

Fascinating countryside, contemporary art, and bright colors just about sum up the Hotel Castell. Situated right next to the ski lift, golf course, and beautiful hiking trails, the hotel boasts a generous Hammam and a varied family program including a park with petanque courts, playground, and ice rink in the winter for outdoor activities as well as a supervised kindergarten, inflatable castle, and play corner to complete the indoor facilities. The Hammam has a kids' day once a week.

Faszinierende Natur, zeitgenössische Kunst und fröhliche Farben – so lässt sich das Castell treffend beschreiben. Direkt neben Skilift, Golf-platz und schönen Wanderwegen bietet das Hotel einen großzügigen Hamam und ein abwechslungsreiches Angebot für Familien: Der Park mit Boule-Bahn, Spielplatz und Eisplatz im Winter sorgt für Vergnügen im Freien. Betreuter Kindergarten, Hüpfzimmer und Spielecke stehen nicht nur bei Regen bereit. Einmal wöchentlich können die Kinder zudem spielerisch den Hamam kennenlernen.

Nature fascinante, art contemporain et couleurs gaies. Ainsi faut-il décrire le Castell. Situé au voisinage direct de remontées mécaniques, d'un parcours de golf et de beaux chemins de randonnée, cet hôtel offre, outre un vaste hammam, un choix d'activités variées pour les familles : son parc avec piste de pétanque, sa plaine de jeux et sa patinoire naturelle en hiver sont autant d'occasions de s'amuser en plein air, la garderie et les espaces de jeu et de défoulement restant bien entendu accessibles quelle que soit la météo. Une fois par semaine, les enfants peuvent en outre découvrir le hammam de façon ludique.

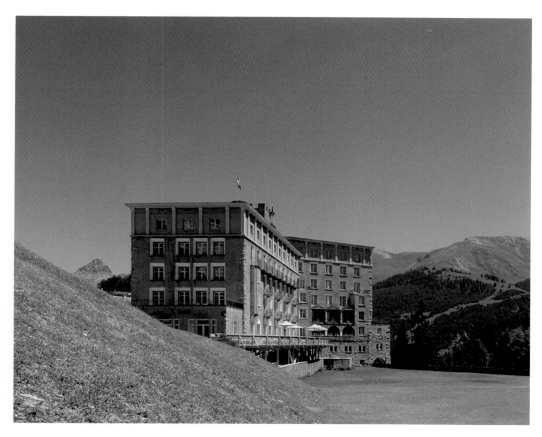

The hotel is situated on a hill above Zuoz with a view over the Engadine.

Das Hotel liegt auf einem Hügel oberhalb von Zuoz mit Blick auf das Engadin.

L'hôtel, perché sur une colline au-dessus du village de Zuoz, offre une vue sur l'Engadine.

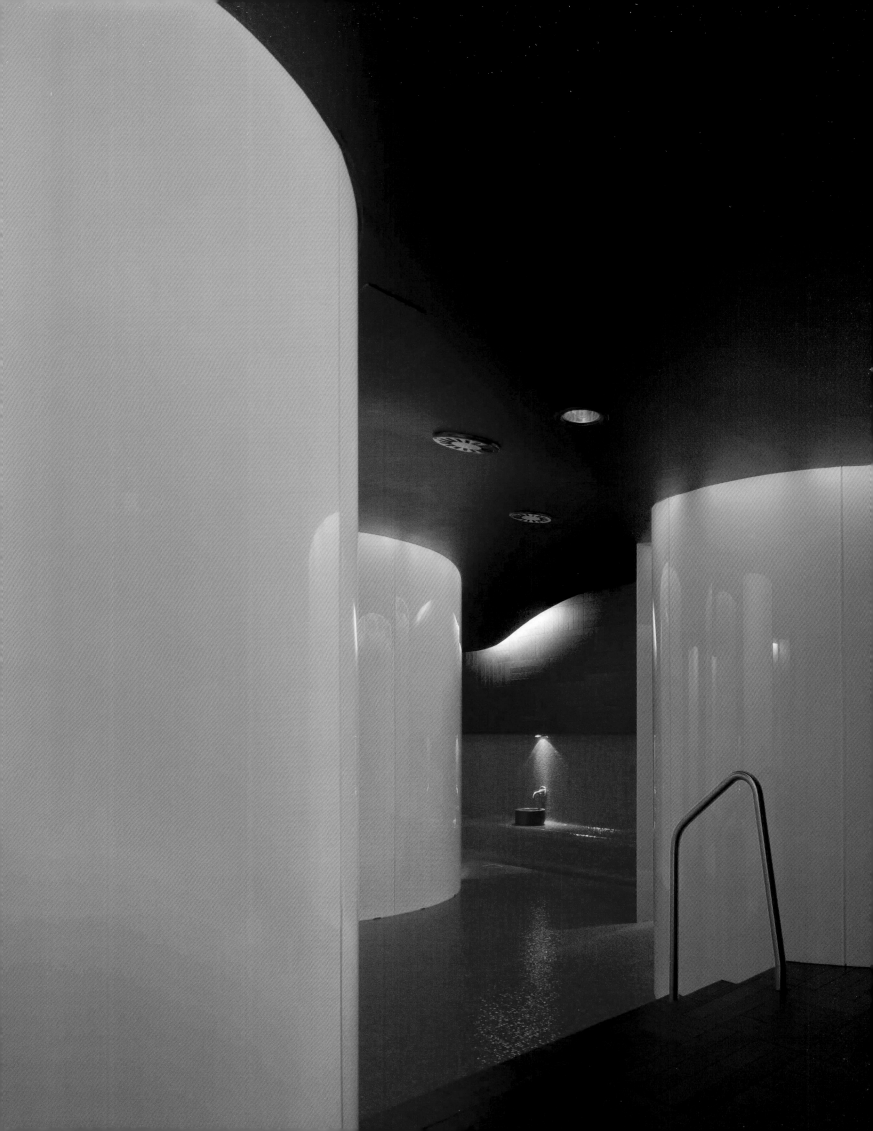

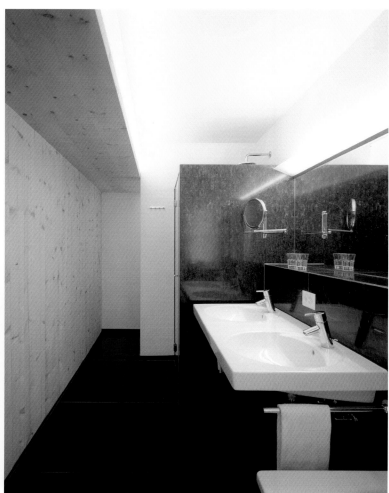

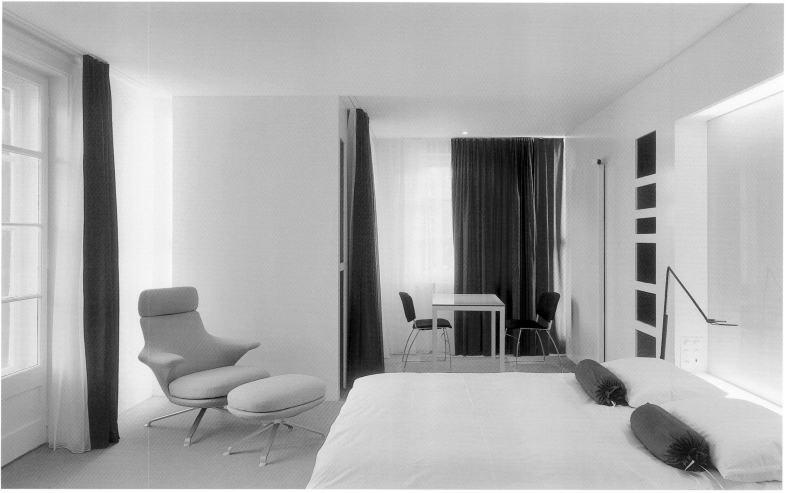

The Hammam ambiance is dominated by light and color design.

Licht- und Farbdesign bestimmen das Ambiente des Hamams.

Le jeu avec les lumières et les couleurs imprègne l'atmosphère du hammam.

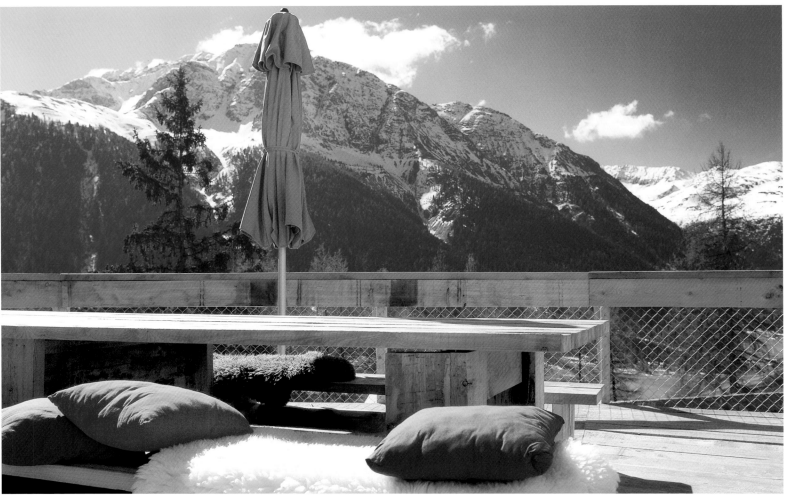

Beau-Rivage Palace
Lausanne, Switzerland

The opulent hotel, majestically located on the shores of Lake Geneva, boasts first class service, a large spa, and fantastic views of the French Alps. Rooms and suites in classic traditional style offer all mod cons—including toys and kids' videos for the smaller guests. A playground and special program ranging from a flower workshop right through to a confectionery course guarantee for exciting times for children as well as relaxing hours for the rest of the family.

Das opulente Hotel, majestätisch am Ufer des Genfer Sees gelegen, bietet erstklassigen Service, einen großen Spa-Bereich und einen weiten Blick auf die französischen Alpen. Die komfortablen Zimmer und Suiten sind im klassisch-traditionellen Still eingerichtet. Für die Kleinen gehören Spielzeug und Kinderfilme selbstverständlich dazu. Ein Spielplatz und ein spezielles Programm vom Blumenworkshop bis zum Konditoreikurs garantieren spannende Erfahrungen für Kinder und erholsame Stunden für den Rest der Familie.

Cet opulent hôtel, majestueusement situé au bord du lac Léman, offre un service de première classe, un grand spa et une belle vue sur les Alpes françaises. Les chambres et les suites en style traditionnel et classique disposent de tout le confort possible, incluant bien entendu des films et des jouets pour les petits. Une aire de jeux et un programme spécial allant des ateliers de composition florale aux cours de pâtisserie sont la promesse d'expériences passionnantes pour les enfants et d'heures reposantes pour le reste de la famille.

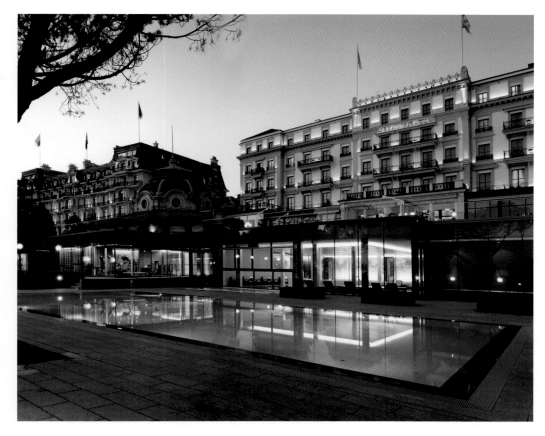

Many rooms afford a view over Lake Geneva and the Savoy Alps.

Von vielen Zimmern blickt man auf den Genfer See und die Savoyer Alpen.

De nombreuses chambres ont vue sur le lac Léman et les Alpes savoyardes.

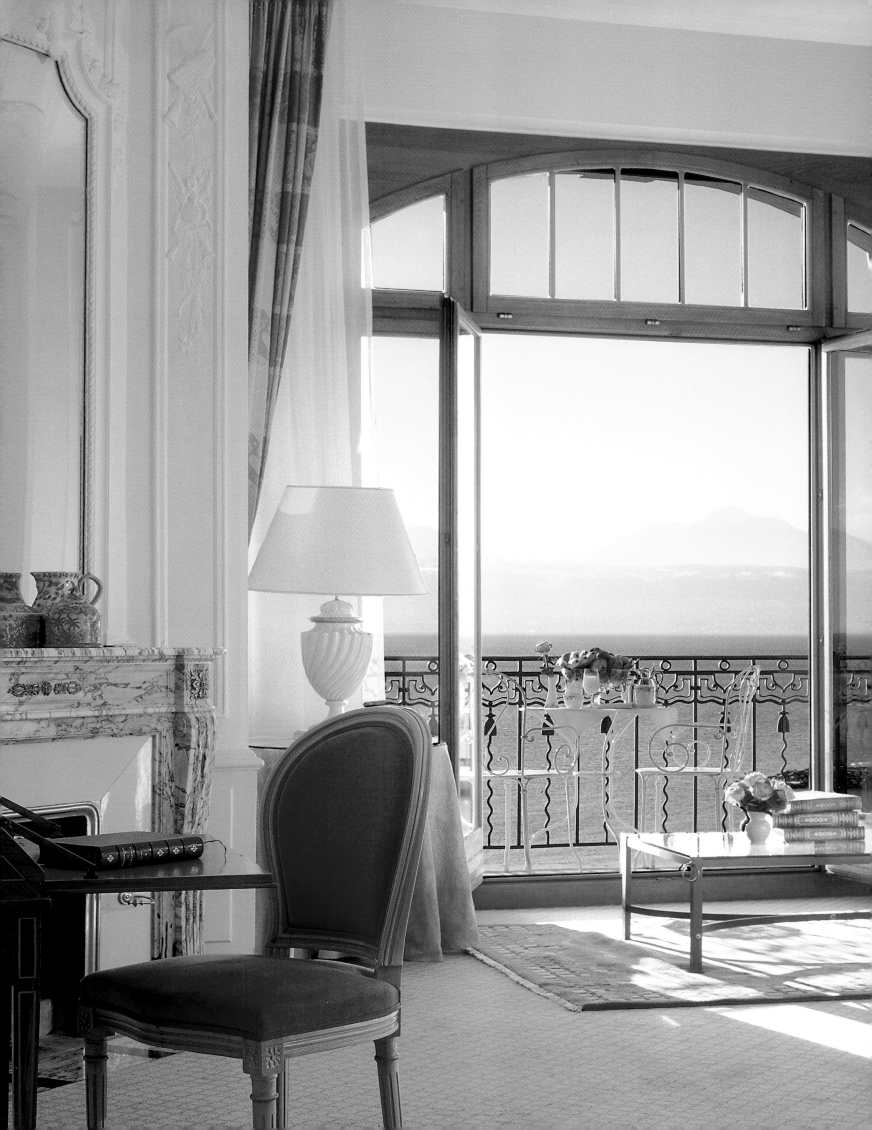

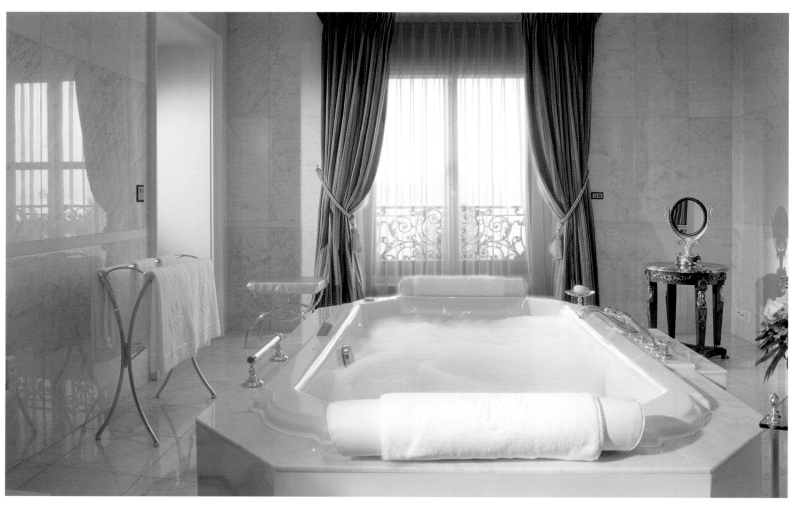

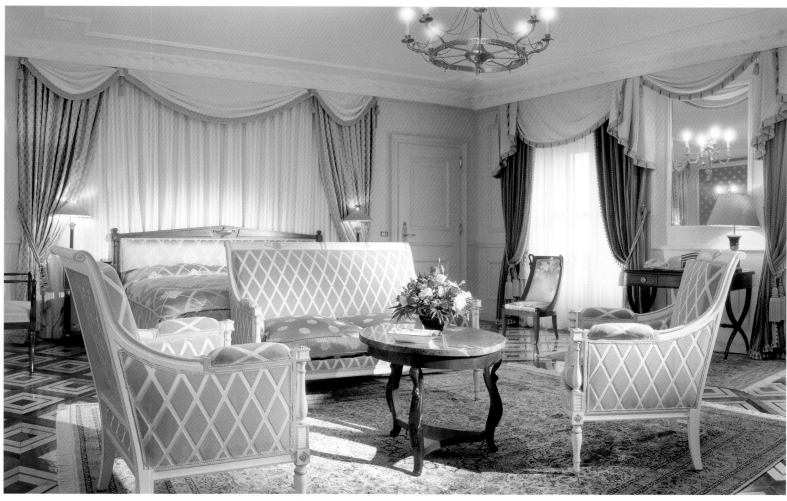

The rooms and suites reflect the style of the Belle Époque.

Die Zimmer und Suiten spiegeln den Stil der Belle Époque wider.

Chambres et suites reproduisent le style belle époque.

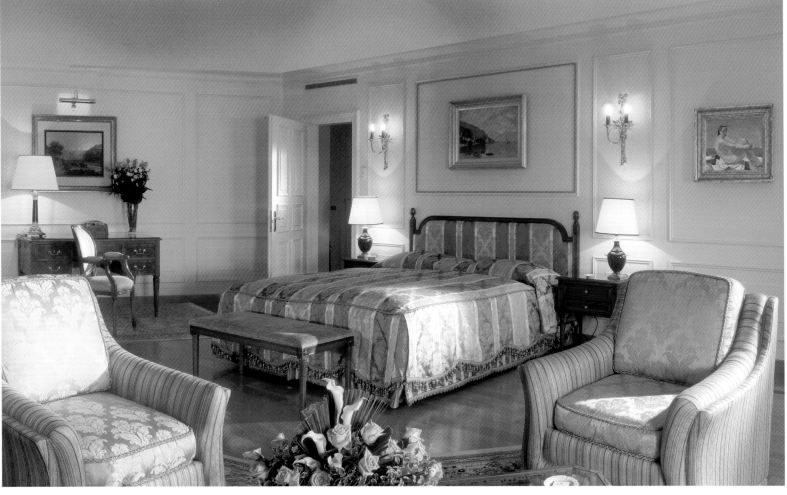

Dream Castle Hotel

Disneyland Resort Paris, France

The ideal family holiday destination: decorative knight's armors, murals, and flags account for the modern hotel's romantic charm. Fairy tales and legends form the main theme for this hotel built in the fashion of a French chateau. The design of the rooms ecalls the adventures of the Three Musketeers. Kids can enjoy the playgrounds, adventure pool, and Dream Castel fairy-tale figures. Relaxation is provided for in the form of comfortable rooms with four beds, beauty and fitness facilities or golf. Disneyland is only a few minutes away by shuttle, while the center of Paris can be reached within 35 minutes by car.

Das ideale Ziel für einen Familienurlaub: Dekorative Ritterrüstungen, Wandmalereien und Fahnen machen den romantischen Charme des modernen Hotels aus. Märchen und Legenden sind das Thema des Hauses, das einem französischen Schloss nachempfunden ist. Die Einrichtung der Zimmer erinnert an die Geschichte der Drei Musketiere. Spielplätze, ein Erlebnisschwimmbecken und Dream-Castle-Märchenfiguren erfreuen die Kleinen.Erholen kann man sich in komfortablen Vier-Bett-Zimmern, bei Wellness, Fitness oder Golf. Der Disneyland Vergnügungspark ist wenige Minuten mit dem Pendelbus entfernt, das Zentrum von Paris in rund 35 Minuten mit dem Auto zu erreichen.

La destination idéale pour des vacances en famille : armures de chevaliers décoratives, peintures murales, et bannières contribuent au charme romantique de cet hôtel moderne. Les contes et légendes constituent le thème de cette maison, inspirée d'un château français. L'aménagement des chambres fait penser à l'histoire des Trois Mousquetaires. Des aires de jeux, un bassin aventure et les personnages de contes de fées du Dream Castle réjouiront les petits. Pour se détendre, on trouvera de confortables chambres à quatre lits, des équipements de fitness, des espaces bien-être, et un golf. Le parc d'attractions Disneyland n'est qu'à quelques minutes en bus-navette, tandis que le centre de Paris n'est qu'à 35 minutes en voiture.

Kids will enjoy the many play corners dotted about the hotel.

Junge Gäste freuen sich über viele Spielecken im ganzen Haus.

Les jeunes pensionnaires se réjouiront des nombreux espaces de jeu répartis dans toute la maison.

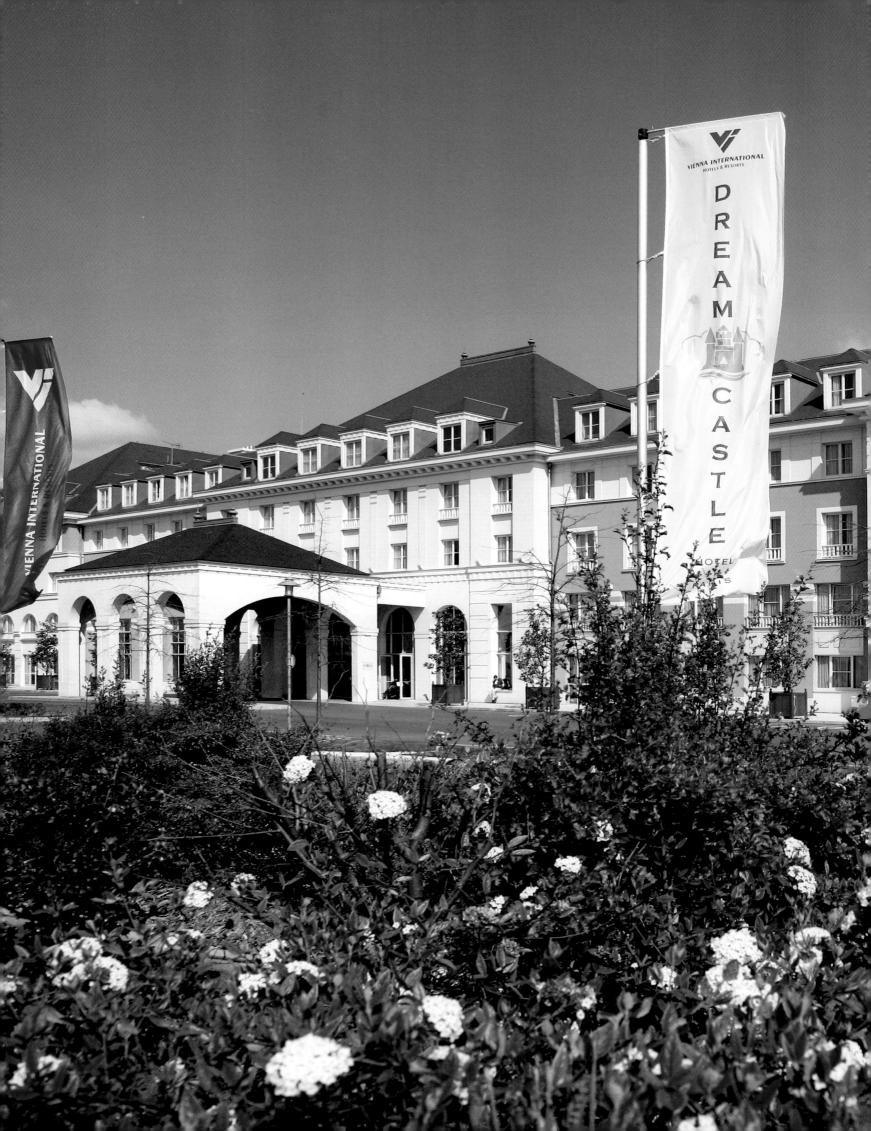

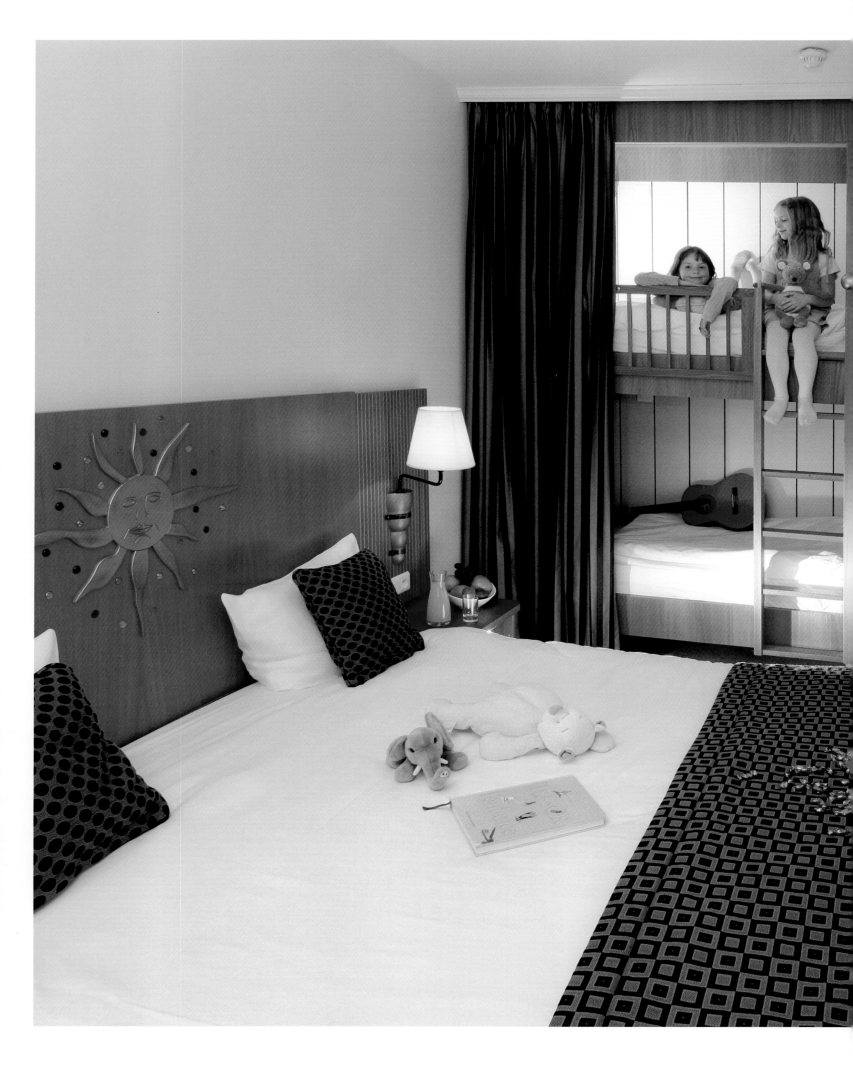

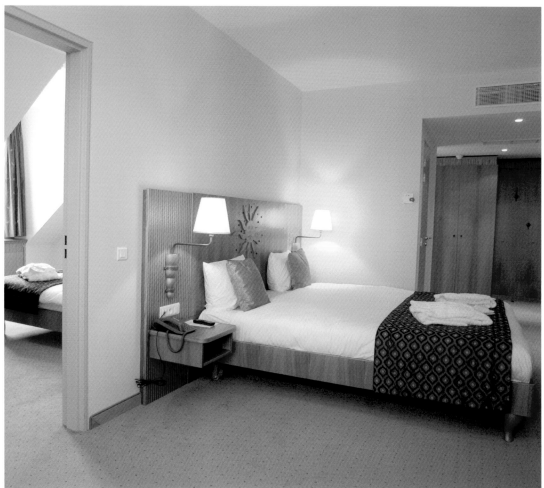

Rooms are family-friendly decorated.

Die Zimmer sind familienfreundlich eingerichtet.

Les chambres sont accueillantes pour les familles.

Château de la Couronne

Marthon, France

An impressive 16th-century chateau transformed into an elegant rural hotel with creative flair, where the original architecture harmonises perfectly with contemporary interior design. Five large suites offer space for children and peace and quiet for parents. The atmosphere is informal, the service attentive. The idyllic park with separate pool, the billiard room, the in-house cinema, the music room complete with instruments and the table tennis room will all help those seeking a little variety in their family holiday.

Ein eindrucksvolles Schloss aus dem 16. Jahrhundert, das in ein elegantes Landhotel mit kreativem Flair verwandelt wurde. Die ursprüngliche Architektur passt perfekt zur zeitgenössischen Innenausstattung. Fünf große Suiten bieten sowohl Platz für Kinder als auch Ruhe für die Eltern. Die Atmosphäre ist familiär, der Service aufmerksam. Ein idyllischer Park mit separatem Pool, ein Billardraum, ein hauseigenes Kino, ein Musikzimmer mit Instrumenten und ein Tischtennisraum tragen dazu bei, dass der Familienurlaub abwechslungsreich gestaltet werden kann.

Un impressionnant château du XVIème siècle transformé en un élégant hôtel de campagne grâce à une particulière touche de créativité; l'architecture originale s'harmonise parfaitement avec le design intérieur contemporain. Cinq suites spacieuses offrent de la place aux enfants et du calme aux parents. L'atmosphère est décontractée et le service attentionné. Le parc idyllique avec sa piscine séparée, la salle de billard, le home cinéma, la salle de musique avec ses instruments et la salle de ping-pong seront précieux pour tous les visiteurs en quête de variété pour leurs vacances en famille.

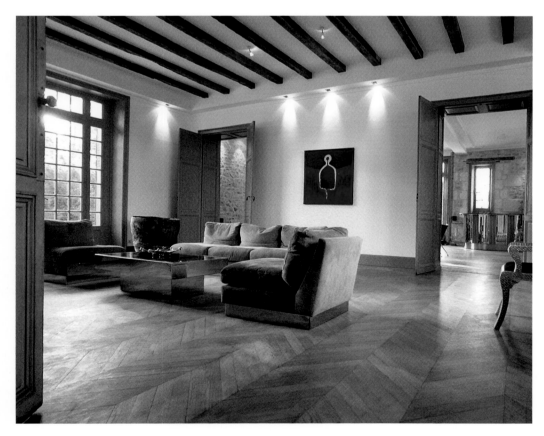

The chateau hotel is located near a small village in south western France.

Das Schlosshotel liegt in der Nähe eines kleinen Dorfes im Südwesten Frankreichs.

L'hôtel-château est situé non loin d'un petit village du sud-ouest de la France.

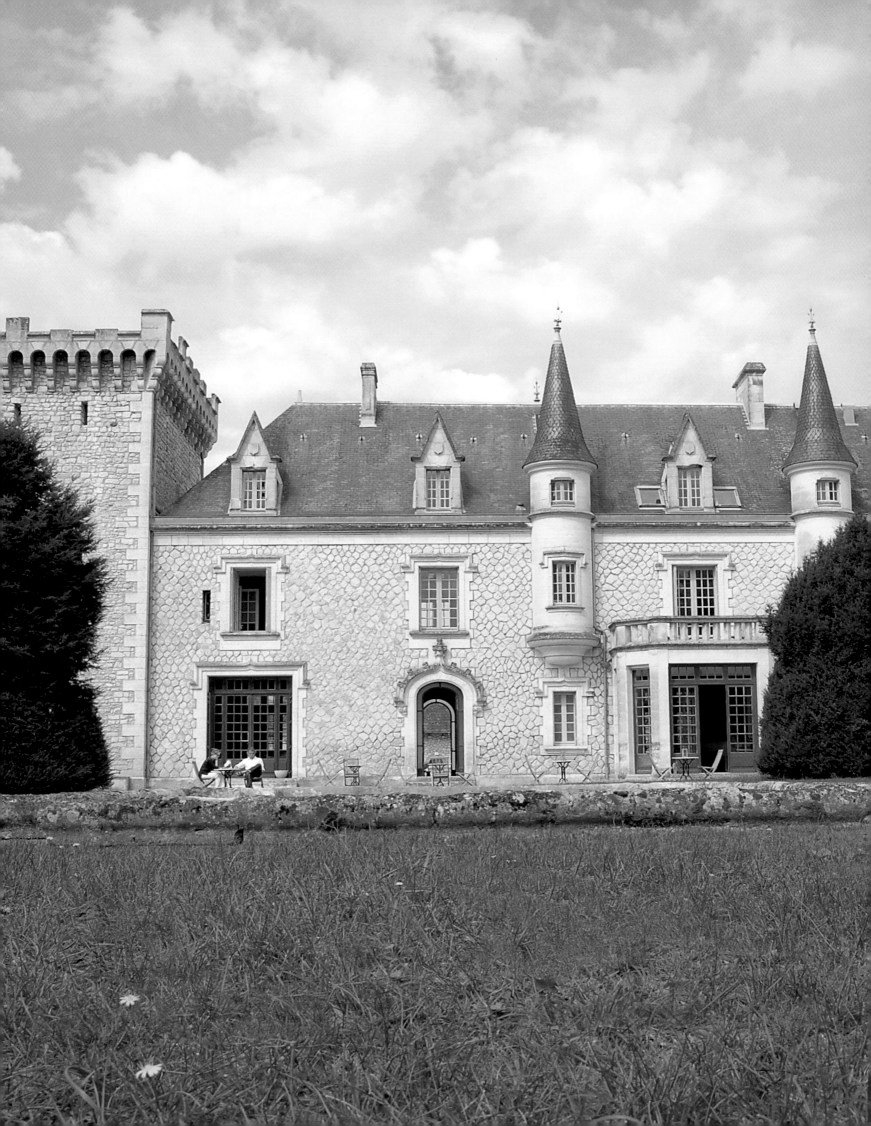

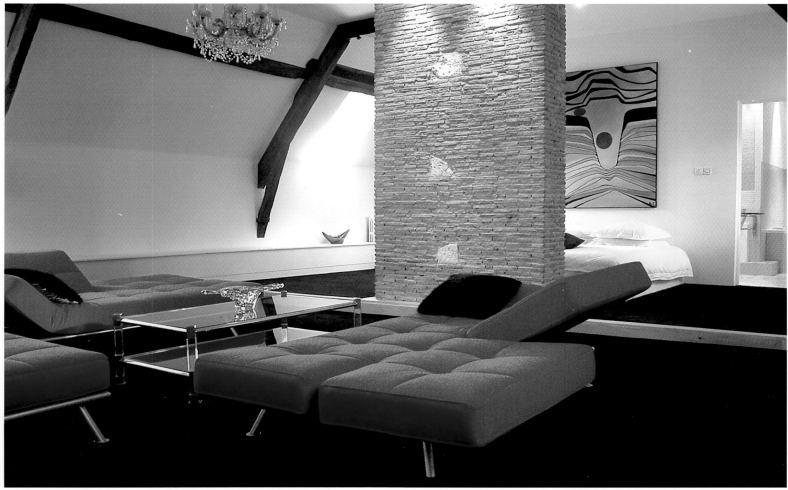

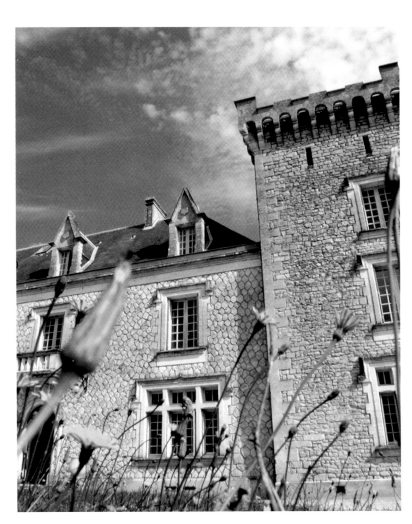

Old walls hide a modern design and contemporary creature comforts.

Hinter alten Mauern erwarten den Gast modernes Design und zeitgemäßer Komfort.

Derrière les vieux murs, un design et un confort modernes.

Fortevillage Resort

Sardinia, Italy

This large holiday village on Sardinia's south-western coast boasts seven hotels, more than 20 restaurants, and its own amusement park amidst 60 acres of gardens and pine forest. Parents can relax playing tennis or golf, horseback riding, ice skating, bowling, doing aquatic sports, or simply enjoy the large pool. Kids will adore the adventure playground, trampoline, electric train, and a supervised kids' pool in the style of a lagoon. The Miniclub is open for children from the age of two. The smallest guests are cared for by the resort's babysitter.

Sieben Hotels, mehr als 20 Restaurants und ein eigener Freizeitpark gehören zu diesem großen Feriendorf inmitten von 25 Hektar Gärten und Pinienwald an der Südwestküste Sardiniens. Eltern entspannen beim Tennis, Reiten, Wassersport, Golf, Schlittschuhlaufen, Bowling oder in der großen Badelandschaft. Auf die Kinder warten Abenteuerspielplatz, Trampolin, elektrische Bimmelbahn und ein beaufsichtigtes Kinderbecken im Lagunen-Stil. Der Miniclub steht Kindern ab zwei Jahren offen, um die Kleineren kümmert sich der Babysitter des Resorts.

Sept hôtels, plus de 20 restaurants et un parc de loisirs privé composent ce gros village de vacances situé au milieu de 25 hectares de jardins et de pinèdes sur la côte sud-ouest de la Sardaigne. Les parents s'y détendent en jouant au tennis, en pratiquant l'équitation, les sports nautiques, le golf, le patinage, en jouant au bowling ou en profitant du vaste espace baignade. Un parc d'aventures, un trampoline, un petit train électrique et un bassin surveillé, de style lagune, attendent les enfants. Le mini-club est ouvert aux enfants à partir de deux ans, la baby-sitter du complexe s'occupant des plus petits.

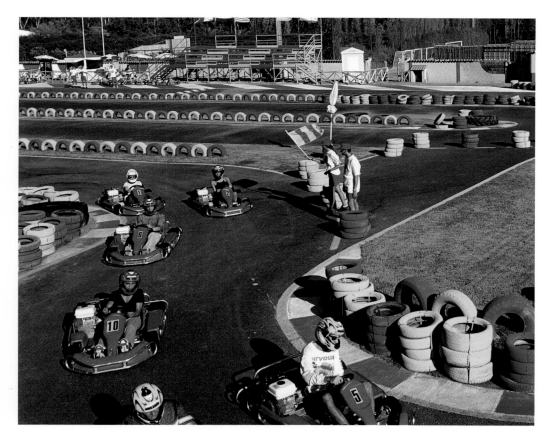

The resort's amusement park includes a kart track.

Im Freizeitpark des Resorts gibt es eine Gokart-Bahn.

Dans le parc de loisirs du complexe, on trouve un circuit de kart.

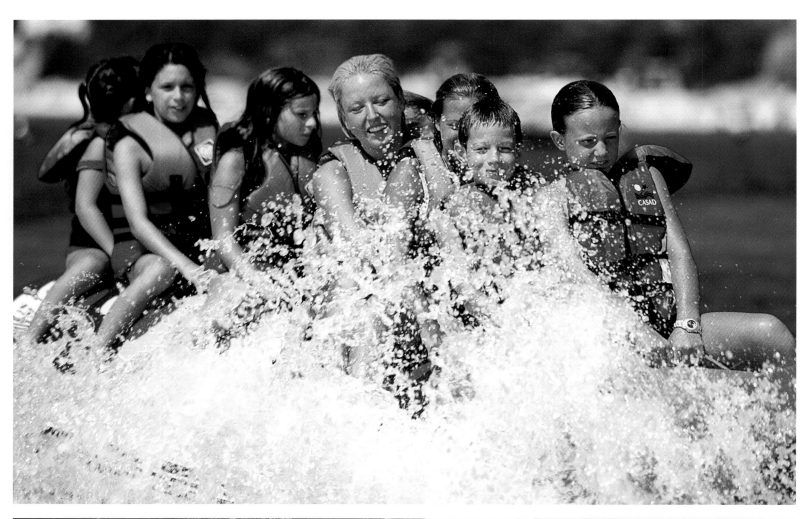

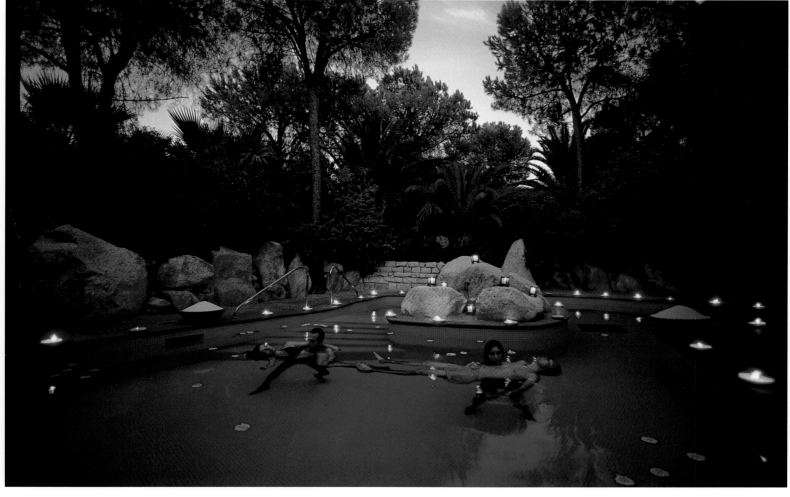

Bathing and Thalasso therapy are part of the holiday village's program.

Badespaß und Thalassotherapie gehören zum Angebot des Feriendorfs.

Plaisir des bains et thalassothérapie font partie de l'offre de ce village de vacances.

Hyatt Regency La Manga

Murcia, Spain

The golf resort, nestled in the hills of Murcia, offers a large variety of sports and leisure facilities. Here one can relax by the pool, in the spa, or on the beach or chose an activity holiday with a multitude of sports ranging from horseback riding via aquatic sports to climbing. Golfers love the challenge provided by three championship courses. Kids play, do crafts, and experiment in the mini club or let off steam in the playgrounds, climbing frames, or kids' pool.

Das Golf-Resort zwischen den Hügeln Murcias bietet eine vielfältige Auswahl an Sport- und Freizeitaktivitäten. Hier kann man sich am Pool, im Spa oder am Strand einfach erholen oder einen Aktivurlaub mit zahlreichen Sportarten von Reiten über Wassersport bis Klettern verbringen. Golfer lieben die Herausforderung auf drei Meisterschaftsplätzen. Kinder spielen, basteln und experimentieren im Miniclub oder toben auf Spielplätzen, Klettergerüsten und im Kinderbecken.

Ce complexe hôtelier avec golf, logé au cœur des collines de Murcie, combine un énorme choix d'activités sportives et de loisirs. S'il y est possible de se détendre tout simplement en allant à la piscine, au spa ou à la plage, on peut également y passer des vacances actives grâce aux nombreux sports proposés, de l'équitation à l'escalade, en passant par les sports nautiques. Les golfeurs adoreront le défi que constituent les trois parcours de compétition. Les enfants, quant à eux, peuvent jouer, bricoler et faire des expériences au mini-club, ou bien se dépenser aux aires de jeux, sur les portiques d'escalade et autres cages à écureuil, et dans la pataugeoire.

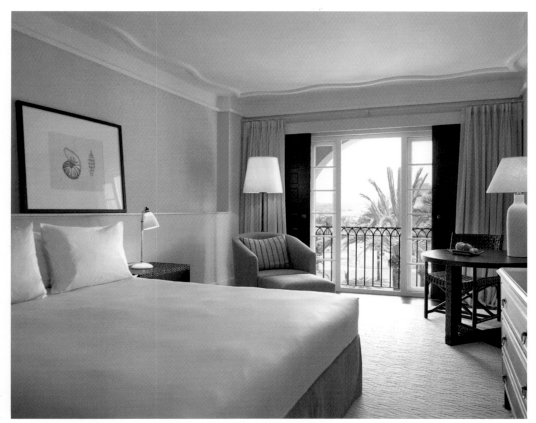

The complex in Andalusian style boasts bright, friendly rooms.

Die im andalusischen Stil erbaute Anlage bietet helle, freundliche Zimmer.

Le complexe, bâti dans le style andalou, propose des chambres sympathiques et bien éclairées.

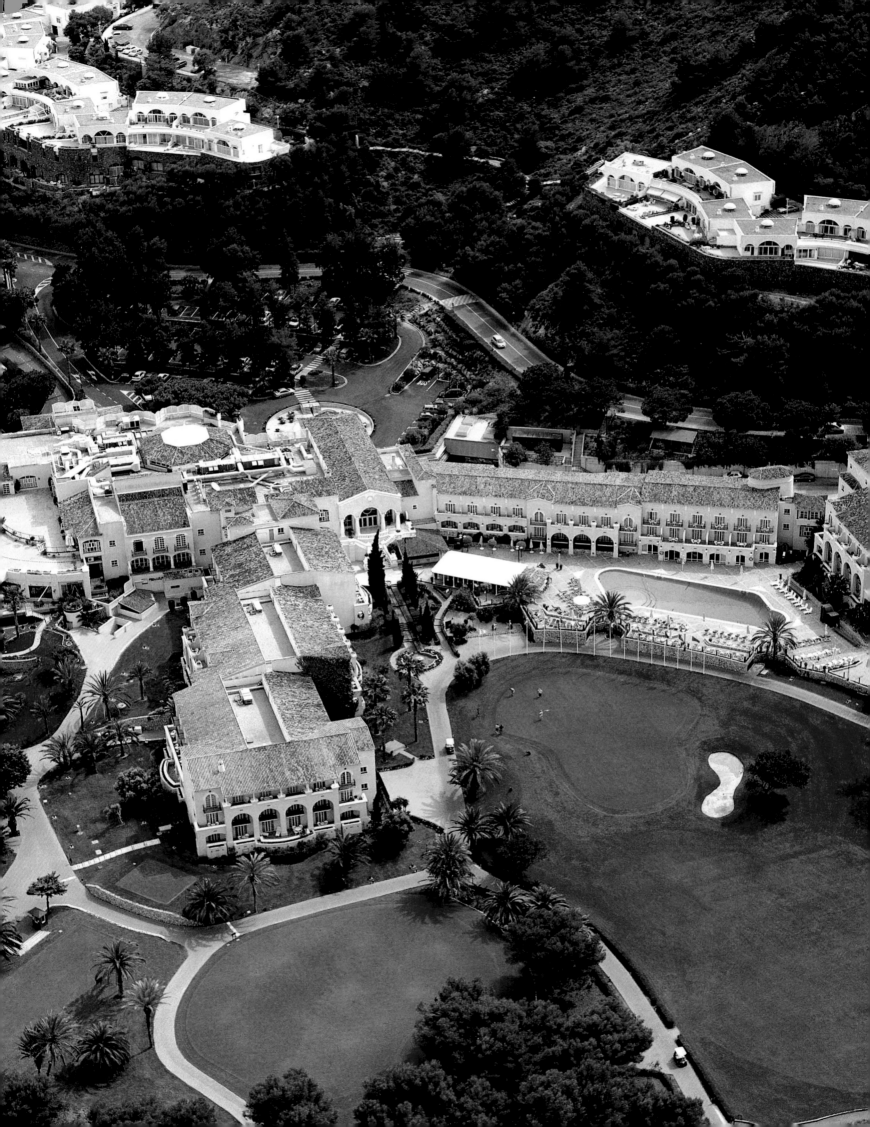

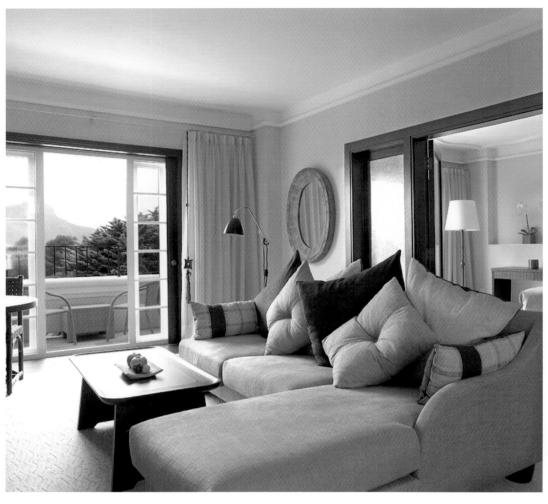

Opulent furnishings and warm colors make for a comfortable atmosphere.

Edle Möbel und warme Farben schaffen eine behagliche Atmosphäre.

Les meubles en bois nobles et les couleurs chaudes créent une atmosphère de confort et de bien-être.

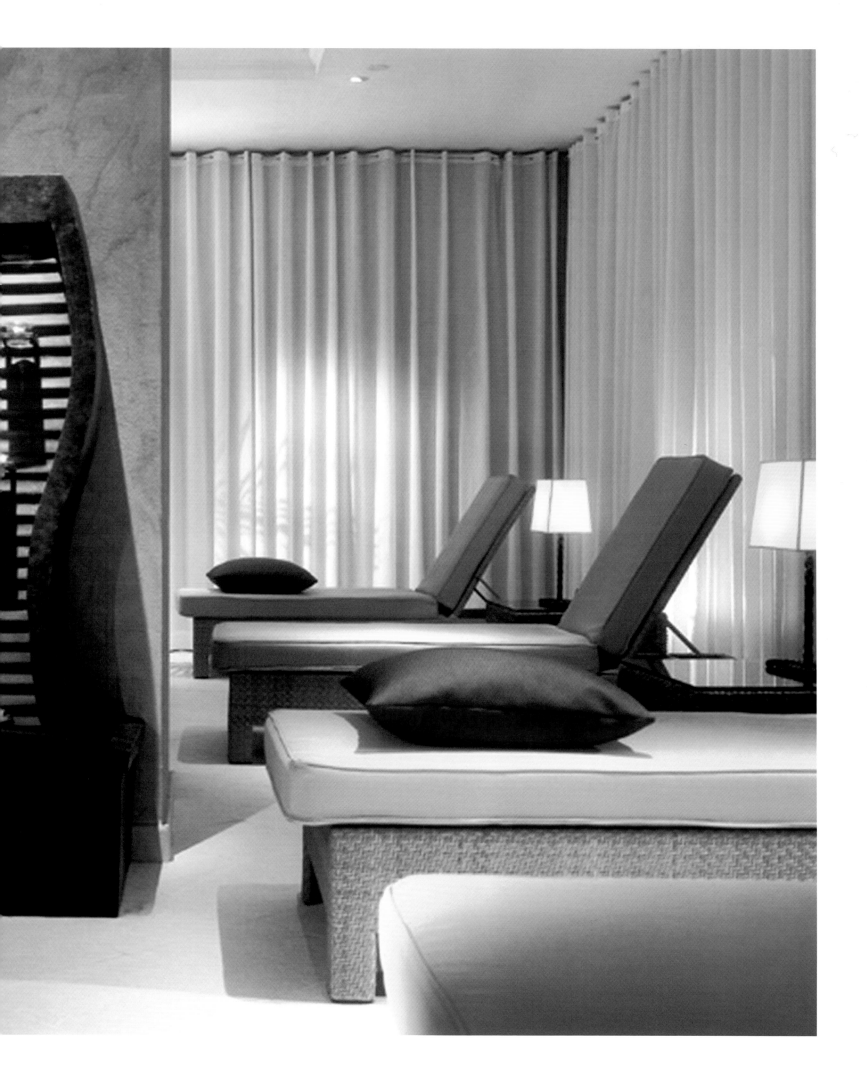

Blau Porto Petro

Mallorca, Spain

This large holiday complex is surrounded by a pine forest and located right next to the sea, near the harbor of the picturesque fishing village of Porto Petro. A luxurious ambiance, modern accommodation, and attentive service allow for peace and relaxation. Leisure facilities are numerous: spa, tai-chi, volleyball, tennis, pools and bicycle, kayak, paddle, and sail boat rental. Kids can choose from a kids' pool, playgrounds, kids' and teens' clubs—all fun and games. The hotel provides swimming lessons during the summer.

Nahe am Hafen des malerischen Fischerdorfs Porto Petro liegt die große Ferienanlage umgeben von Pinien direkt am Meer. Luxuriöses Ambiente, moderne Unterkünfte und aufmerksamer Service garantieren Ruhe und Erholung. Das Freizeitangebot ist umfangreich: Spa, Tai-Chi, Volleyball, Tennis, Schwimmbäder und Verleih von Fahrrädern, Kajaks, Tret- und Segelbooten. Auch die Kleinen kommen auf ihre Kosten: Kinderschwimmbad, Spielplätze, Kinderclub und Teens Club sorgen für Spiel und Spaß. Im Sommer gibt es sogar einen Schwimmkurs.

Ce grand centre de vacances entouré de pins est situé directement sur le littoral, non loin du port de pêcheurs pittoresque de Porto Petro. L'intérieur luxueux, les habitations modernes et le service irréprochable sont promesse de calme et de repos. L'éventail des activités récréatives proposées est large : spa, tai-chi, volley-ball, tennis, piscines et location de vélos, de kayaks, de pédalos et de voiliers. Les petits ne sont pas en reste : la piscine enfants, les aires de jeux, le mini-club et le club ados veillent à ce que tout le monde s'amuse. Il y a même un cours de natation en été.

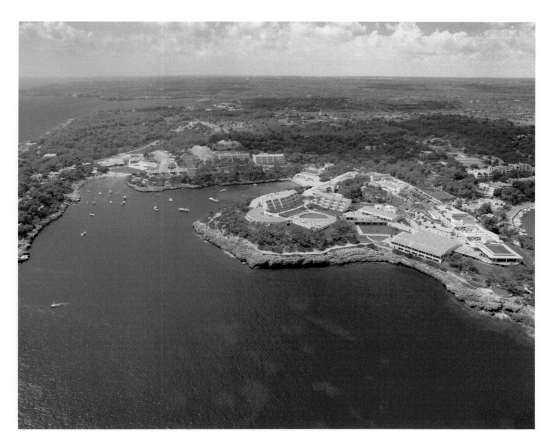

The extensive, modern complex lies in a protected bay.

Die weitläufige, moderne Anlage liegt in einer geschützten Bucht.

Ce vaste complexe moderne est situé dans un baie retirée.

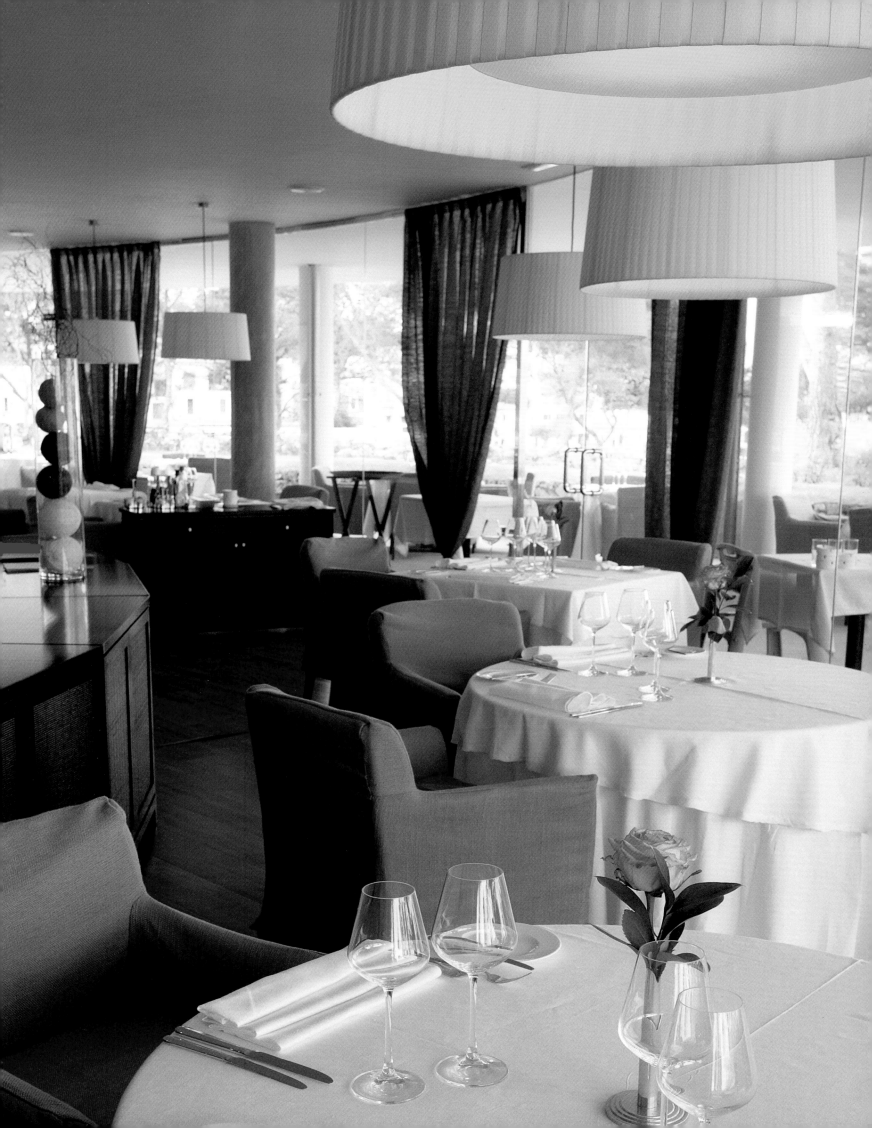

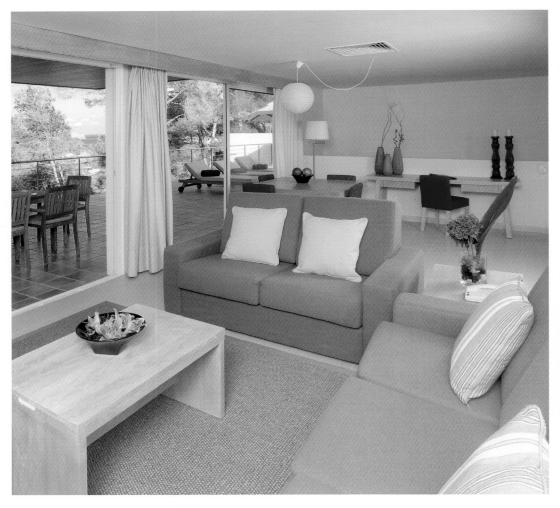

The large poolscape with beauty and fitness program.

Der große Bäderbereich bietet Schönheits- und Vitalbehandlungen.

Le grand espace bains propose soins de beauté et traitements revitalisants.

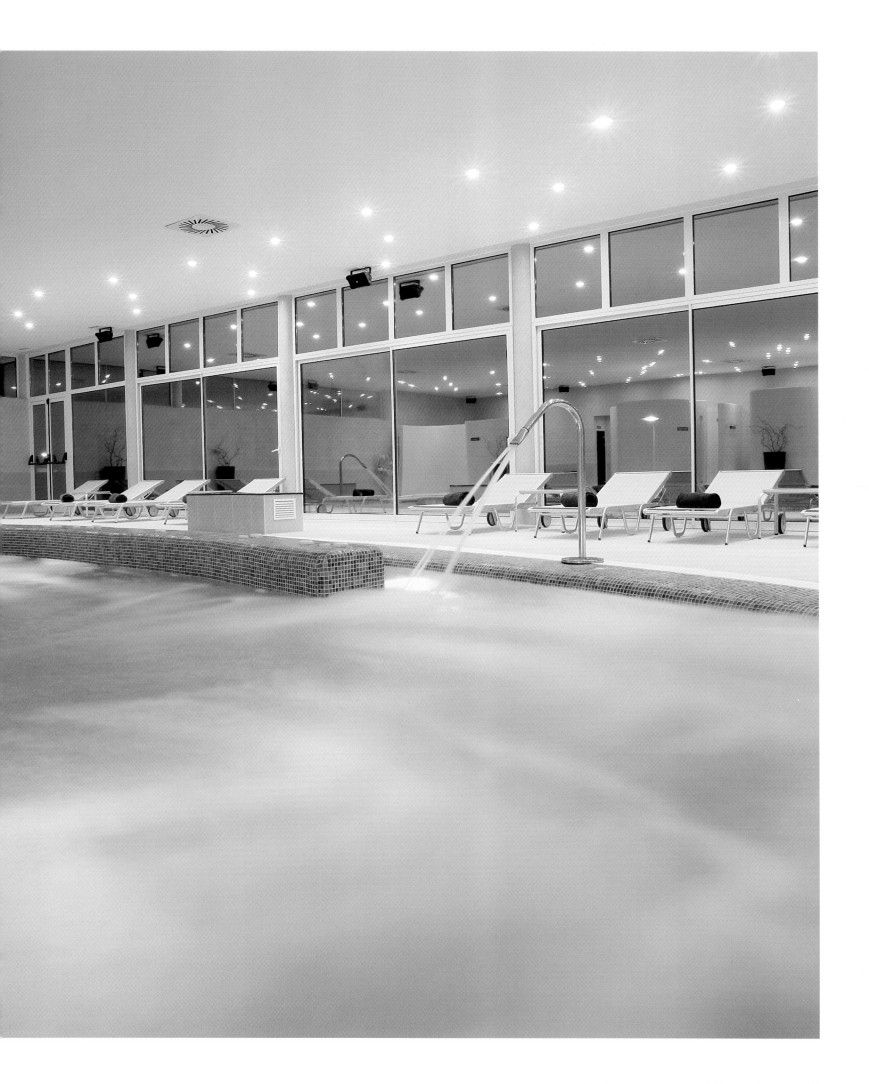

The Westin Dragonara Resort
St. Julians, Malta

Generous, comfortable rooms with a view over the ocean, a broad range of services, and the beautiful location on a headland promise a relaxing holiday within an elegant atmosphere. The resort is only a few minutes' walk from downtown St. Julians with its shopping and entertainment facilities. A beautiful pool including kids' pool, playground, kids' club, and a family program with games, sports, and cooking courses make for an exciting stay. There are welcome presents for children, while parents can enjoy the sauna, steam bath, and fitness facilities.

Großzügige, komfortable Zimmer mit Blick aufs Meer, ein breites Serviceangebot und die herrliche Lage auf einer Landzunge versprechen einen erholsamen Urlaub in eleganter Atmosphäre. Das Resort liegt wenige Minuten vom Zentrum entfernt und bietet viele Unterhaltungs- und Einkaufsmöglichkeiten. Ein schönes Schwimmbad mit Kinderbecken, Spielplatz, Kinderclub und ein Familienprogramm mit Spielen, Sport und Kochkursen machen den Aufenthalt für alle Gäste zum Erlebnis. Auf Kinder wartet ein Begrüßungsgeschenk, die Eltern freuen sich über Sauna, Dampfbad und Fitnessmöglichkeiten.

Ses chambres spacieuses et confortables avec vue sur la mer, sa large palette de services et sa situation sur une magnifique bande de terre sont la promesse de vacances reposantes dans une atmosphère élégante. Bâti à quelques minutes du centre, ce complexe est doté de nombreux commerces et offre de non moins nombreuses occasions de se divertir. Une belle piscine avec bassin enfants, une aire de jeux, un club juniors et un programme spécial familles comprenant jeux, sport et cours de cuisine font de chaque séjour un véritable événement pour tous les membres de la famille. Un cadeau de bienvenue attend les enfants. Les parents, eux, seront ravis de pouvoir profiter du sauna, du bain de vapeur et des équipements de fitness.

The hotel with a games room and a water park is located right next to the beach.

Das Hotel mit Spielzimmer und Badelandschaft liegt direkt am Strand.

Cet hôtel, doté de pièces de jeux et d'un espace baignade, donne directement sur la plage.

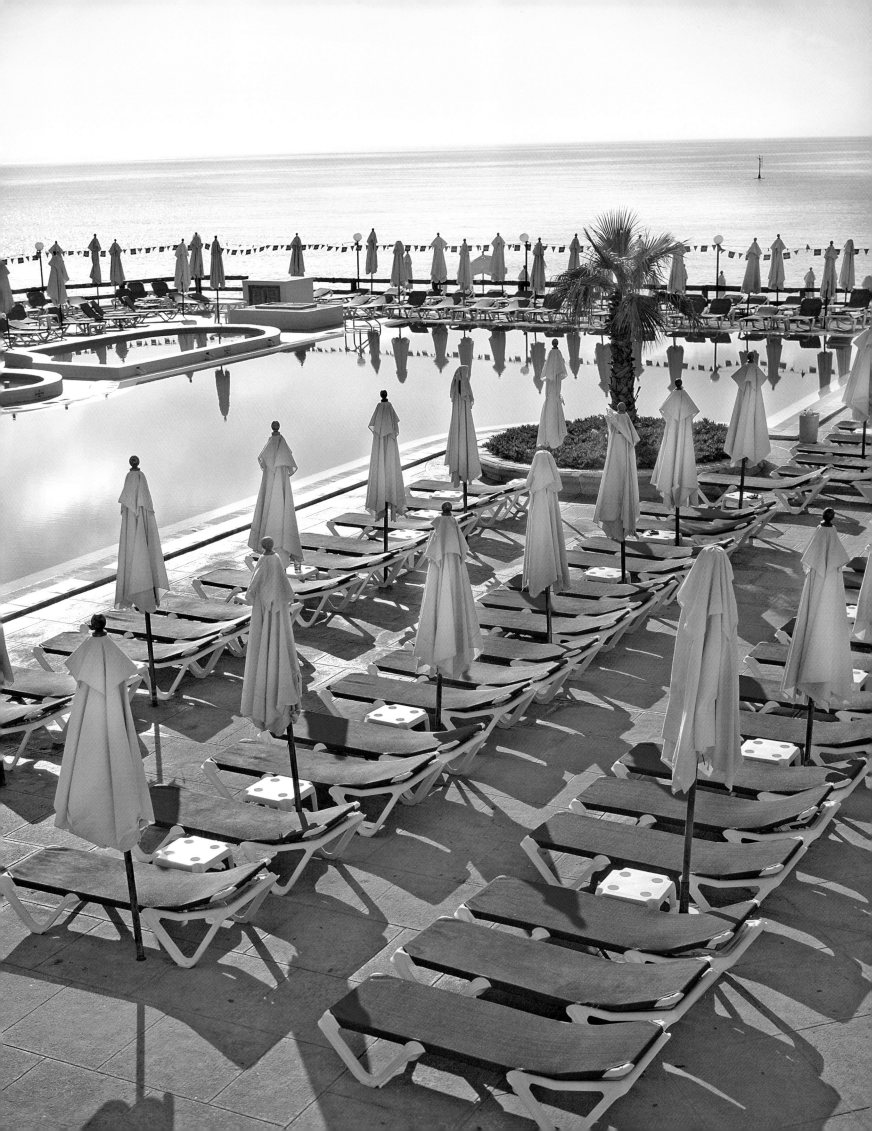

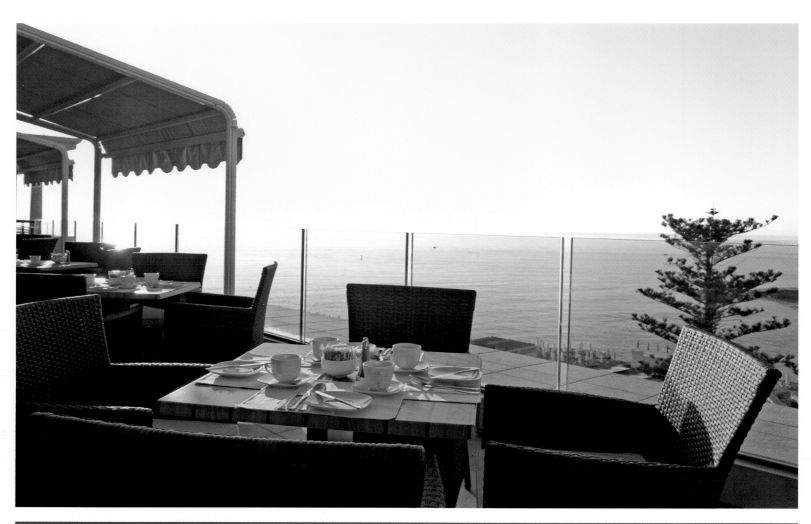

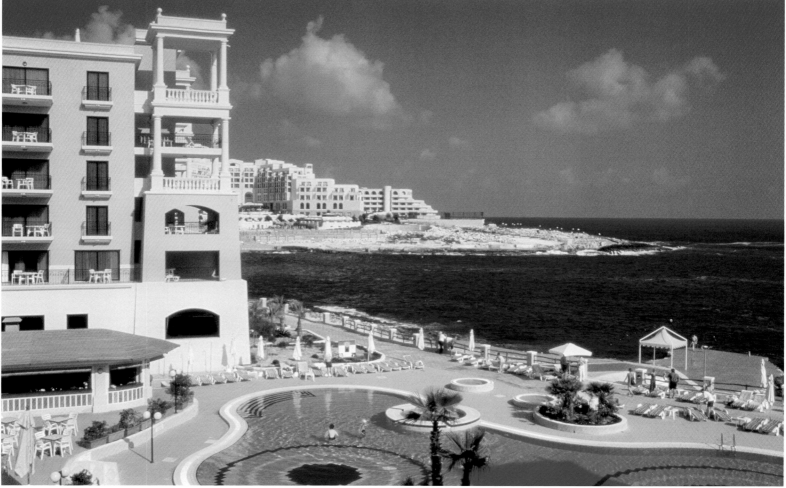

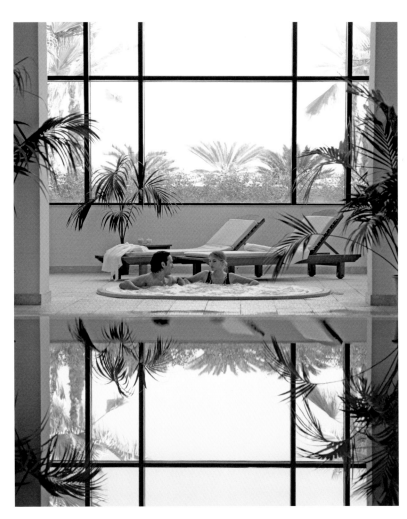

The resort boasts large indoor and outdoor pools with views of the Mediterranean.

Große Innen- und Außenpools und weite Ausblicke aufs Mittelmeer zeichnen das Resort aus.

Le complexe se distingue par ses grandes piscines (couvertes et en plein air) et sa vue imprenable sur la Méditerranée.

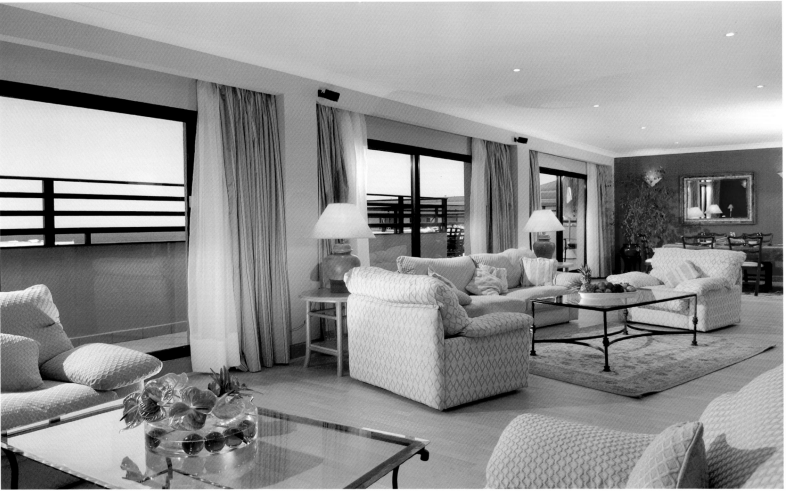

Porto Sani Village & Spa
Chalkidiki, Greece

Entertainment, relaxation, and convenience amidst wonderful surroundings—a perfect family destination. The holiday complex in the form of a Greek village with flowering gardens lies in a large nature reserve. The suites' furnishings are made of natural stone, marble, and wood. A varied leisure and sports program guarantees fun for all. A waterscape awaits the children in the mini club. There is an extensive sandy beach where the little ones can be looked after, if desired.

Unterhaltung, Erholung und Komfort in traumhafter Umgebung – ein perfektes Ziel für Familien. Umgeben von einem großen Naturschutzgebiet liegt die Ferienanlage im Stil eines griechischen Dorfes in blühenden Gärten. Naturstein, Marmor und Holz prägen die Einrichtung der Suiten. Ein großes Freizeit- und Sportangebot garantiert Abwechslung für alle. Für Kinder stehen eine Badelandschaft mit Kinderbecken, ein Spielplatz und ein buntes Programm im Miniclub bereit. Am breiten Sandstrand werden die Kleinen auf Wunsch beaufsichtigt.

Divertissement, repos et confort dans un décor de rêve – une destination parfaite pour les familles. Ce centre de vacances conçu dans le style d'un village grec traditionnel est entouré de jardins en fleurs, au milieu d'une vaste réserve naturelle. La pierre naturelle, le marbre et le bois constituent l'essentiel de l'aménagement des suites. Un vaste choix d'activités sportives et de loisirs empêchera quiconque de s'ennuyer. Un espace baignade avec bassin enfants, une aire de jeux et un programme plus que varié au mini-club attendent les enfants. Sur demande, il est également possible de faire garder les petits sur la vaste plage de sable.

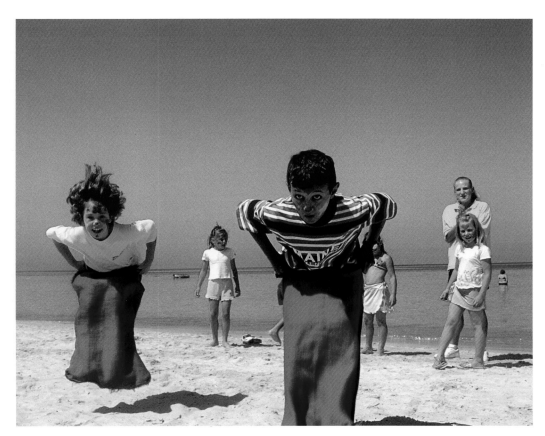

Fun by the sea: the hotel lies near the broad sandy beach of the Aegean Sea.

Viel Spaß am Meer: Das Hotel liegt nah am breiten Sandstrand der Ägäis.

Plaisir garanti au bord de la mer : l'hôtel est situé tout près d'une large plage de la mer Égée.

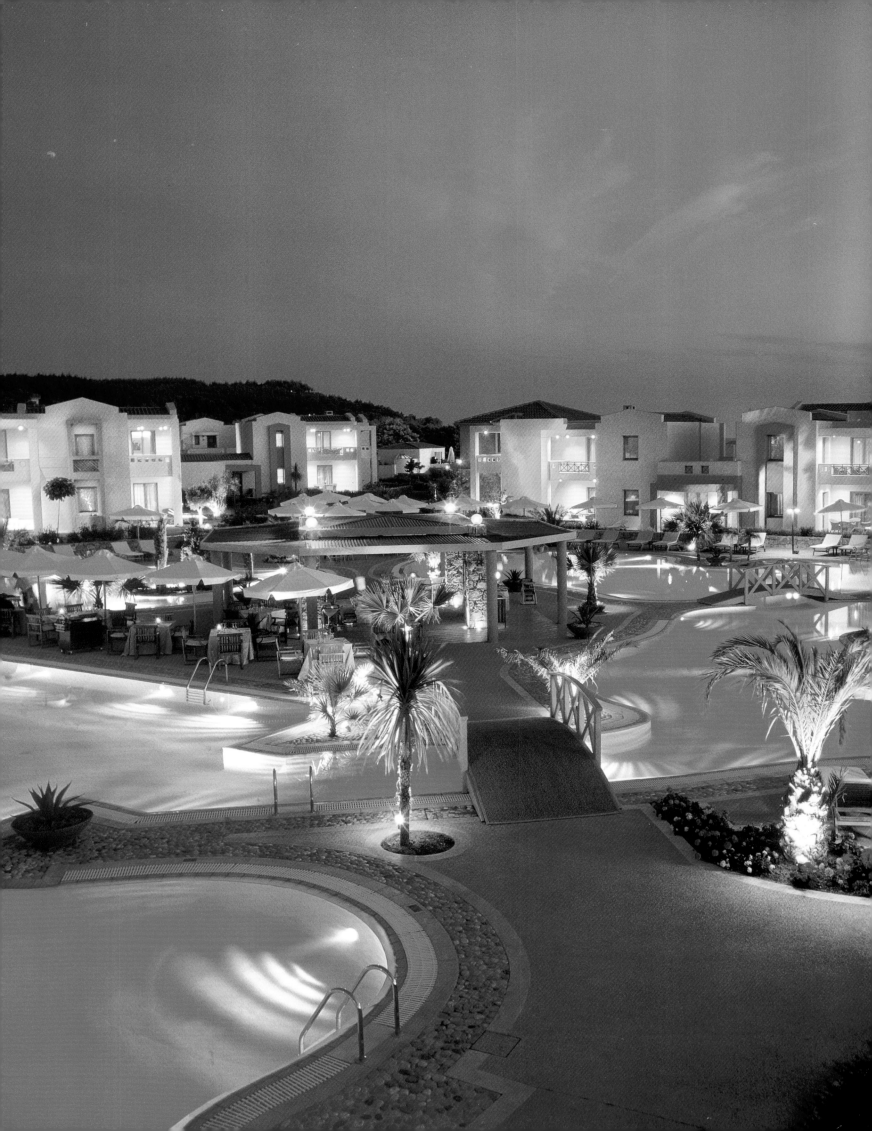

A **marina** is befitting for a resort with such classically furnished suites.

Zum Resort mit klassisch eingerichteten Suiten gehört eine eigene Marina.

Ce complexe aux suites classiques comprend également une marina privée.

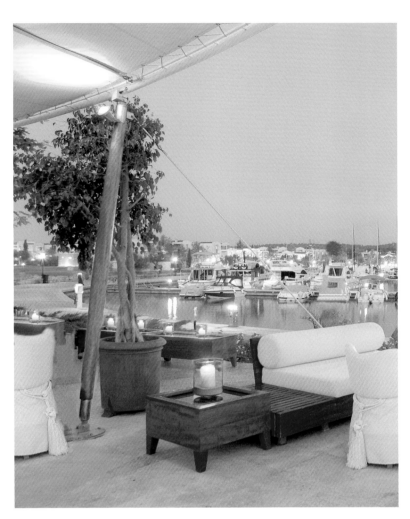

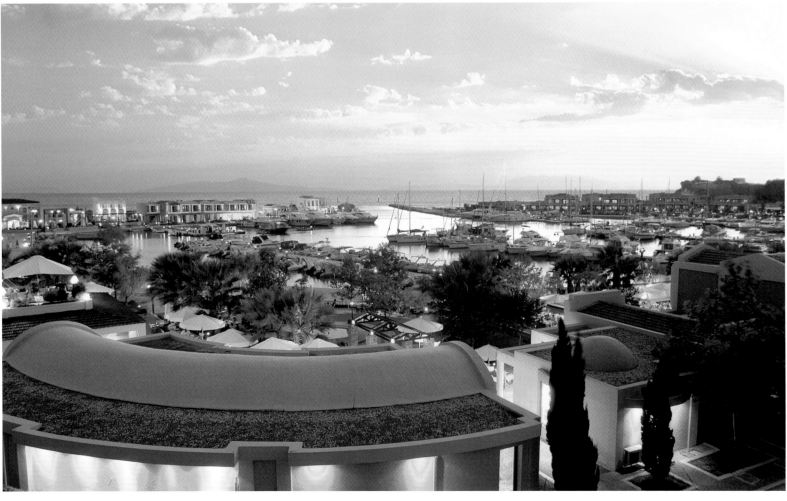

Almyra
Paphos, Cyprus

The stylish hotel by the sea with a view of Paphos harbor and the old fortress offers all you need for a successful holiday. Parents can enjoy aquatic sports, tennis, or the health and beauty program, while kids amuse in the supervised mini club and on the playground. Worth a special mention: even before setting off, parents can book everything their little one needs online—from a stroller to kids' games and arm floats, which means more space in your luggage for clothes.

Direkt am Meer, mit Blick auf den Hafen von Paphos und die alte Festung, bietet das stilvolle Hotel beste Voraussetzungen für einen gelungenen Urlaub. Eltern erholen sich bei Wassersport, Tennis oder Wellness, Kinder vergnügen sich im betreuten Miniclub und auf dem Spielplatz. Ein besonders hervorzuhebender Service: Eltern können vor der Reise alles online bestellen, was ihr Baby braucht – vom Buggy bis zu Spielen und Schwimmflügeln. So bleibt im Koffer viel Platz für die Sommergarderobe.

Situé juste au bord de la mer, avec vue sur le port de Paphos et l'ancienne citadelle, cet hôtel stylé réunit les meilleures conditions pour réussir ses vacances. Tandis que les parents se détendent en pratiquant les sports nautiques, le tennis ou en s'adonnant aux ateliers de soins et de remise en forme, les enfants, eux, s'amusent au mini-club (surveillé) et à la plaine de jeux. À noter tout particulièrement que les parents ont la possibilité de commander en ligne avant le départ tout ce dont bébé a besoin : de la poussette aux brassards, en passant par des jeux, ce qui laisse ainsi encore beaucoup de place dans la valise pour la garde-robe d'été.

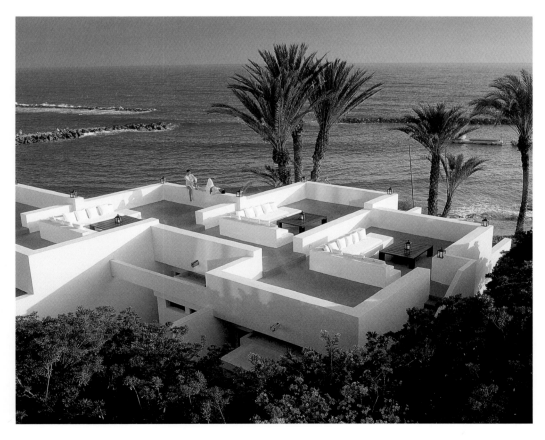

Comfortable sun beds surround the pool of the modern beach hotel.

Komfortable Liegen säumen den Pool des modernen Strandhotels.

De confortables transats jalonnent la piscine de cet hôtel moderne en bord de plage.

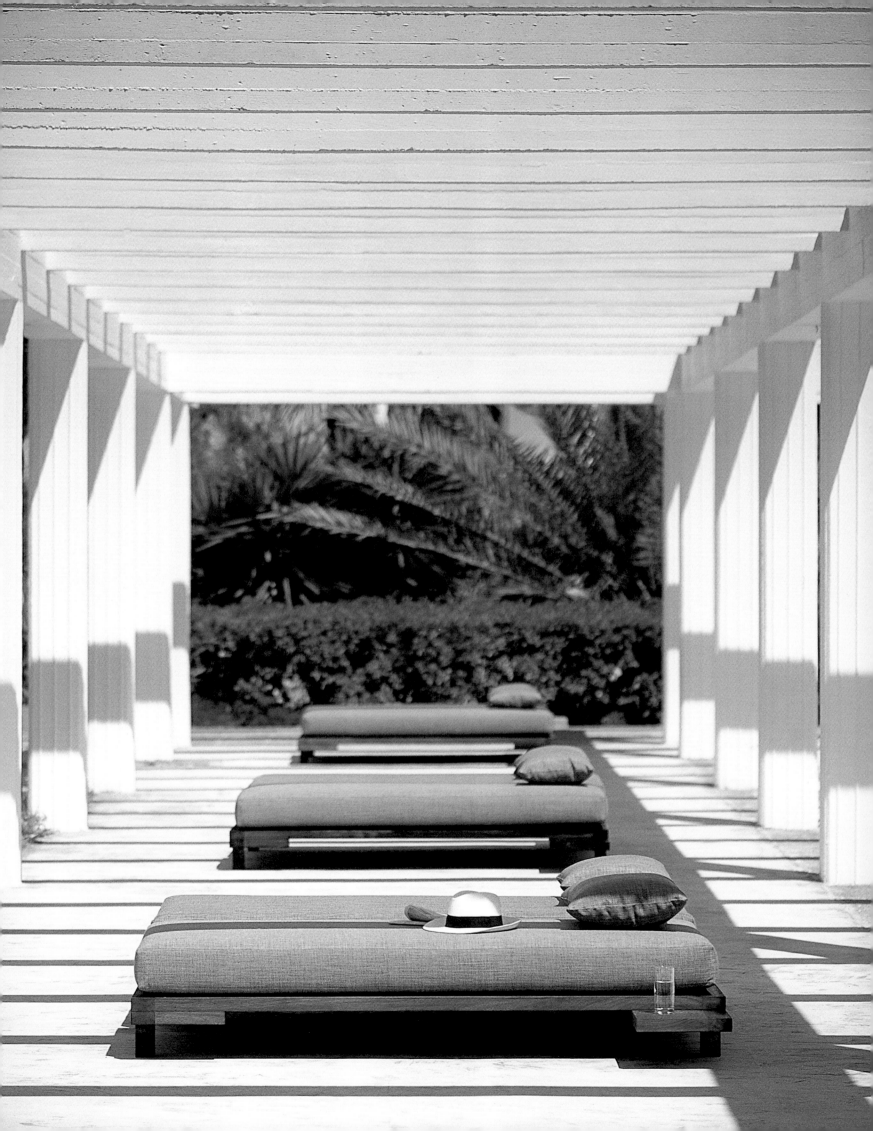

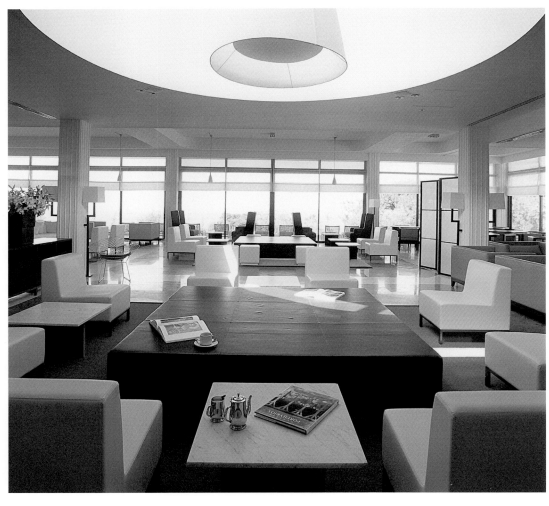

Each Kymasuite comes with its own roof terrace and large sofas.

Jede Kyma-Suite hat eine eigene Dachterrasse mit großen Sofas.

Chacune des suites Kyma possède son propre toit aménagé en terrasse, lequel est doté de gros sofas.

Anassa

Polis, Cyprus

The hotel in the style of a Cypriot village is located next to a fine shingle beach and near the Akama peninsula. Some of the comfortable lodgings boast their own pool. The complex offers tennis, squash, fitness, and spa facilities as well as three pools. The in-house Miniclub organizes cooking courses, T-shirt printing, yoga, beach games, and handicrafts with paper-mâché for smaller kids, while bigger ones can learn tennis, diving or water skiing. Babies from the age of six months are looked after professionally. Parents can order the usual baby equipment online from the hotel before arrival.

Das Hotel im Stil eines zypriotischen Dorfes liegt oberhalb eines feinen Kiesstrands in der Nähe der Akamas-Halbinsel. Einige der komfortablen Unterkünfte haben einen eigenen Pool. Tennis, Squash, Fitness, Spa und drei Schwimmbäder gehören zum Angebot der Anlage. Für Kinder organisiert der Miniclub Kochkurse, T-Shirt-Druck, Yoga, Strandspiele und Basteln mit Pappmaschee. Die Größeren lernen Tennis, Tauchen oder Wasserskifahren. Babys ab einem Alter von sechs Monaten werden professionell betreut. Benötigte Babyausstattung können Eltern vor der Reise online beim Hotel bestellen.

Cet hôtel, bâti dans le style d'un village chypriote, surplombe une plage de galets fins, à proximité de la péninsule d'Akamas. Certaines des suites, confortables, possèdent leur propre piscine. L'offre du complexe comprend tennis, squash, fitness, un spa et trois piscines. Pour les enfants, le mini-club organise des cours de cuisine, des impressions sur t-shirts, des séances de yoga, des jeux de plage et des bricolages avec du papier mâché ; les plus grands apprennent le tennis, la plongée ou le ski nautique. Les bébés âgés de six mois et plus peuvent être confiés à des puéricultrices diplômées. Les parents peuvent commander en ligne auprès de l'hôtel les équipements pour bébé dont ils auront besoin.

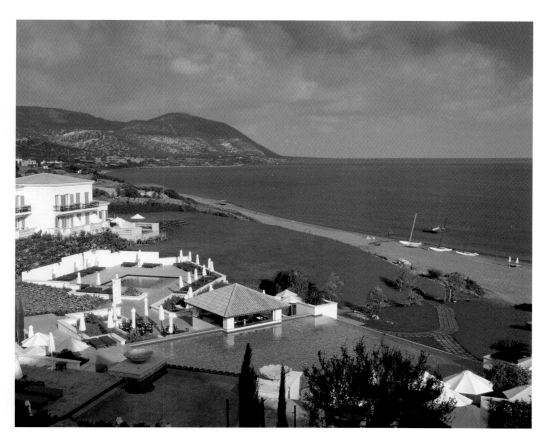

Three large indoor and outdoor pools are part of the resort.

Drei große Innen- und Außenschwimmbecken gehören zum Resort.

Trois grandes piscines, dont une couverte, font partie du complexe.

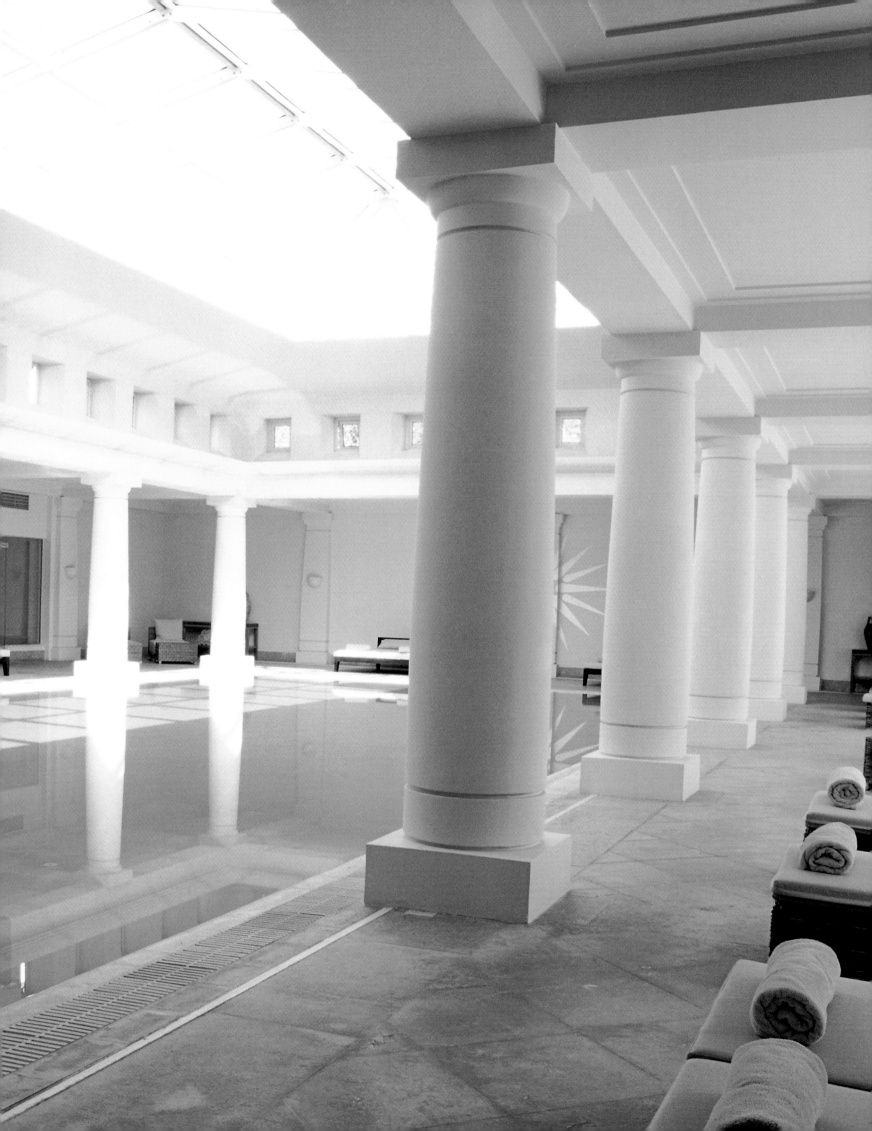

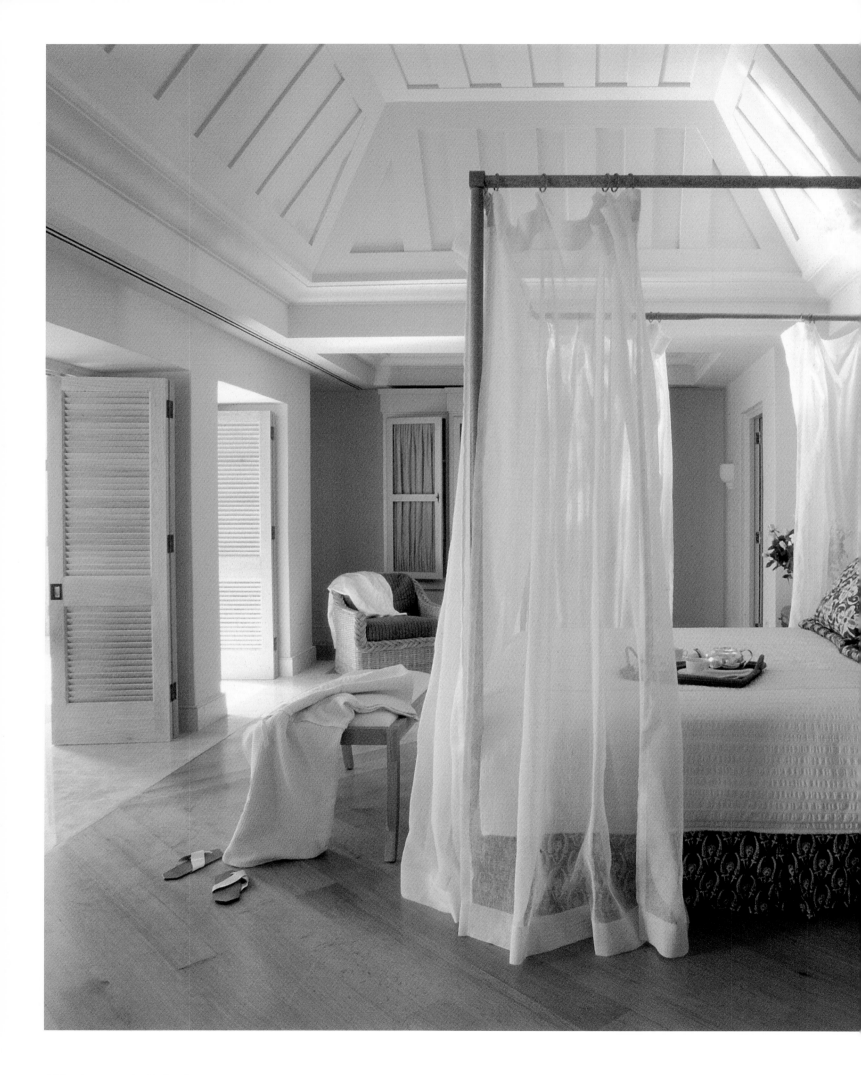

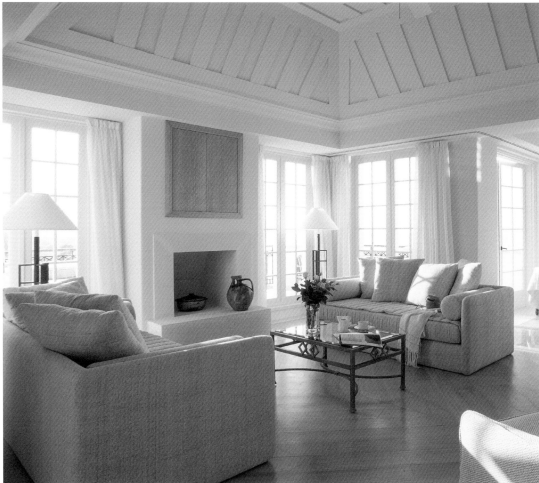

The hotel with elegant rooms is in the quiet northwestern part of the island.

Das Hotel mit eleganten Zimmern liegt im ruhigen Nordwesten der Insel.

L'hôtel, aux suites élégantes, est situé dans la partie nord-ouest de Chaypre, une région paisible de l'île.

Club Orient Holiday Resort

Ören-Burhaniye, Turkey

Small houses with their neat rooms lie dotted around the beautiful garden of this family-friendly complex. Both the pool and the gently sloping beach with canoe and snorkel hire are great for children. A varied program is ensured: the kids' center offers everything from acting to nature trails. Many hotel excursions—such as to Troy or Pergamon—are organized. The hotel has a very special beauty and fitness program: meadows instead of a spa—plowing, raking, and harvesting to combat stress.

Die gepflegten Zimmer der familiären Anlage liegen in kleinen Häuschen im schönen Garten. Am Pool und am flachen Sandstrand mit Kanu- und Schnorchelverleih haben auch die Kleinsten viel Spaß. Für abwechslungsreiche Betreuung ist gesorgt: Das Kinderzentrum bietet zum Beispiel Theaterspielen und Naturerlebnisse. Viele Ausflüge des Hotels in die Umgebung – etwa nach Troja oder Pergamon – werden organisiert. Zudem hat das Hotel ein ganz besonderes Wellness-Programm. Statt ins Spa geht es auf die Felder: Pflügen, Harken und Ernten gegen den Alltags-stress.

Les chambres soignées de ce complexe familial se trouvent dans des maisonnettes situées au cœur d'un beau jardin. Que ce soit à la piscine ou à la plage de sable lisse, où l'on loue des canoës et du matériel de snorkeling, même les tout-petits sauront bien s'amuser. Aucun souci à avoir pour ce qui est des activités, encadrées et variées : le centre enfants propose par exemple des pièces de théâtre et des sorties-décou-vertes dans la nature environnante. Nombreuses sont également les excursions proposées par l'hôtel – notamment à Troie ou à Pergame – à être organisées. L'hôtel offre en outre un programme de détente et de remise en forme tout à fait particulier. En effet, au lieu d'aller au spa,

The hotel is located right next to the sea and offers a varied kid's program.

Das Hotel liegt direkt am Meer und bietet ein umfangreiches Kinderprogramm.

L'hôtel est situé juste au bord de la mer et propose tout un panel d'activités pour les enfants.

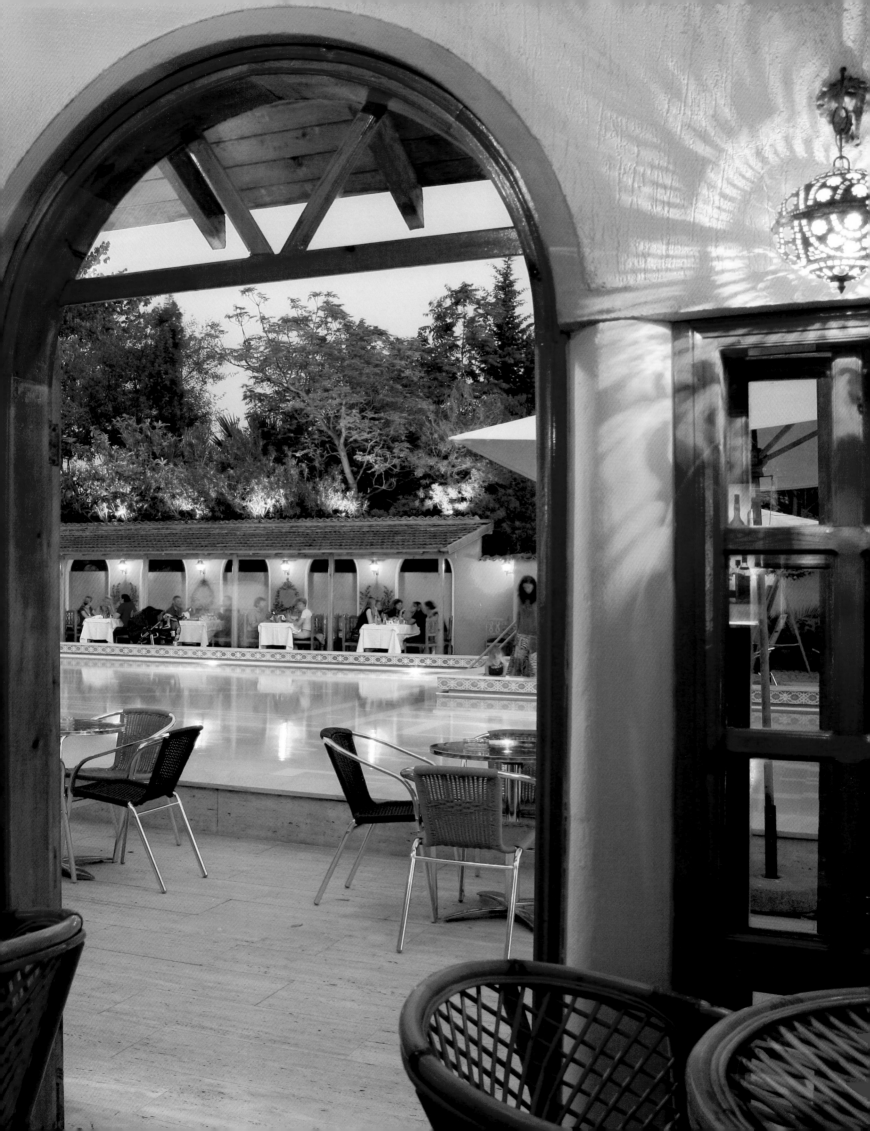

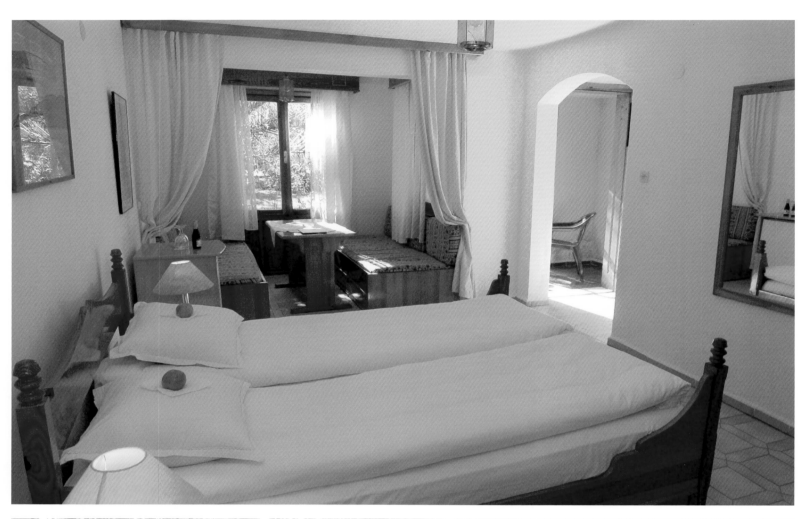

It is only a few steps from the pool to the private beach.

Vom Schwimmbecken geht man nur wenige Schritte bis zum privaten Strand.

La piscine n'est qu'à quelques pas de la plage privée.

Club Orient Holiday Resort | Ören-Burhaniye, Turkey 137

Hillside Beach Club

Fethiye, Turkey

The large holiday complex in a beautiful bay with its own pebble beach offers not only a varied sports and leisure program, but also peace and relaxation. Terraced bungalows provide a modern accommodation. Qualified supervisors tend to the small guests in the Kid Side club, which boasts slides, swings, pools, toys, PlayStations, and a kids' disco. The hotel has facilities for tennis, beach volleyball, archery, an open-air spa, and aquatic sports. It also organizes excursions ranging from trekking to rafting, from jeep safaris to horseback riding.

Die große Ferienanlage in einer schönen Bucht mit eigenem Kiesstrand bietet ein reichhaltiges Sport- und Freizeitprogramm – und natürlich Ruhe und Erholung. Die modernen Zimmer sind in terrassenförmig angelegten Bungalows untergebracht. Im Kid Side-Club mit Rutschen, Schaukeln, Schwimmbädern, Spielzeug, PlayStation und Kinderdisco kümmern sich ausgebildete Betreuer um die kleinen Gäste. Das Hotel bietet Tennis, Beachvolleyball, Bogenschießen, Open-Air-Spa und Wassersport und organisiert Ausflüge von Trekking bis zu Rafting, Jeepsafaris und Reiten.

Ce grand centre de vacances situé dans une jolie baie offre calme et repos bien sûr, mais aussi tout un programme d'activités sportives et de loisirs. Les chambres, modernes, se trouvent dans des bungalows aménagés en terrasses. Des animateurs diplômés s'occupent des petits pensionnaires au club Kid Side, où l'on trouve toboggans, balançoires, piscines, jouets, PlayStation et une discothèque pour enfants. L'hôtel propose pour sa part du tennis, du beach volley, du tir à l'arc, un spa en plein air et des sports nautiques, et organise également des excursions, du trekking à l'équitation, en passant par le rafting et le safari en jeep.

The Kid Side club offers a varied program for all ages.

Der Kid Side-Club bietet ein abwechslungsreiches Programm für jedes Alter.

Le club Kid Side offre un choix d'activités variées pour tous les âges.

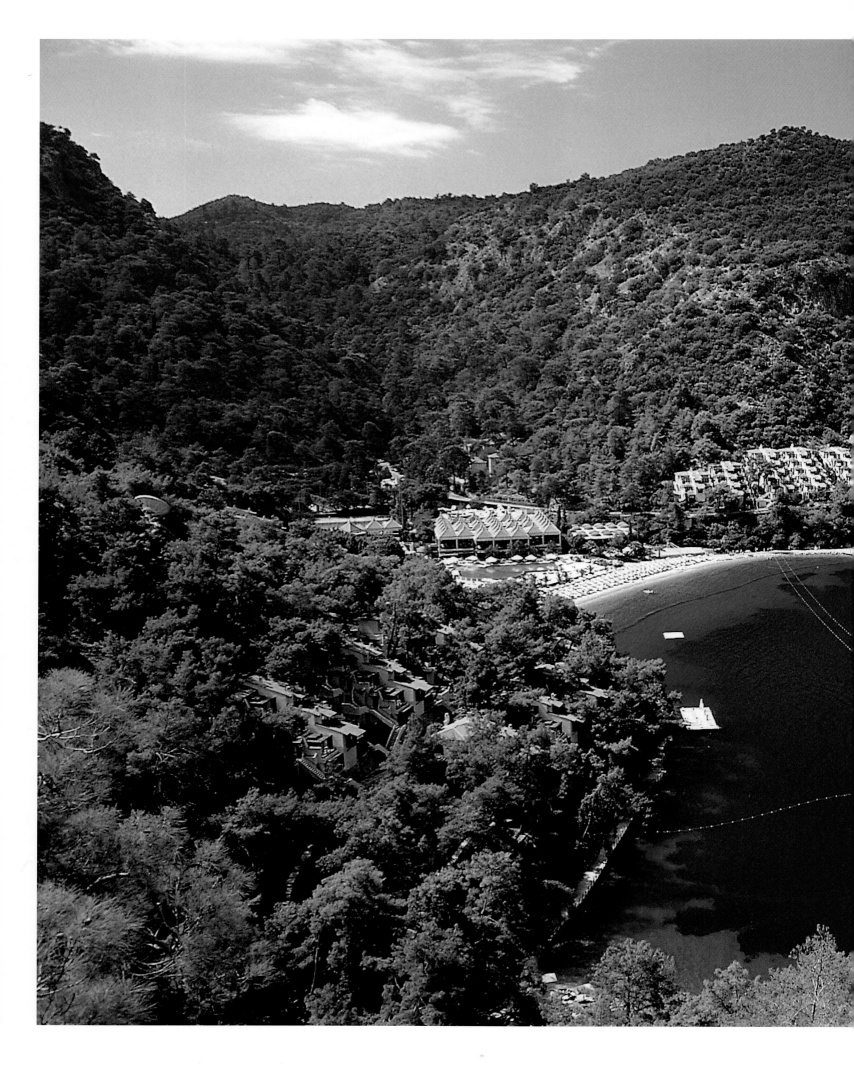

The resort lies in a private bay surrounded by a pine forest.

Das Resort liegt in einer privaten Bucht umgeben von Pinienwäldern.

Le complexe est situé dans une baie privée entourée de pinèdes.

Villa Vanille

Marrakesh, Morocco

The perfect choice for those who prefer peaceful seclusion but want to have the lively souqs and sights of Marrakech within reach: the small house combines individual style with traditional Moroccan furnishings and has the charm of a private residence. Kids can enjoy the playground with small animals. The beautiful gardens boast two pools, hammocks, and a Bedouin tent for relaxation. Camel riding is also possible. Downtown Marrakesh is only a 15-minutes drive away.

Die perfekte Wahl für Genießer, die einen ruhigen Rückzugsort suchen und doch in Reichweite der lebhaften Souks und Sehenswürdigkeiten von Marrakesch sein wollen: Das kleine Haus verbindet individuellen Stil mit traditioneller marokkanischer Einrichtung und hat den Charme einer privaten Unterkunft. Für Kinder gibt es einen Spielplatz mit Kleintieren. Im schönen Garten laden zwei Schwimmbecken, Hängematten und ein Beduinenzelt zum Entspannen ein. Kamelreiten ist in der nächsten Umgebung möglich. Zum Zentrum von Marrakesch fährt man 15 Minuten.

Une adresse parfaite pour les jouisseurs en quête d'un refuge tranquille, mais désireux de rester à portée des souks animés et des curiosités de Marrakech : cette petite maison combine style individuel et aménagement marocain traditionnel, et possède le charme d'une habitation privée. Les enfants y trouveront une aire de jeux et des petits animaux. Dans le beau jardin, deux piscines, des hamacs et une tente de bédouins invitent à la détente. Il y a également possibilité de partir en promenade à dos de dromadaire à proximité immédiate. Le centre de Marrakech est à 15 minutes en voiture.

Each room of the small hotel is furnished individually in true Moroccan style.

Jedes Zimmer des kleinen Hotels ist individuell im marokkanischen Stil eingerichtet.

Chacune des chambres de ce petit hôtel possède son propre aménagement intérieur, de style marocain.

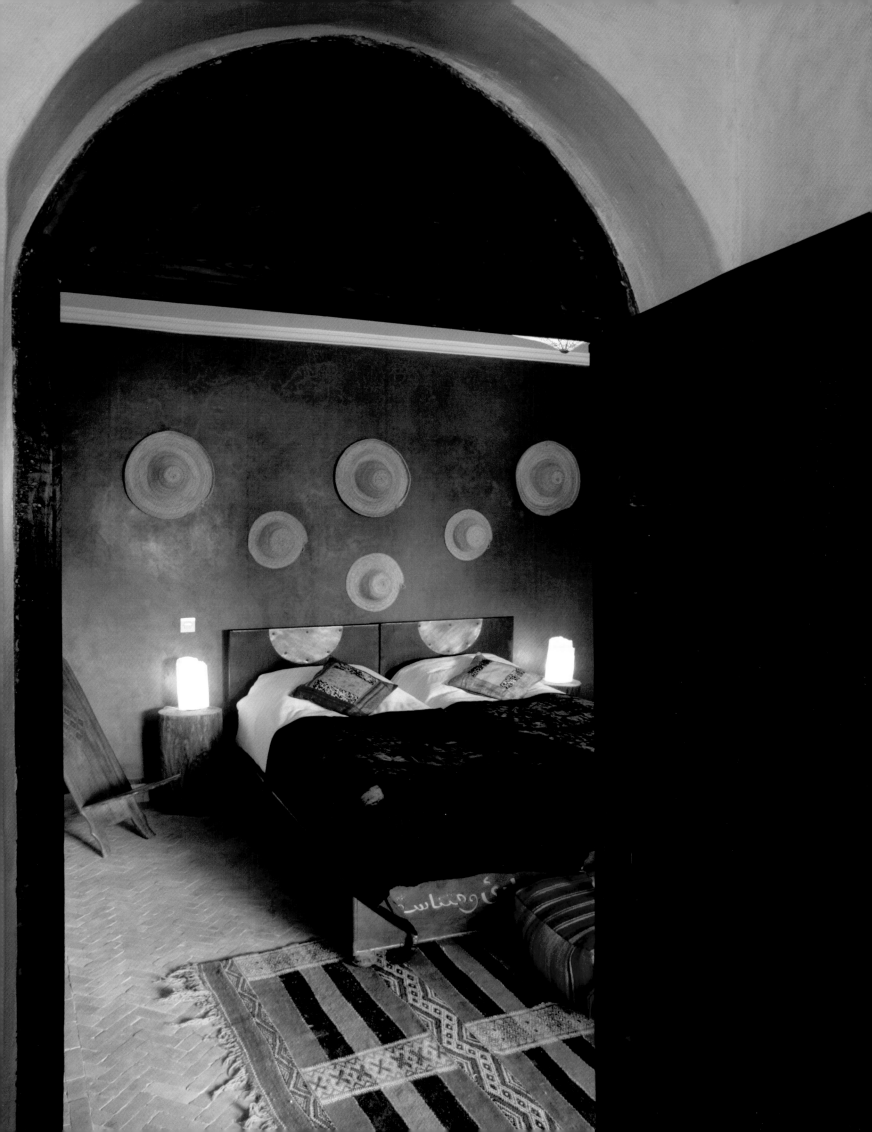

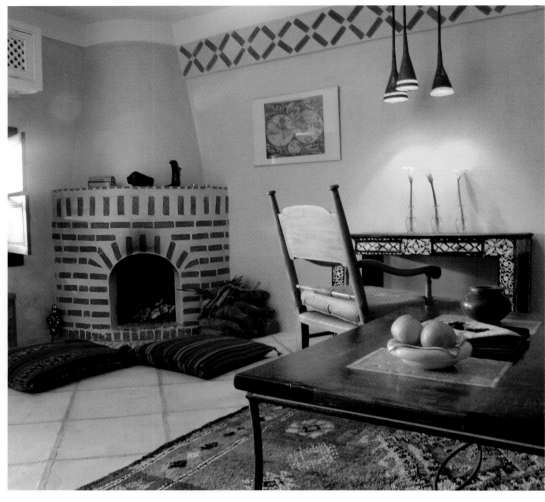

The comfy Bedouin tent provides much-needed shade.

Im gemütlichen Beduinenzelt im Garten findet man Schutz vor der Sonne.

L'agréable tente de bédouins dans le jardin permet de se protéger du soleil.

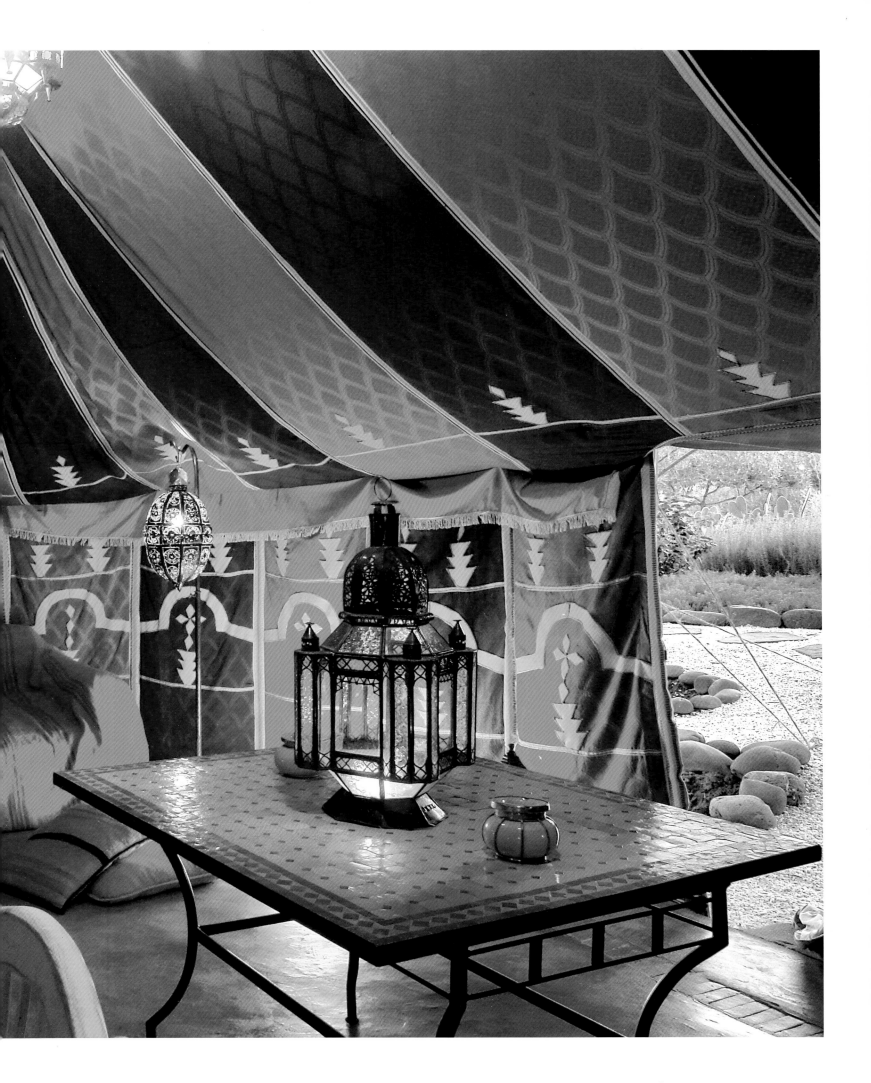

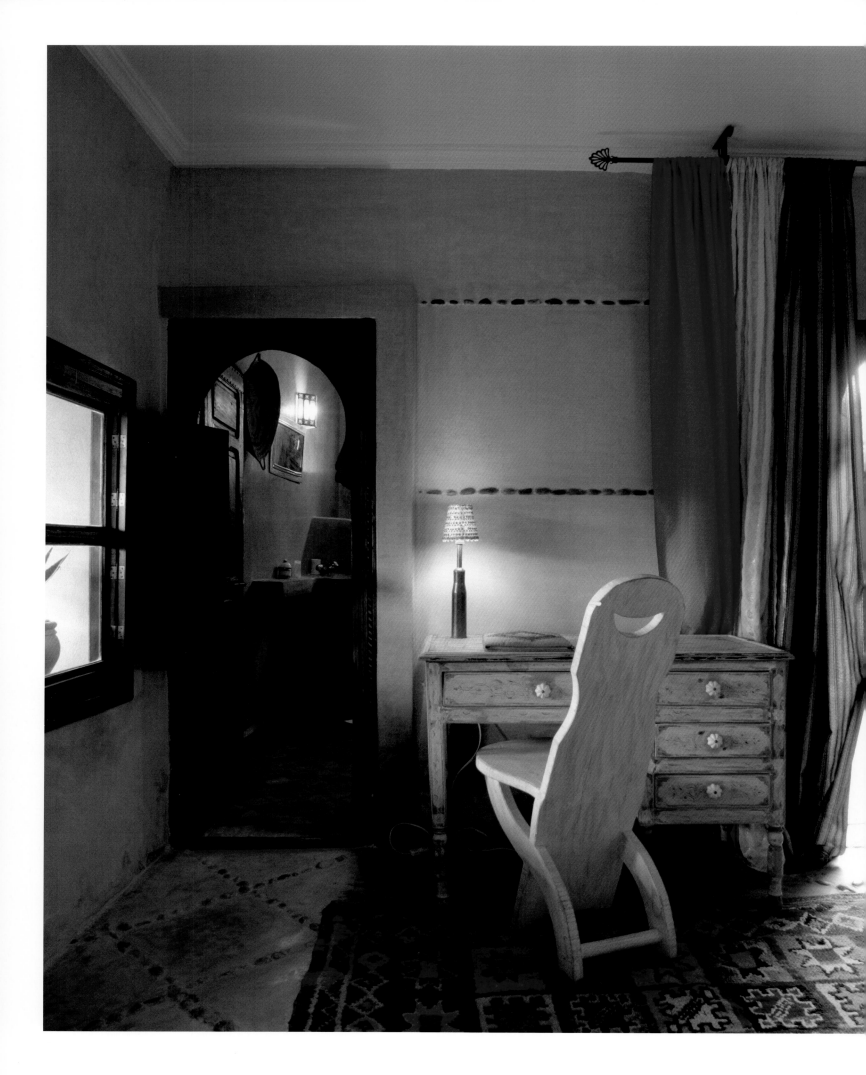

The hotel boasts large gardens with two pools.

Das Hotel hat eine große Gartenanlage mit zwei Pools.

L'hôtel possède un vaste espace vert doté de deux piscines.

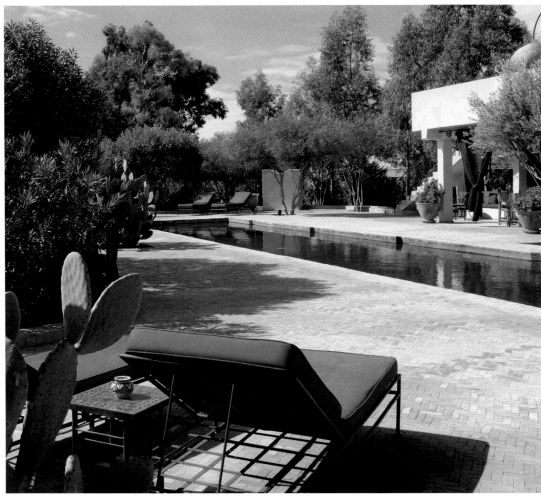

Beit Al Bahar
Dubai, United Arab Emirates

Large and elegant traditional Arabian villas embedded in luscious greenery right next to the beach—an ideal family resort. The associated Jumeirah Beach Hotel boasts a kids' and a family pool, kids' and teens' clubs, toddlers' play area, children's videos, and computer games for all ages. Families get free entry to the spectacular neighboring Wild Wadi Water Park. Water slides, wild water creeks, and wave pools guarantee fun for young and old alike.

Große, elegante Villen im traditionellen arabischen Stil, eingebettet in üppiges Grün direkt am Strand – das Resort ist ideal für Familien. Das zugehörige Jumeirah Beach Hotel bietet ein Kinder- und Familienschwimmbad, einen Kinder- und einen Teens-Club für die Größeren. Außerdem gibt es einen Kleinkinderspielbereich, Kinderfilme auf DVD und Computerspiele für jedes Alter. Familien haben kostenlosen Eintritt in den angrenzenden, spektakulären Wild Wadi Water Park. Wasserrutschen, Wildwasserbäche und Wellenbäder garantieren Badespaß für Groß und Klein.

De grandes et élégantes villas, construites dans le style arabe traditionnel, enchâssées dans un écrin de verdure luxuriante juste au bord d'une plage … Un complexe idéal pour les familles. L'hôtel Jumeirah Beach, qui fait partie du complexe, propose une piscine pour les familles et les enfants, un club enfants et un club juniors (Teens Club) pour les plus grands. On trouvera en outre une aire de jeux pour les tout-petits, des films pour enfants en DVD et des jeux sur PC pour tous les âges. Les familles ont également accès gratuitement au spectaculaire Wild Wadi Water Park attenant, où toboggans nautiques, torrents artificiels et piscines à vagues apportent joie et détente aux petits comme aux grands.

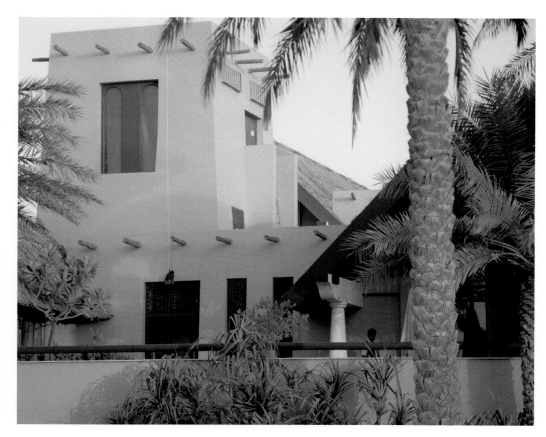

The villas reflect the country's traditional architecture.

Die Villenanlage spiegelt die traditionelle Baukunst des Landes wider.

Cette station de villas reproduit l'architecture traditionnelle du pays.

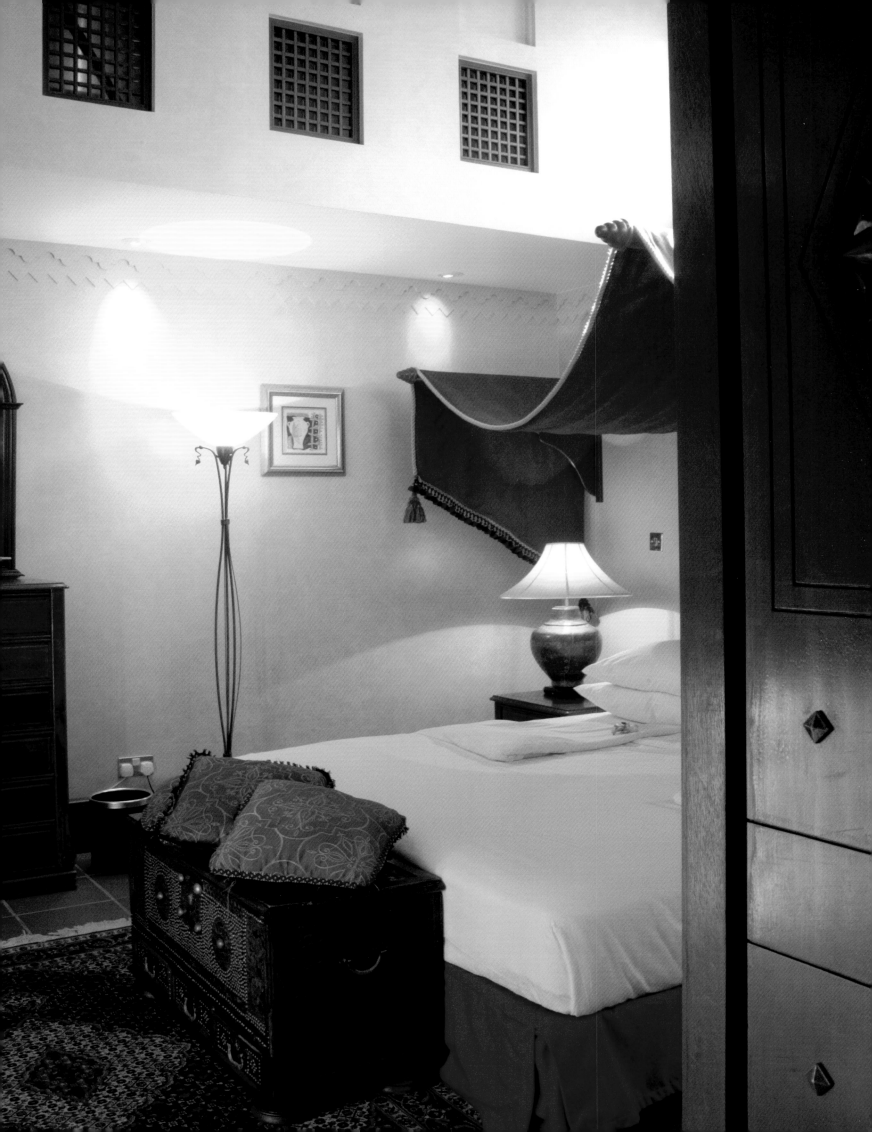

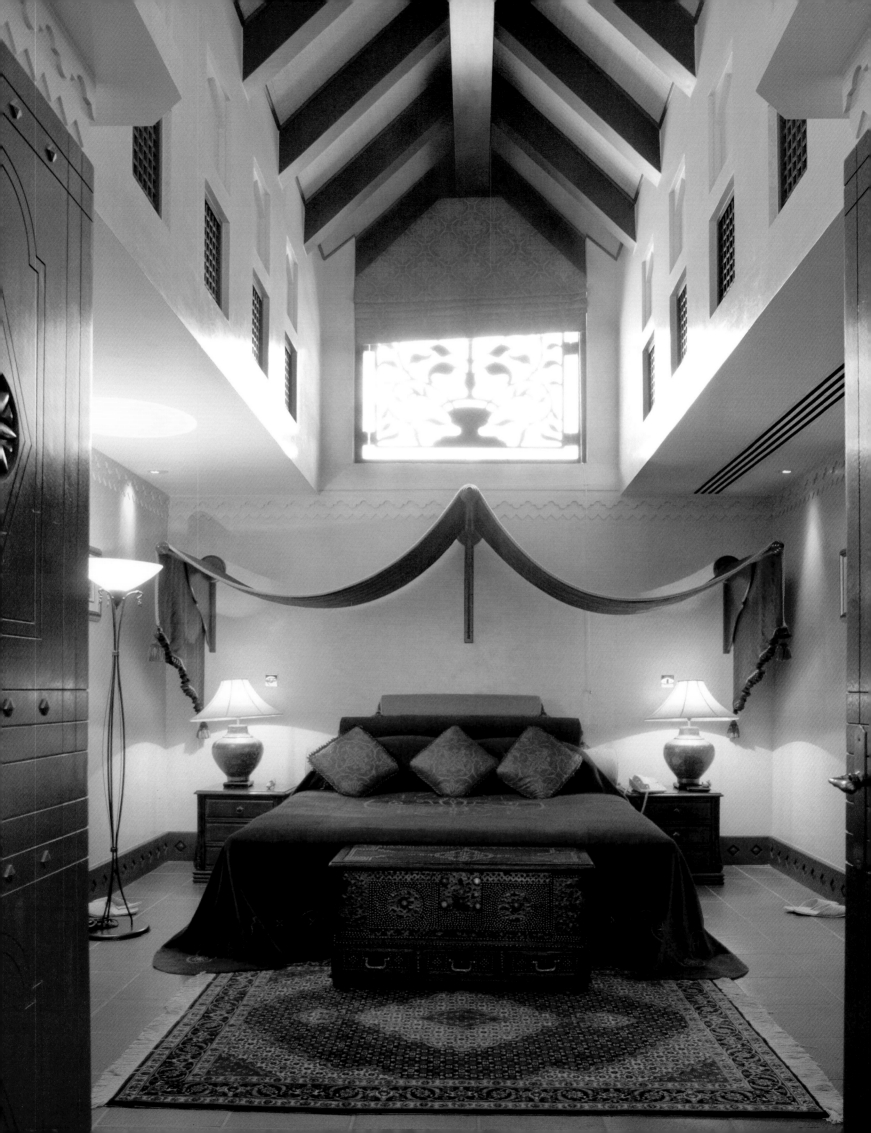

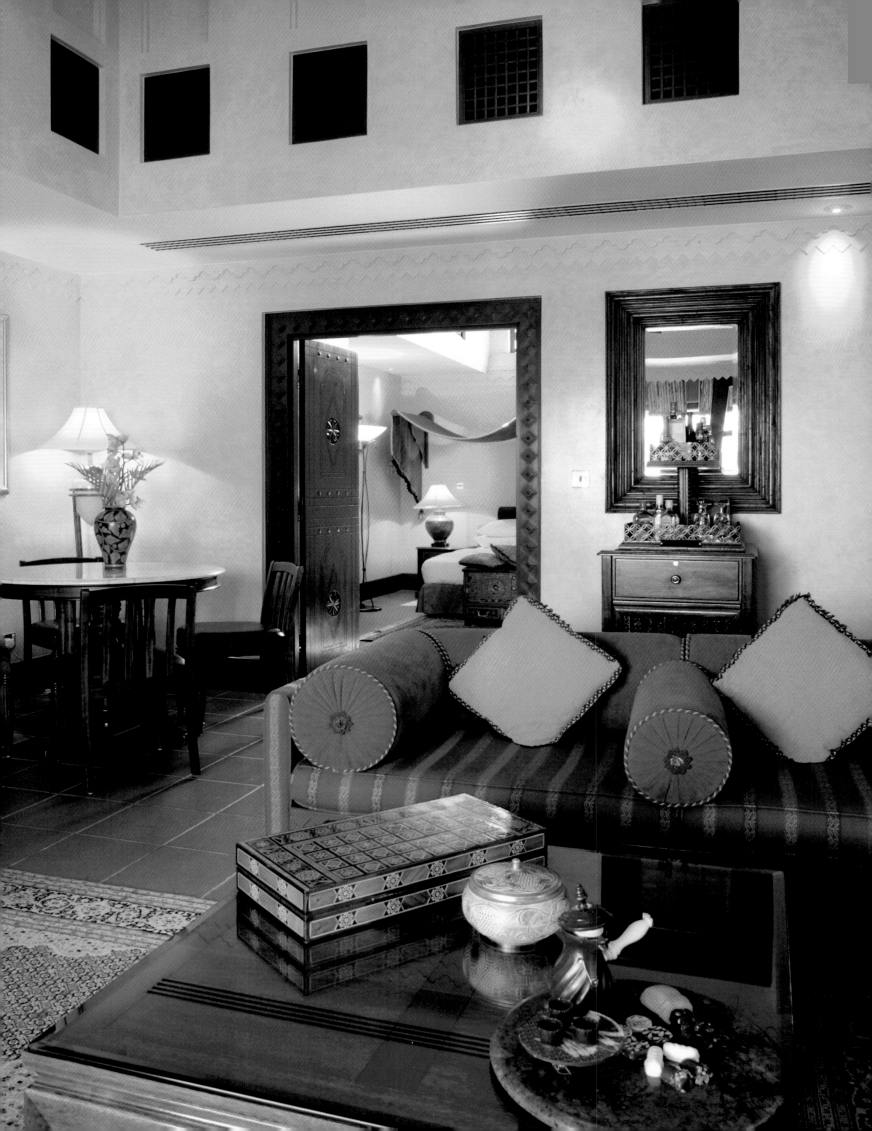

Shangri-La's Barr Al Jissah Resort & Spa

Muscat, Oman

The modern resort is located next to the beach and boasts an impressive mountainous backdrop. Kids' and teens' clubs offer treasure hunts, henna painting, play areas, and a children's pool. The young charges learn traditional arts and crafts and can experience Arabian horses and camels. Organized desert safaris and whale, dolphin, or turtle watching excursions are part of the program. Muscat's old part of town with the Mirani fortress, the Al-Alam palace, and its Khor mosque are only a 15 minutes' drive away.

Die moderne Anlage liegt direkt am Strand vor eindrucksvoller Bergkulisse. Kids und Teens Club bieten Schatzsuche, Hennamalerei, verschiedene Spielbereiche und einen Kinderpool. Die Kinder lernen das traditionelle Kunsthandwerk kennen und erleben arabische Pferde und Kamele aus der Nähe. Zudem organisiert das Resort Wüstensafaris und Ausflüge zur Wal-, Delfin- oder Schildkrötenbeobachtung. Die Altstadt Muscats mit der Festung Mirani, dem Al-Alam-Palast und der Khor-Moschee erreicht man in 15 Minuten mit dem Auto.

Cette station moderne donne directement sur la plage, sur fond de montagnes impressionnantes. Si les clubs enfants et juniors proposent des chasses au trésor et de la peinture au henné, ils tiennent également à disposition différents espaces de jeux et une piscine enfants. Les enfants découvrent l'artisanat traditionnel et peuvent voir des pur-sang arabes et des dromadaires de près. La station organise en outre des safaris dans le désert et des excursions pour aller observer baleines, dauphins et tortues. La vieille ville de Mascate, où se trouvent le fort de Mirani, le palais Al-Alam et la mosquée de Khor, est à 15 minutes en voiture.

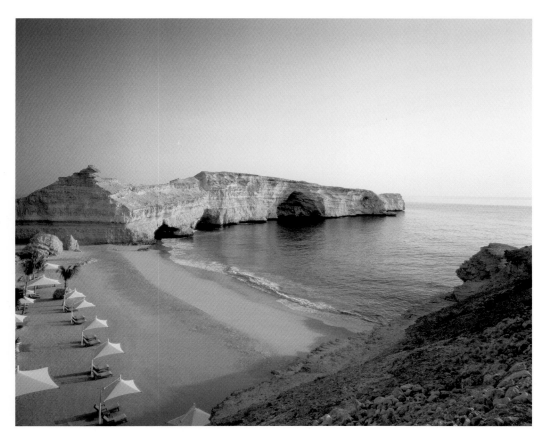

The resort is located next to the beach and boasts an impressive mountainous backdrop.

Die Anlage liegt direkt am Strand vor eindrucksvoller Bergkulisse.

Cette resort donne directement sur la plage, sur fond de montagnes impressionnantes.

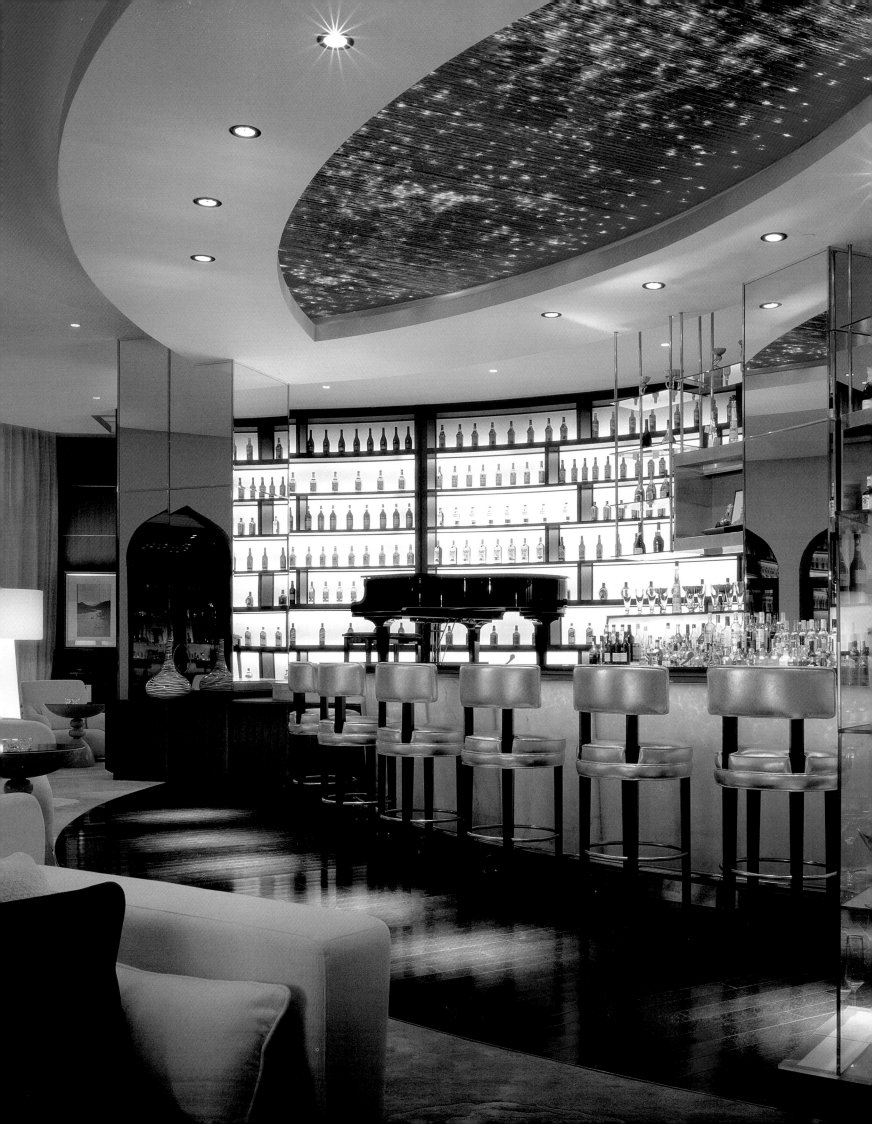

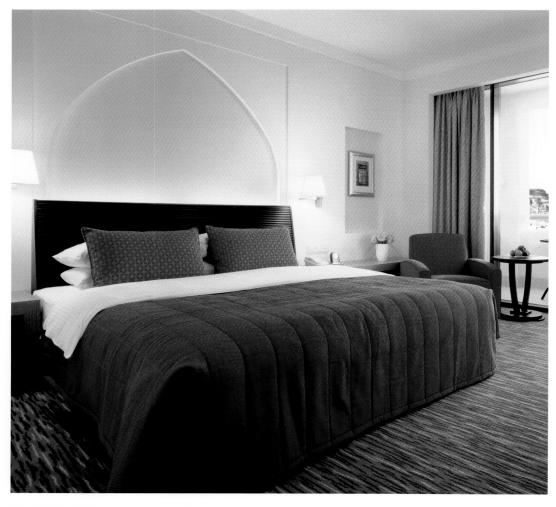

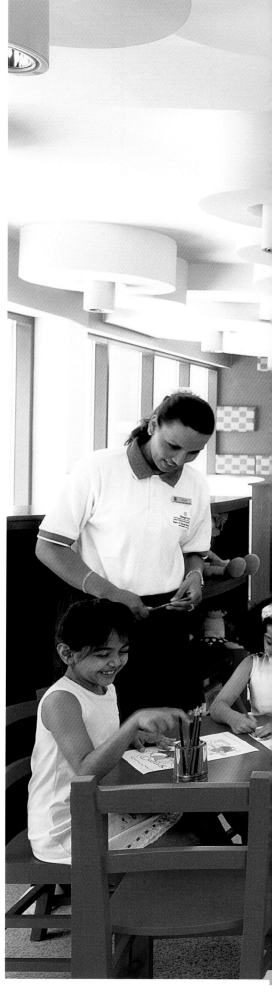

The supervised club offers games and a comprehensive program for all ages.

Im betreuten Club gibt es viele Spiele und ein umfangreiches Programm für jedes Alter.

Le club-garderie abrite de nombreux jeux et propose un vaste programme d'activités pour enfants de tous âges.

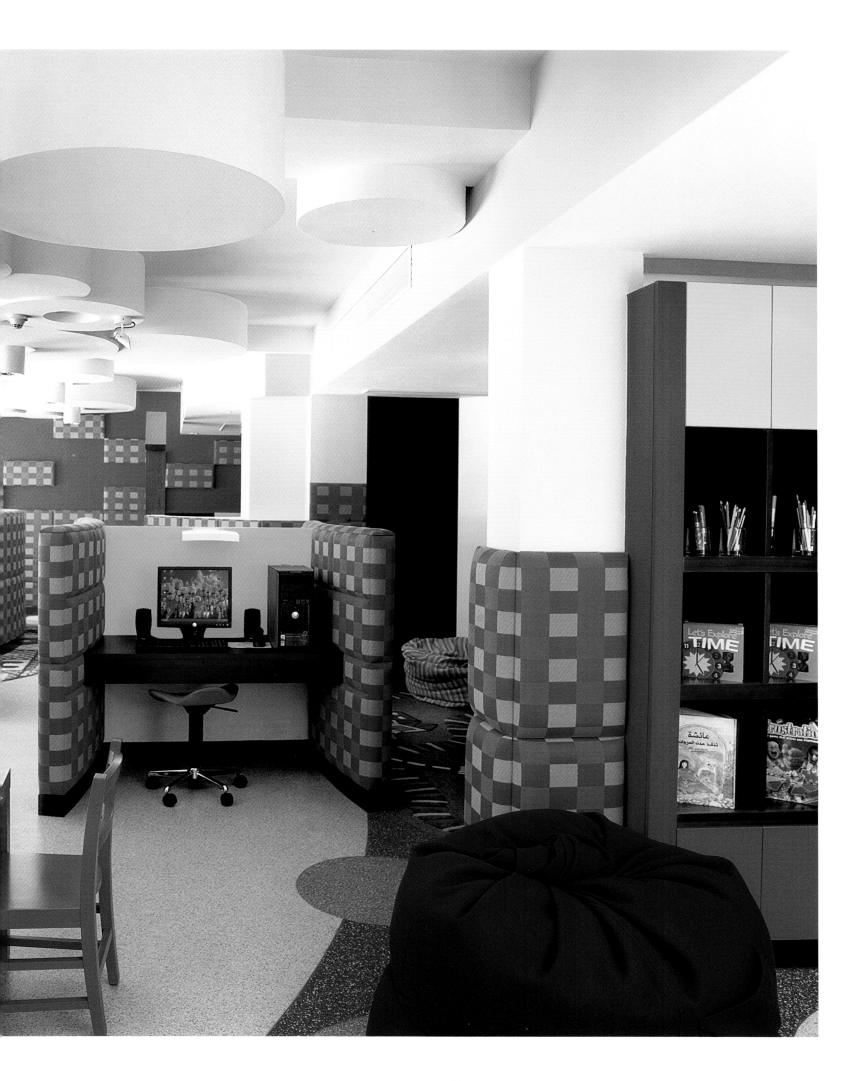

Frégate Island Private

Frégate Island, Seychelles

Secluded bays, turquoise water, green jungle, dramatic rock cliffs, and pure luxury in 16 villas in front of a magical backdrop, all of which feature a private pool, Jacuzzi, daybed, and dining pavilion: that is Frégate Island. The fascinating fauna and flora—including giant tortoises—is best explored on foot. Qualified biologists give guided tours of the island. Small sailing boats and a number of larger yachts await the guests. The Castaway Kids' Club welcomes children from the age of five, where they play, do arts and crafts, read, learn about the environment, and explore the island.

Einsame Buchten, türkisblaues Wasser, grüner Dschungel, dramatische Felsenkliffs und purer Luxus in 16 Villen, alle mit privatem Pool, Jacuzzi, Daybed und Dining Pavillon vor magischer Kulisse: Das ist Frégate Island. Die faszinierende Tier- und Pflanzenwelt – hier leben freie Riesenschildkröten – erlebt man am besten zu Fuß. Ausgebildete Biologen führen Wanderungen über die Insel. Kleine Segelboote und mehrere große Yachten stehen für die Gäste bereit. Kinder ab fünf Jahren sind im Castaway Kids' Club gut aufgehoben: Sie spielen, basteln, lesen, lernen die Umwelt kennen und erforschen die Insel.

Baies isolées, eaux turquoise, jungle verte, falaises qui donnent le tournis et luxe à l'état pur réparti en 16 villas possédant toutes leur propre piscine, leur propre Jacuzzi, un lit extérieur et un pavillon de réception, le tout dans un décor magique, tels sont les ingrédients de Frégate Island. Et c'est à pied que l'on fera le mieux connaissance avec la faune et la flore fascinantes de l'île, où des tortues géantes vivent encore en liberté. Des biologistes de formation servent de guides pour des randonnées à travers l'île. De petits voiliers et plusieurs grands yachts sont à disposition des clients. Les enfants à partir de cinq ans sont en de bonnes mains au Castaway Kids' Club, où ils peuvent jouer, bricoler, lire, découvrir l'environnement et explorer l'île.

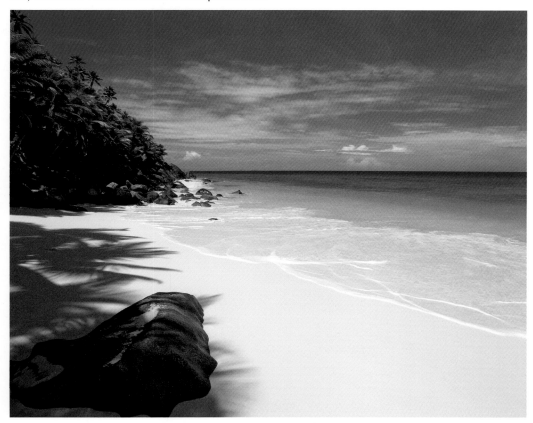

The elegant resort was built in an open, colonial style.

Das elegante Resort wurde in einem offenen, kolonialen Stil erbaut.

Les villas de cet élégant resort sont de style colonial ouvert.

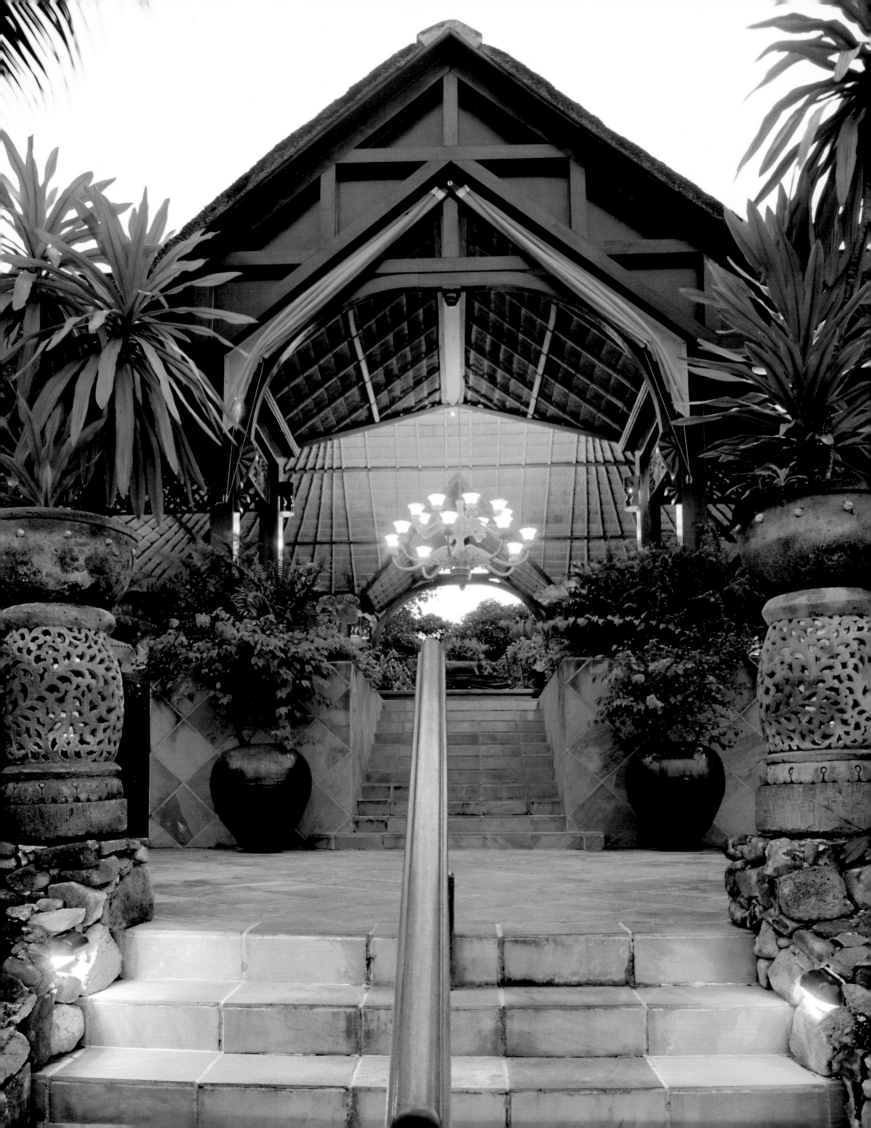

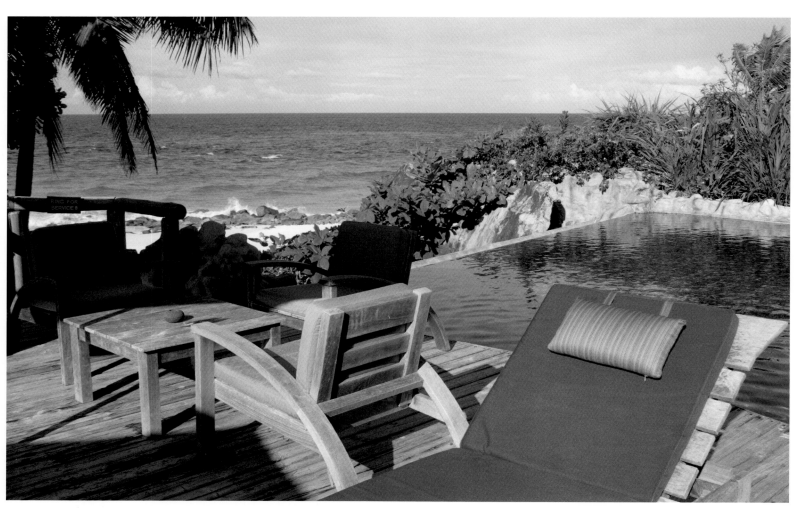

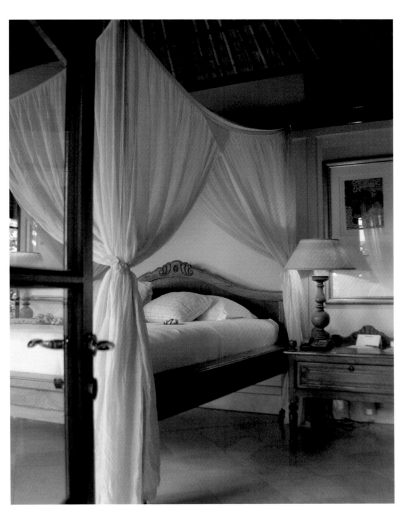

The villas exude a very private atmosphere.

In den Villen erleben Gäste ein sehr privates Wohngefühl.

Dans ces villas, les clients éprouvent un sentiment de grande intimité.

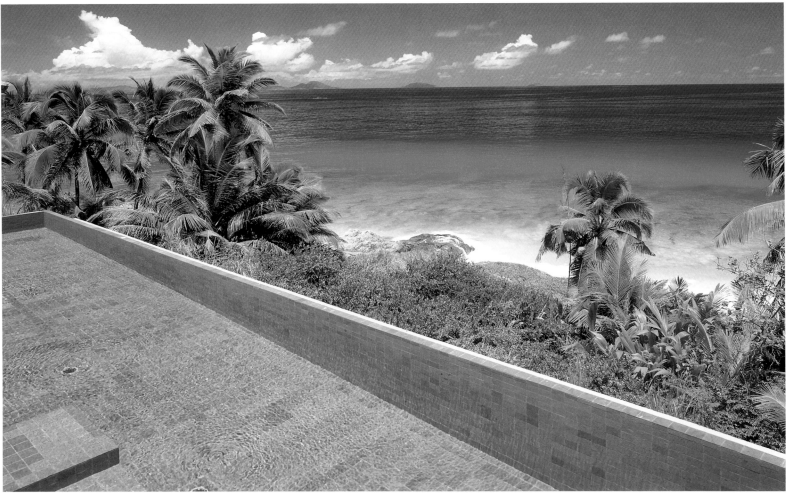

Hatari Lodge

Arusha Nationalpark, Tanzania

A family atmosphere in front of a breathtaking backdrop: the small lodge with view of the Kilimanjaro is located at the foot of Mount Meru and surrounded by lakes, craters, rain forest, and acacias. The décor: modern retro style mixed with African materials and colors. From the hotel's own pier one can literally be next to the animals of the Momella marshes. Guided hikes, game drives, canoe safaris, and visits to the Massai—all off the beaten track—guarantee an unforgettable Africa experience for the whole family.

Familiäre Atmosphäre vor atemberaubender Kulisse: Die kleine Lodge mit Blick auf den Kilimandscharo liegt malerisch am Fuß des Mount Meru und ist umgeben von Seen, Kratern, Regenwäldern und Akazienlandschaften. Das Dekor: moderner Retro-Stil gemischt mit afrikanischen Materialien und Farben. Vom hoteleigenen Steg kann man die Tiere am Momella-Sumpf aus nächster Nähe beobachten. Abseits überfüllter Safaripfade garantieren geführte Wanderungen, Pirschfahrten, Kanusafaris und Besuche bei den Massai ein unvergessliches Afrika-Erlebnis für Eltern und Kinder.

Ambiance familiale dans un décor époustouflant : cette petite lodge pittoresque avec vue sur le Kilimandjaro est située au pied du mont Meru et est entourée de lacs, de cratères, de forêts tropicales et de paysages d'acacias. Le style : rétro-moderne, intégrant matériaux et coloris africains. Depuis la passerelle privée de l'hôtel, on peut observer les animaux du marais de Momella de très très près. Des randonnées guidées, des observations des animaux, des safaris en canoë et des visites chez les Masaï promettent de faire vivre des vacances africaines inoubliables aux parents comme aux enfants, à l'écart des sentiers battus et rebattus.

The rooms combine natural materials with strong colors.

Die Einrichtung der Zimmer verbindet natürliche Materialien mit starken Farben.

L'aménagement des chambres allie matériaux nobles et couleurs vives.

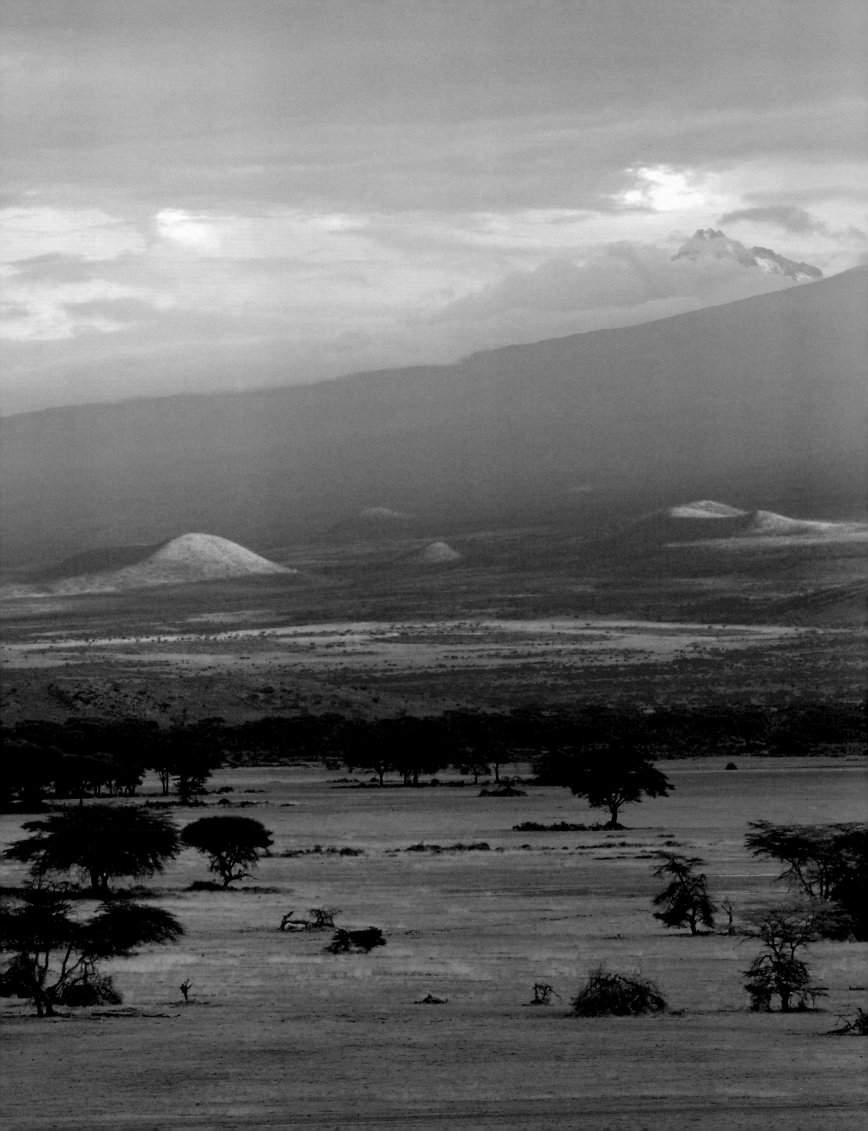

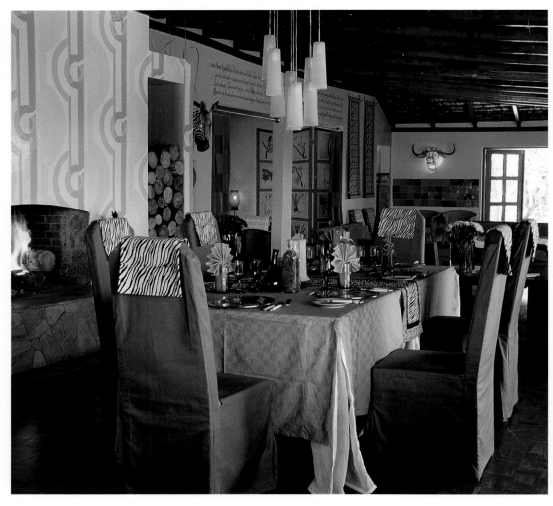

Wild nature and a fresh elegance characterize the hotel.

Wilde Natur und frische Eleganz zeichnen das Hotel aus.

Nature sauvage, fraîcheur et élégance caractérisent cet hôtel.

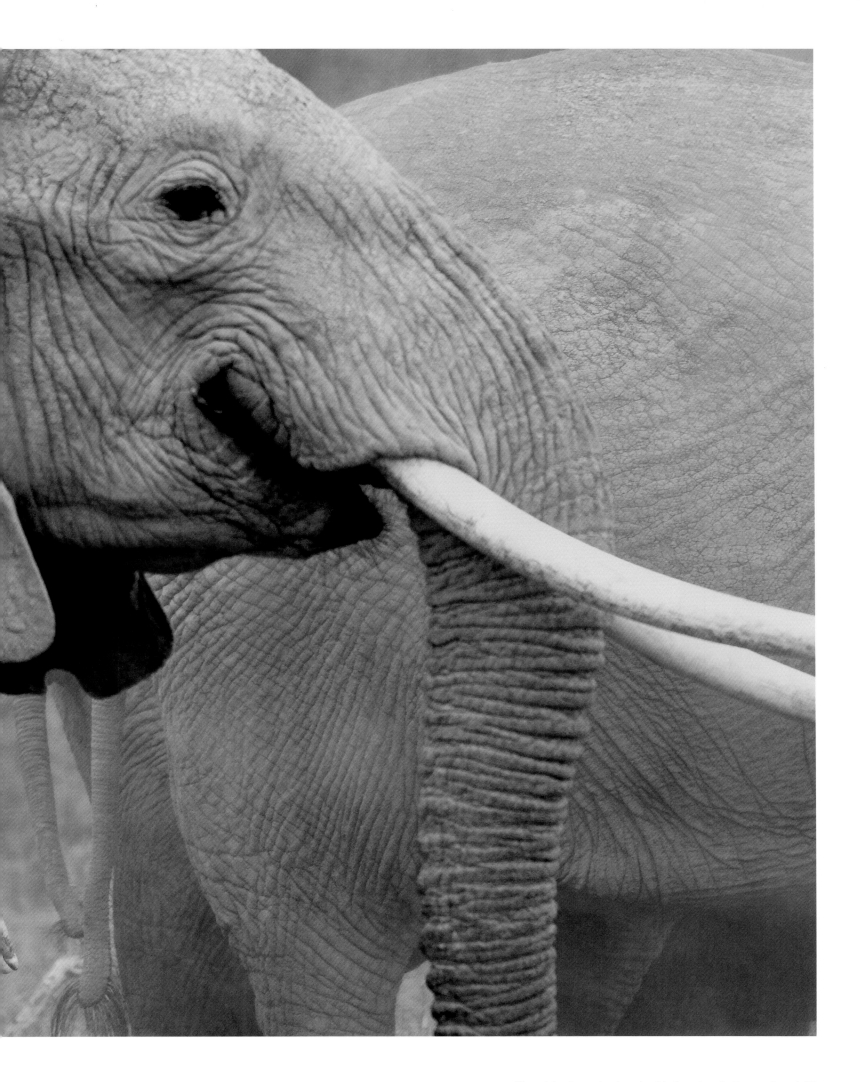

Wolwedans Dunes Camp
Namib Rand, Namibia

The stylish Wolwedans Camp and Lodges complex is situated amidst the malaria-free NamibRand Nature Reserve on the border to the Namib desert. The atmosphere is very child-friendly, and guests under the age of twelve are welcome. Guests will learn to appreciate the impressive beauty, color intensity, and incredible variety of the desert on guided tours—either by foot, jeep, plane, or hot-air balloon. Families with children are well advised to book free standing lodges to experience the wonders of nature at first hand.

Inmitten des NamibRand Naturreservats am Rand der Namib Wüste liegen die stilvollen Wolwedans-Camps und -Lodges, die auch für Gäste unter zwölf Jahren offen sind. Die Atmosphäre ist sehr kinderfreundlich, die Gegend malariafrei. Auf geführten Touren – zu Fuß, mit dem Geländewagen, dem Kleinflugzeug oder dem Heißluftballon – lernen Urlauber die eindrucksvolle Schönheit, Farbintensität und Formenvielfalt der Wüste kennen. Familien mit kleinen Kindern buchen am besten eine der Unterkünfte für sich allein und genießen ein ganz besonderes Naturerlebnis.

Les camps et gîtes de caractère de Wolvedans, accessibles également aux pensionnaires de moins de douze ans, sont situés au beau milieu de la réserve naturelle du NamibRand, à la lisière du désert du Namib. Dans la région exempte de malaria, où est installé celui-ci, on aime les enfants, et cela se sent. Les vacanciers pourront découvrir la beauté, l'intensité des couleurs et la diversité des formes impressionnantes du désert à l'occasion d'excursions guidées, à pied, en 4x4, en petit avion monomoteur ou en montgolfière. Les familles avec petits enfants gagneront à réserver une lodge entière pour elles seules, et vivront ainsi une expérience inoubliable au contact de la nature.

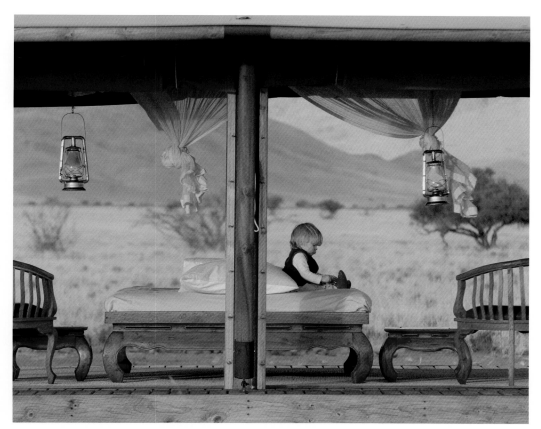

This terrace affords beautiful views of the Namib desert.

Von dieser Terrasse aus öffnet sich der Blick in die malerische Wüste Namib.

S'asseoir à cette terrasse, c'est contempler la nature sauvage du désert du Namib.

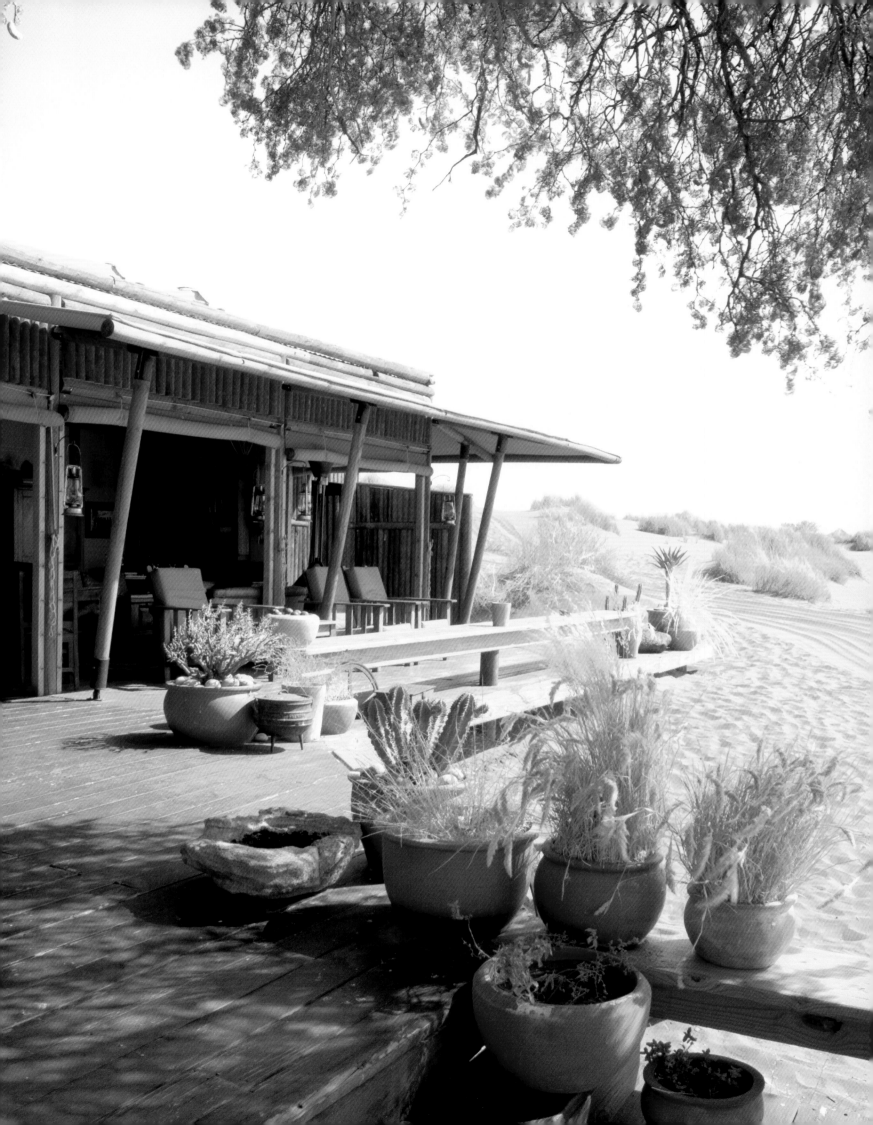

Four quiet, rustic lodgings provide comfortable living quarters.

Vier ruhige, rustikale Unterkünfte bieten behaglichen Komfort.

Quatre logements calmes et rustiques offrent un agréable confort.

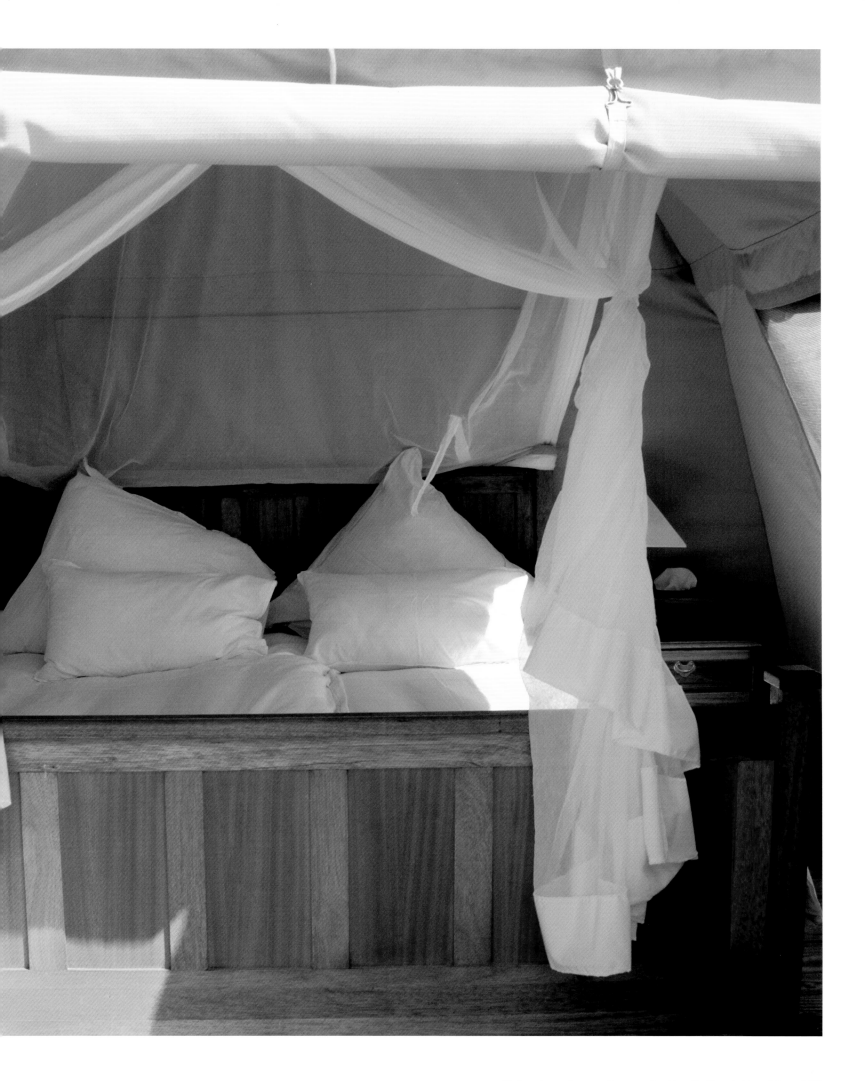

Alfajiri Villas
Danai Beach, Kenya

One of East Africa's most beautiful hotels: three comfortable villas amidst luscious gardens with a view of the Indian Ocean. Caribbean architecture meets African and Far Eastern furnishings. The program includes snorkeling along the reef with local fishermen and their traditional boats, yoga exercises, and excursions to the Tsavo East and Kisite Marine national parks as well as to Funzi island. A golf course is only a stone's throw away. Supervised 24 h childcare is part of the service, as are games and videos.

Eine der schönsten Unterkünfte Ostafrikas: drei komfortable Villen in einem üppigen Garten mit Blick auf den Indischen Ozean. Karibischer Baustil trifft auf afrikanische und fernöstliche Einrichtung. Schnorcheln am Riff mit örtlichen Fischern und ihren traditionellen Booten, Yoga-übungen und Ausflüge zum Tsavo East Nationalpark, zum Kisite Marine Nationalpark und nach Funzi Island werden arrangiert. Ein Golfplatz liegt in nächster Nähe. Kinderbetreuung rund um die Uhr gehört zum Service, außerdem gibt es Spiele und Videos.

Un des plus beaux gîtes d'Afrique orientale : trois confortables villas situées dans un jardin luxuriant ayant vue sur l'océan Indien, où l'architecture caribéenne se marie aux intérieurs de types africain et extrême-oriental, et d'où l'on organise des sessions de snorkeling dans les récifs avec des pêcheurs locaux à bord de leurs embarcations traditionnelles, des exercices de yoga, et des excursions au parc national de Tsavo East, au parc national marin de Kisite et à Funzi Island. Un parcours de golf se trouve à proximité immédiate. Une garderie 24h/24 est comprise dans le service, sans parler des jeux et des vidéos.

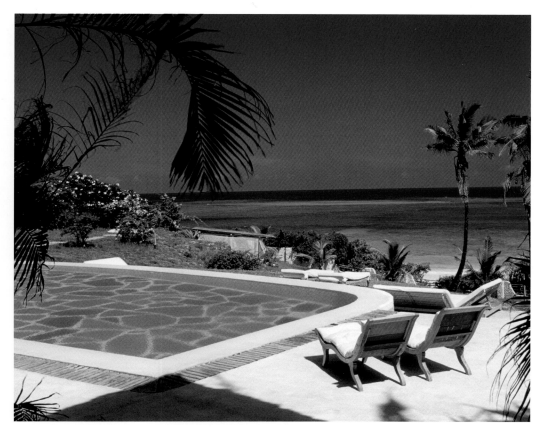

The villas boast a stylish interior and their own pools.

Die Villen sind stilvoll eingerichtet und haben jeweils ein eigenes Schwimmbecken.

Les villas, aménagées avec goût, ont chacune leur propre piscine.

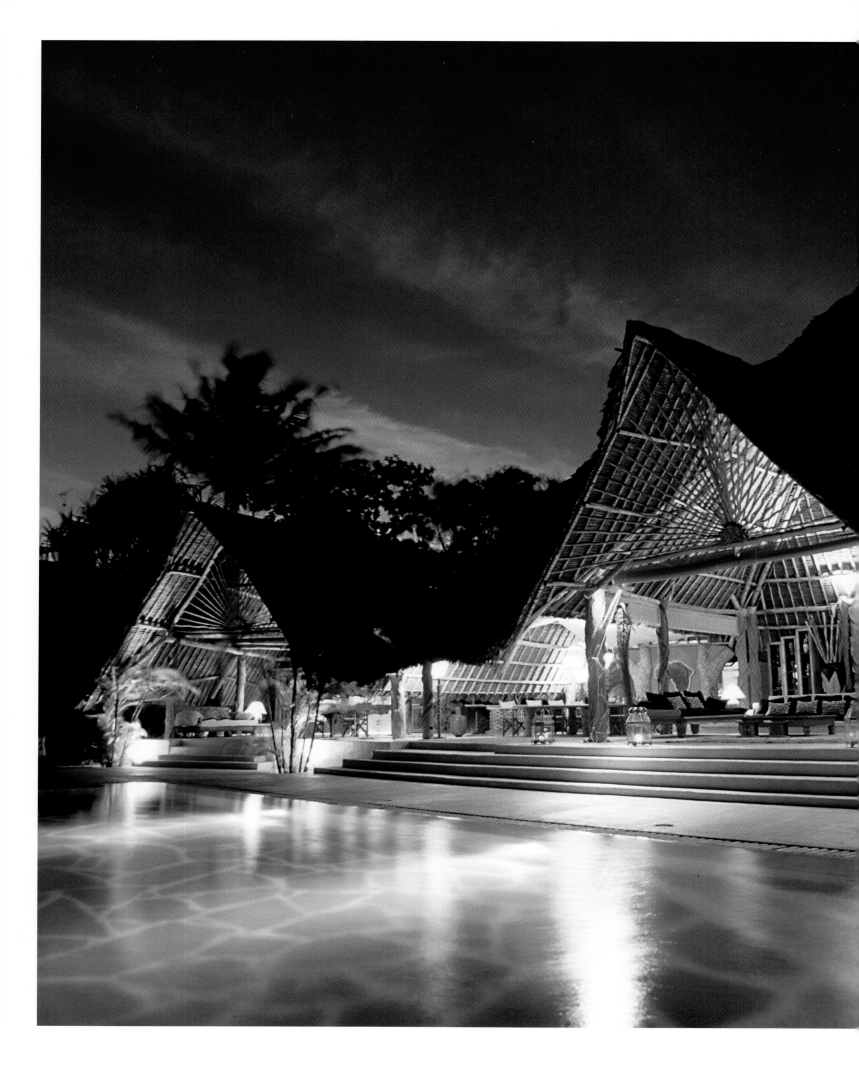

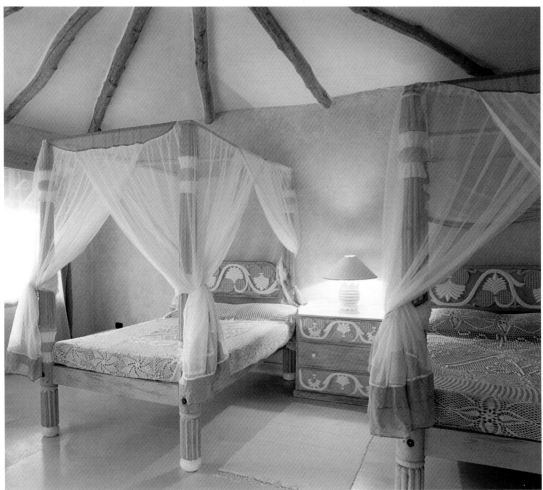

The large "Garden Villa" has four individually designed rooms.

Die großzügige „Garden Villa" verfügt über vier individuell gestaltete Zimmer.

La somptueuse « Garden Villa » dispose de quatre chambres personnalisées.

Beau Rivage

Belle Mare, Mauritius

The colonial style five-star hotel, surrounded by fragrant gardens, is located at the most beautiful beach of the island, and near the fishing village of Trou d'Eau Douce—a wonderful place to spend a relaxing, sporty holiday. Comfortable suites and villas reflect the island's rich cultural heritage. The large pool complex with children's pool forms the heart of the hotel. The program for smaller guests includes glass boat trips, riding a pedal-boat, playing table tennis, snorkeling and crazy golf.

Nahe des Fischerdorfs Trou d'Eau Douce liegt das im Kolonialstil erbaute Fünf-Sterne-Hotel umgeben von duftenden Gärten am schönsten Strand der Insel – ein herrlicher Ort für einen erholsamen oder auch sportlichen Urlaub. Komfortable Suiten und Villen spiegeln die kulturelle Vielfalt der Insel wider. Der große Pool mit Kinderbecken ist das Herzstück der Anlage. Für kleine Gäste wird viel geboten: Ausflüge mit dem Glasboden-Boot, Tretbootfahren, Tischtennis, Schnorcheln und Minigolf.

Cet hôtel cinq étoiles de style colonial entouré de jardins odorants est situé au bord de la plus belle plage de l'île et non loin du Trou D'Eau Douce, un village de pêcheurs. Il constitue un superbe endroit pour des vacances à la fois réparatrices ou aussi sportives. Ses confortables suites et villas reproduisent la diversité culturelle de l'île. La grande piscine avec bassin enfants est le cœur de la station. Les petits pensionnaires ont le choix entre de nombreuses activités : excursions en bateau à fond de verre, piloter un pédalo, jouer au tennis de table, snorkeling et mini-golf.

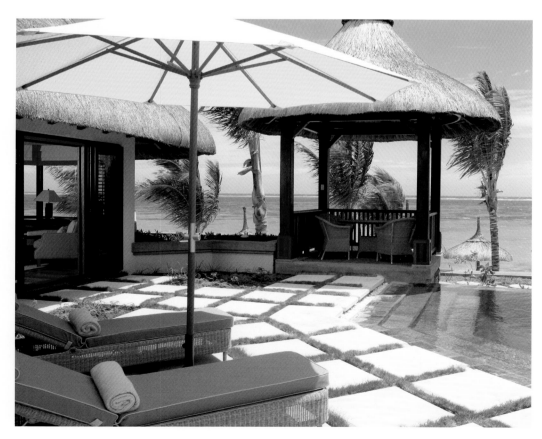

The villas and suites offer a phantastic view of the beach and the Indian Ocean.

Die Villen und Suiten gewähren einen fantastischen Blick auf den Strand und den Indischen Ozean.

Les suites et les villas offrent une vue fantastique sur la plage et sur l'océan Indien.

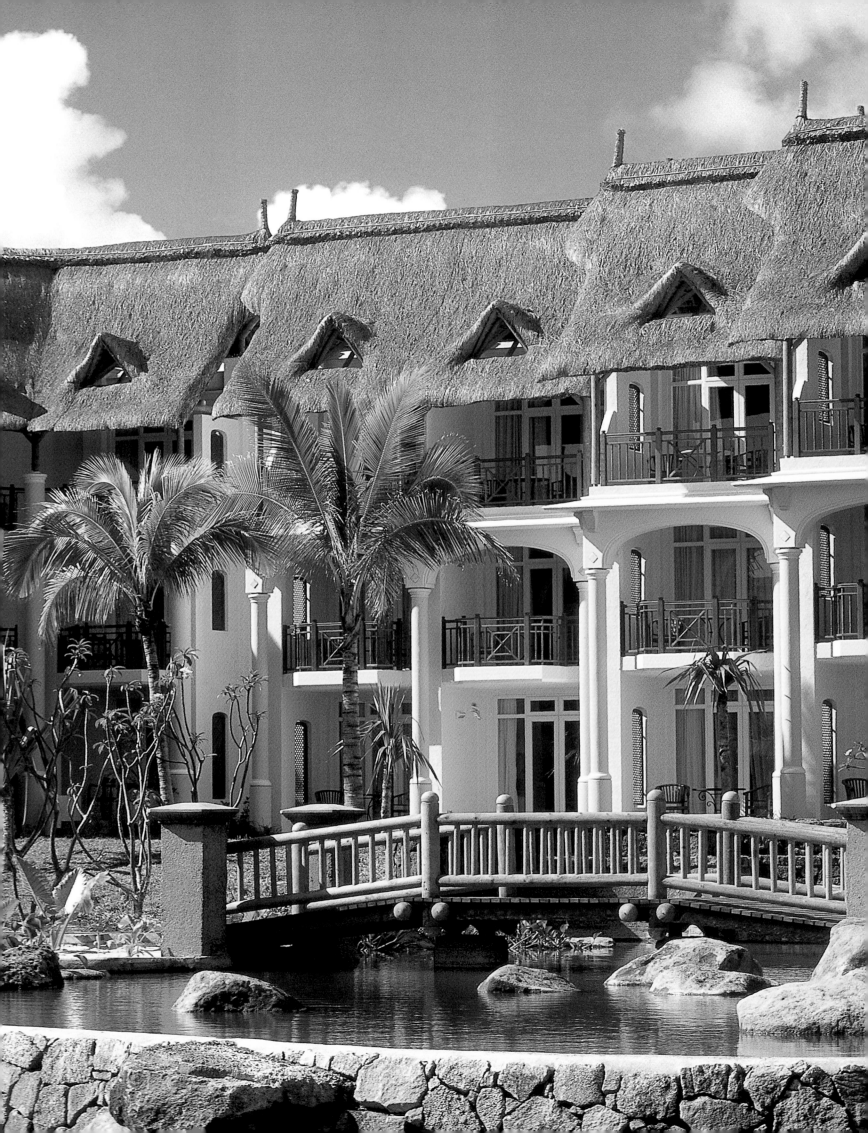

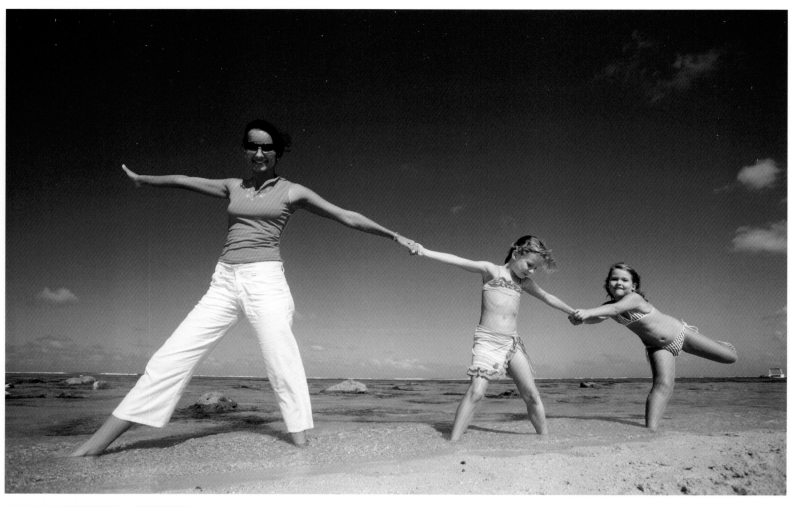

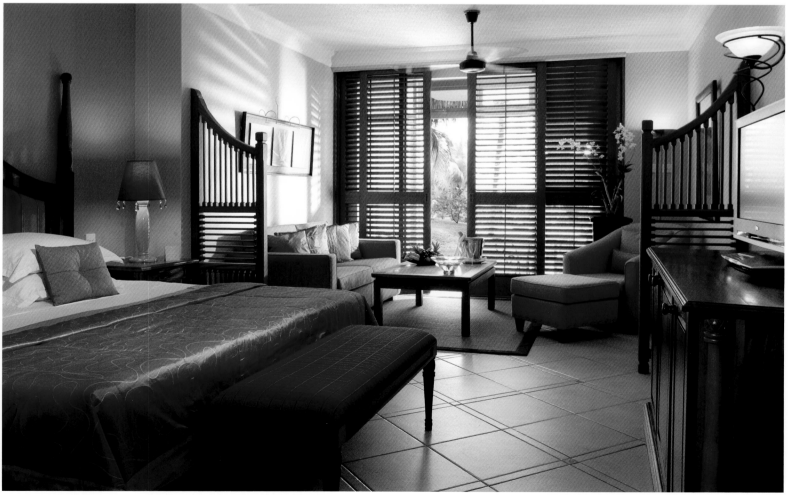

In the kids' club and at the sea children awaits a comprehensive program.

Im Kinderclub und am Meer wartet ein abwechslungsreiches Freizeitangebot.

Un vaste choix d'activités récréatives variées attend les enfants au mini-club et au bord de la mer.

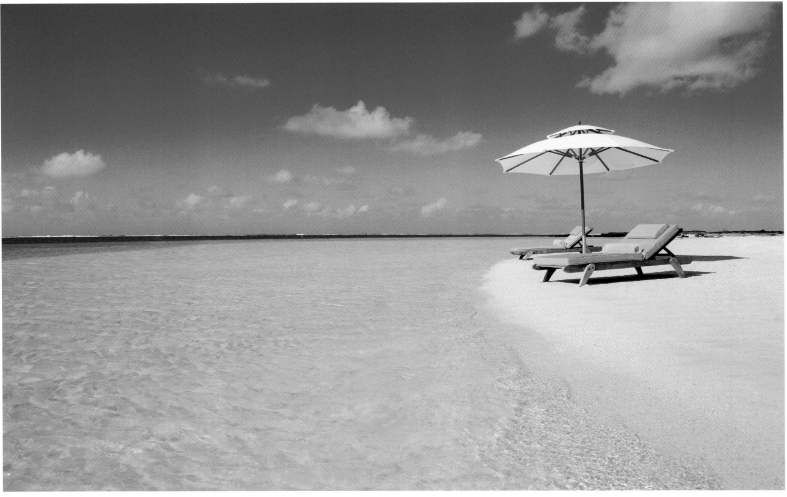

One of the island's loveliest beaches.

Der breite Sandstrand gehört zu den schönsten der Insel.

La grande plage de sable est l'une des plus belles de l'île.

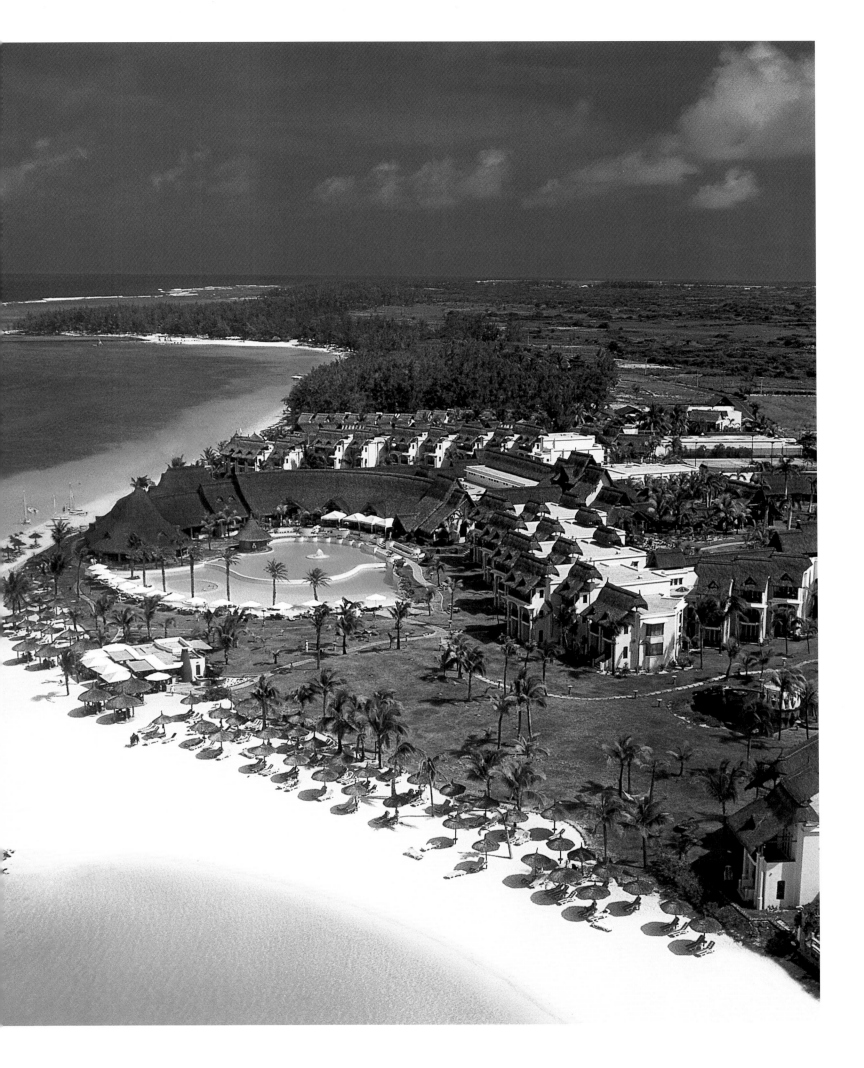

Constance Belle Mare Plage

Belle Mare, Mauritius

Two golf courses and an extended beach on a bay that is protected by a coral reef—ideal for swimming and snorkeling: the resort is a paradise for golfers and families. Kids receive a welcome present, parents a brochure with tips for an unforgettable family holiday. The complex boasts a playroom, playground, and a kids' pool. The supervised kids's club offers a comprehensive program. The luxurious accommodation is child-friendly, including even baby monitors and toys. All ages and tastes are catered for.

Zwei Golfplätze und ein langer Strand an einer Bucht, die durch ein Korallenriff geschützt ist – ideal zum Schwimmen und Schnorcheln: Das Resort ist ein Paradies für Golfer und Familien. Kinder erhalten ein Willkommensgeschenk, Eltern eine Broschüre mit Tipps für einen unvergesslichen Familienurlaub. Zur Anlage gehören Spielzimmer, Spielplatz und Kinderpool. Der betreute Kinderclub bietet ein abwechslungsreiches Programm. Die luxuriösen Unterkünfte sind auf Kinder eingestellt – vom Babyfon bis zum Spielzeug – für jede Altersgruppe ist gesorgt.

Deux parcours de golf et une longue plage située dans une baie protégée par un récif corallien idéal pour la natation et le snorkeling : ce complexe est un paradis des golfeurs et des familles. Tandis que les enfants reçoivent un cadeau de bienvenue, les parents, eux, reçoivent une brochure contenant des astuces pour des vacances en famille inoubliables. Une pièce et une aire de jeux, ainsi qu'une piscine enfants, font également partie du complexe. Le programme d'activités du mini-club encadré est riche et varié. Les suites, luxueuses, sont adaptées aux enfants. Du babyphone aux jouets, l'établissement prévoit des équipements pour chaque tranche d'âge.

A protected beach, four pools, and a large spa to relax in.

Geschützter Strand, vier Pools und großes Spa versprechen Erholung.

Une plage bien abritée, quatre piscines et un grand spa sont promesse de repos et de récupération.

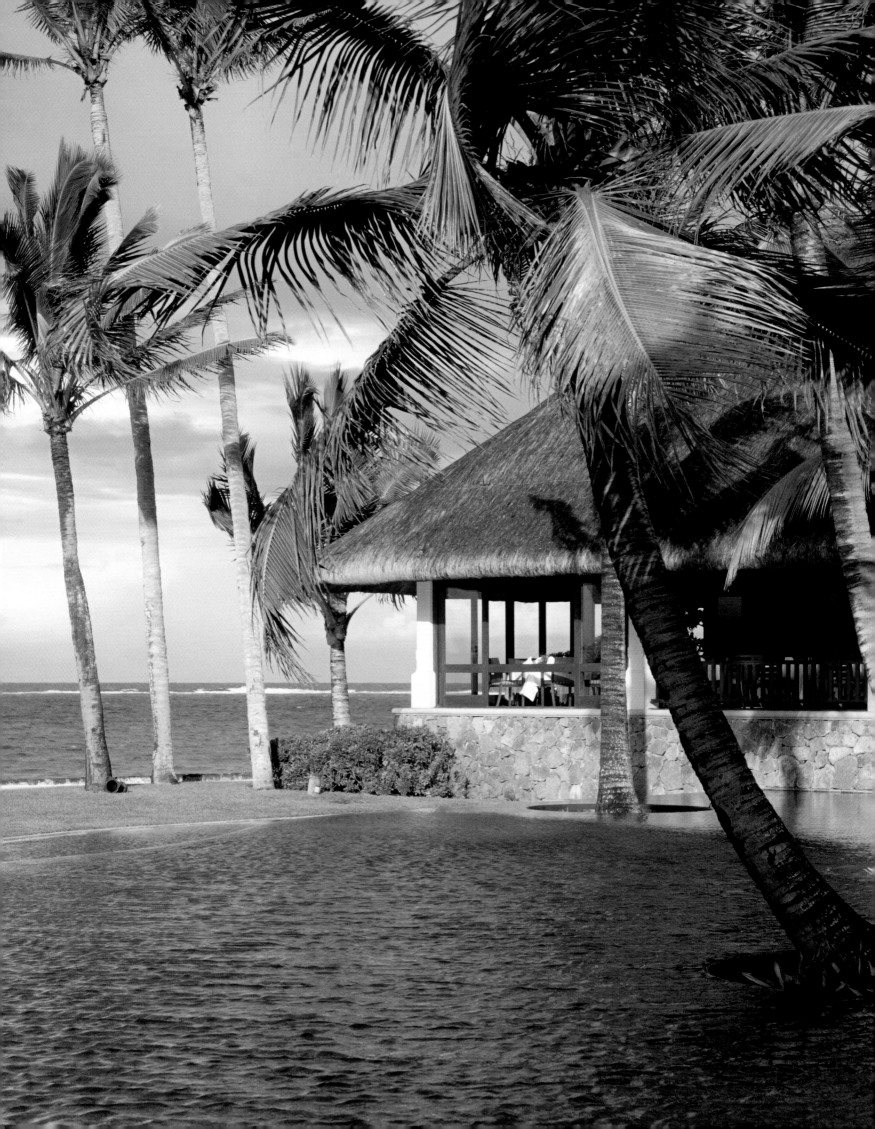

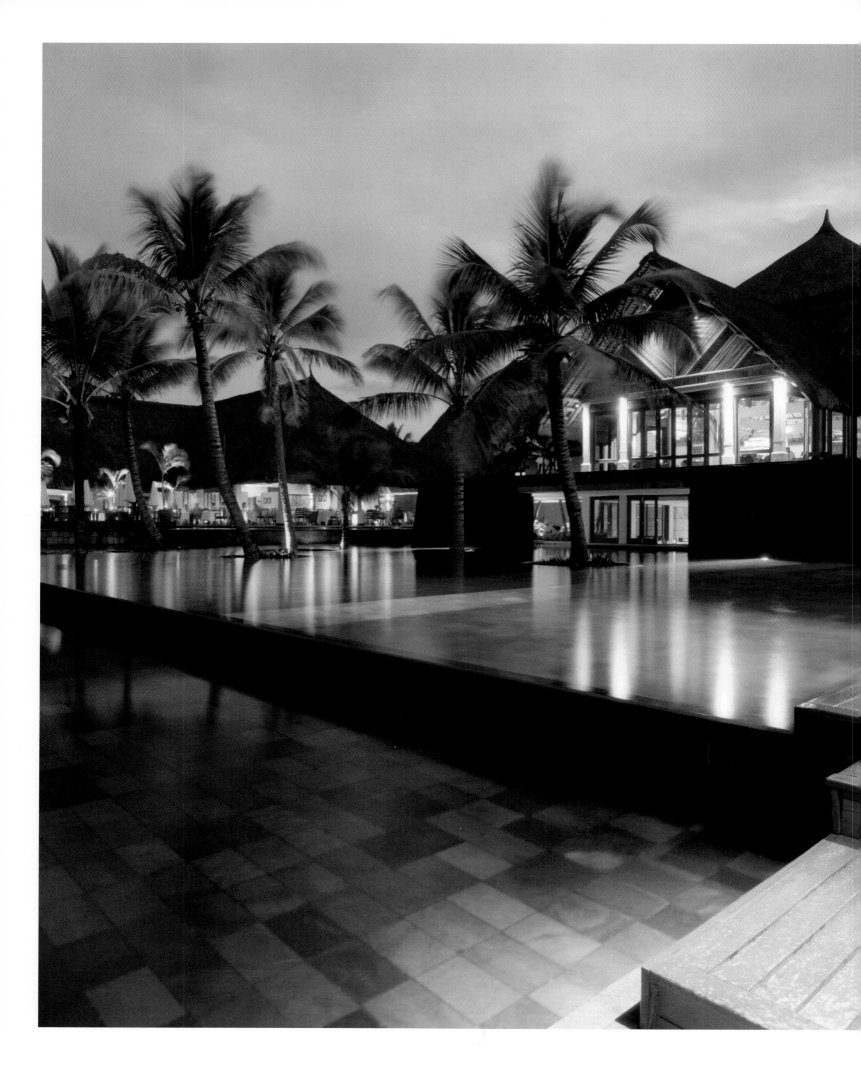

Dinner is served next to the illuminated pool.

Das Abendessen wird am beleuchteten Pool serviert.

Le souper est servi au bord de la piscine éclairée.

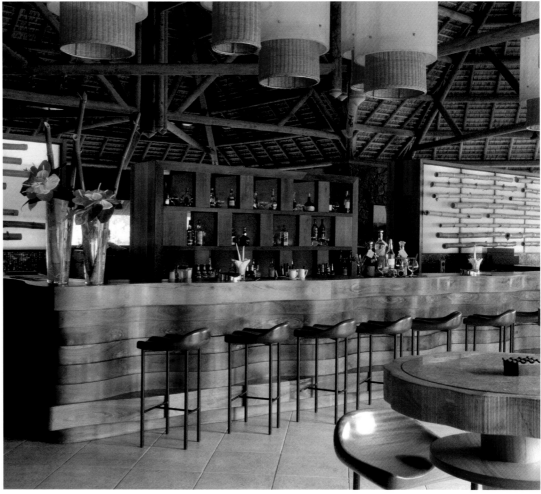

Island Hideaway
Spa, Resort & Marina
Dhonakulhi, Maldives

White beach, luscious greenery, and an unspoilt reef—a paradise for the discerning snorkeler and families alike. Stylish villas are embedded in tropical vegetation close to the beach. While parents go snorkeling, diving, or relax in the sun, small guests can go cycling, use the playground, or join the kids' club, where they will be trained as ecologists, cooks, or marine biologists in courses spanning over a number of days—and receive a "diploma" at the end.

Weißer Strand, üppiges Grün und ein unberührtes Hausriff – ein Paradies für anspruchsvolle Wassersportler und Familien gleichermaßen. Stilvoll eingerichtete Villen liegen eingebettet in tropische Vegetation nahe des Strandes. Während die Eltern schnorcheln, tauchen oder in der Sonne entspannen, wartet auf die kleinen Gäste neben Fahrrädern, Spielplatz und Kinderclub ein besonderes Programm: Sie werden in mehrtägigen Workshops zu Umweltschützern, Köchen und Meeresbiologen ausgebildet – selbstverständlich mit „Diplom".

Plage de sable blanc, végétation luxuriante et un récif frangeant encore intact – un paradis pour les pratiquants exigeants de sports nautiques et les familles. Les villas, rustiques, stylées et presque noyées dans la végétation, se trouvent tout près de la plage. Pendant que les parents pratiquent le snorkeling, font de la plongée ou se détendent au soleil, un programme spécial attend les petits pensionnaires, outre les vélos, l'aire de jeux et le club enfants : en effet, ceux-ci sont formés à la protection de la nature, à la cuisine et à la biologie marine dans le cadre d'ateliers de plusieurs jours, le tout sanctionné par des « diplômes », bien entendu.

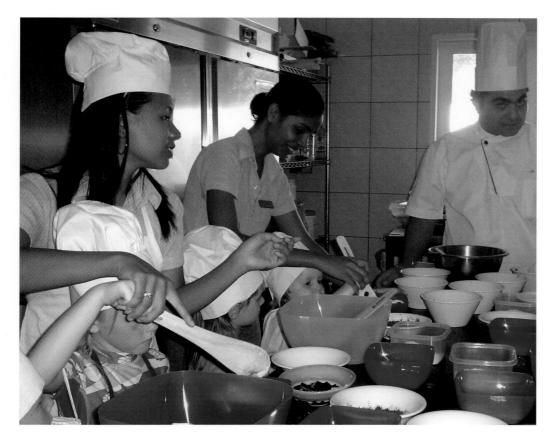

The little ones complete the cooking course and receive a "diploma."

Kinder am Herd: Den Kochworkshop beenden die Kleinen mit „Diplom".

Les enfants aux fourneaux : l'atelier cuisine se termine par la remise d'un « diplôme » aux petits.

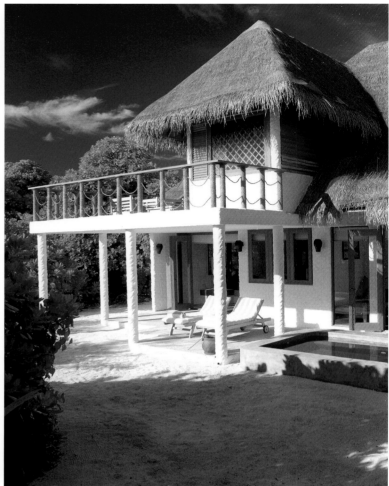

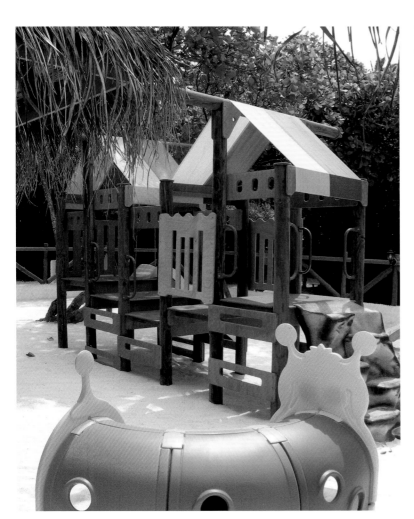

The resort boasts a lot of space and a comprehensive children's program.

Viel Platz und ein großes Kinderprogramm zeichnen das Resort aus.

Beaucoup de place et un vaste programme enfants caractérisent le complexe.

The Fortress
Galle, Sri Lanka

The modern resort on the beach of Koggala has an "olde worlde" style. The design is based on an old Dutch fortress, while the modern rooms are classy yet classic. There is a kids' club. A breeding station for turtles is located at a five-minutes drive from the resort. A good starting point for exploring southern Sri Lanka: the resort organizes excursions to the historical Galle fortress (UNESCO World Heritage Site), the Handunugoda Tea Factory, the Sinharaja rain forest, and the Yala national preserve with its elephants, leopards, and crocodiles.

Das Resort am Strand von Koggala verbindet vergangene Zeiten und zeitgemäßen Komfort. Einer alten holländischen Festung nachempfunden, bietet es moderne Zimmer in edlem, klassischem Design. Zum Hotel gehören ein Kinderclub. Eine Schildkröten-Brutstation liegt fünf Autominuten entfernt. Das Resort ist ein guter Ausgangspunkt zur Erkundung des Südens von Sri Lanka: Ausflüge zur historischen Festung von Galle (UNESCO Weltkulturerbe), zur Handunugoda Tea Factory, zum Sinharaja Regenwald und zum Yala Nationalpark, in dem Elefanten, Leoparden und Krokodile leben, werden organisiert.

Confort actuel et époques passées se combinent dans ce resort, situé à même la plage de Koggala. Bâti sur le modèle d'une ancienne forteresse hollandaise, il propose des chambres modernes, au design à la fois noble et classique. Un club enfants et une station de reproduction de tortues font également partie de l'hôtel à une distance de cinq minutes en voiture. Un bon point de départ en tout cas pour explorer le sud du Sri Lanka : la maison organise en effet des excursions à la forteresse historique de Galle (inscrite au patrimoine mondial de l'UNESCO), à la Handunugoda Tea Factory, à la forêt tropicale de Sinharaja et au parc national de Yala, où vivent éléphants, léopards et crocodiles.

The resort has modern furnishings and an attentive service.

Moderne Einrichtung und aufmerksamer Service zeichnen das Haus aus.

Aménagement moderne et service attentionné caractérisent la maison.

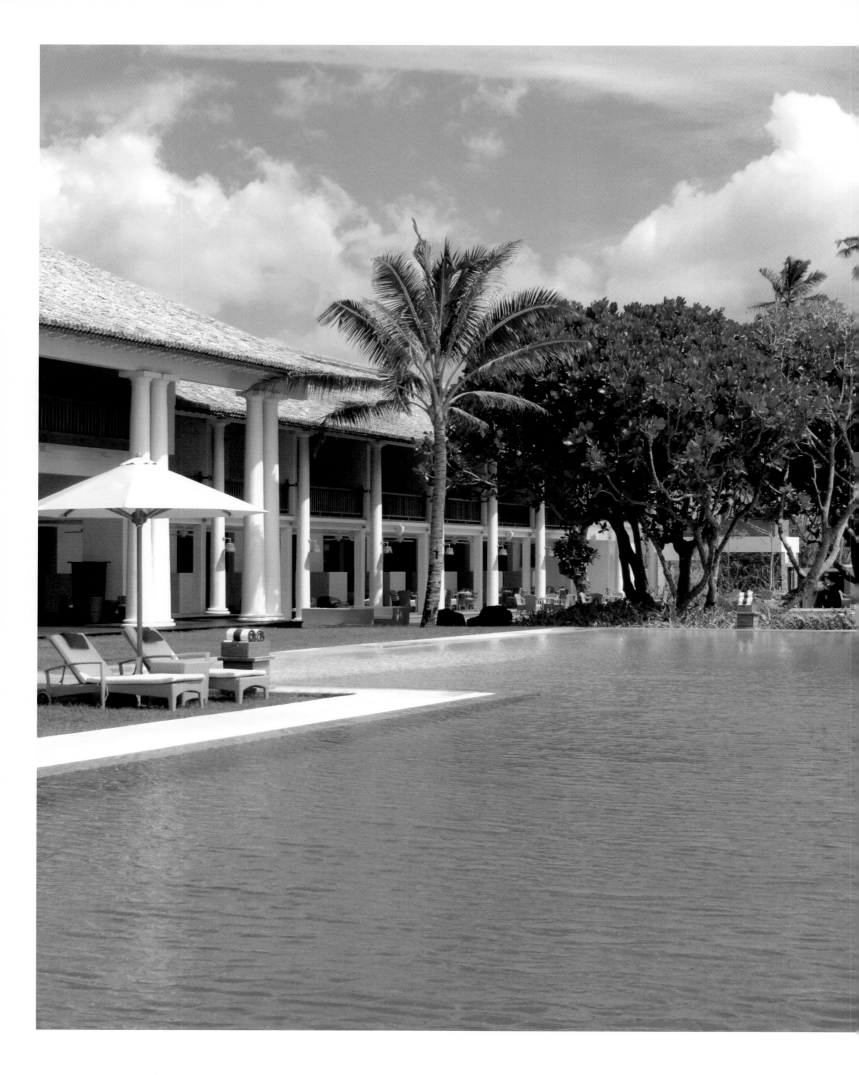

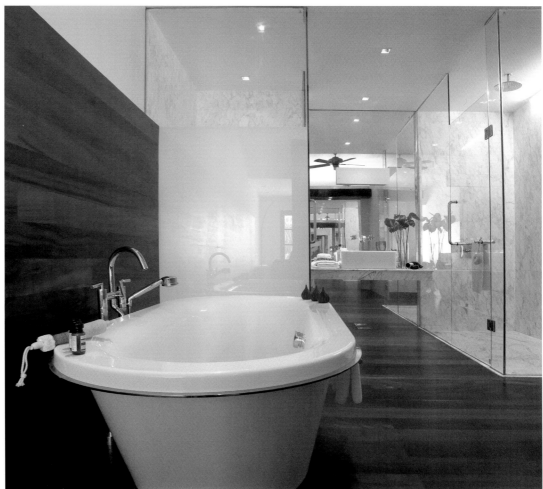

The free flow swimming pool affords views over the nearby ocean.

Das Hotel hat ein großes Schwimmbad mit Blick auf das nahe Meer.

L'hôtel possède une grande piscine avec vue sur la mer toute proche.

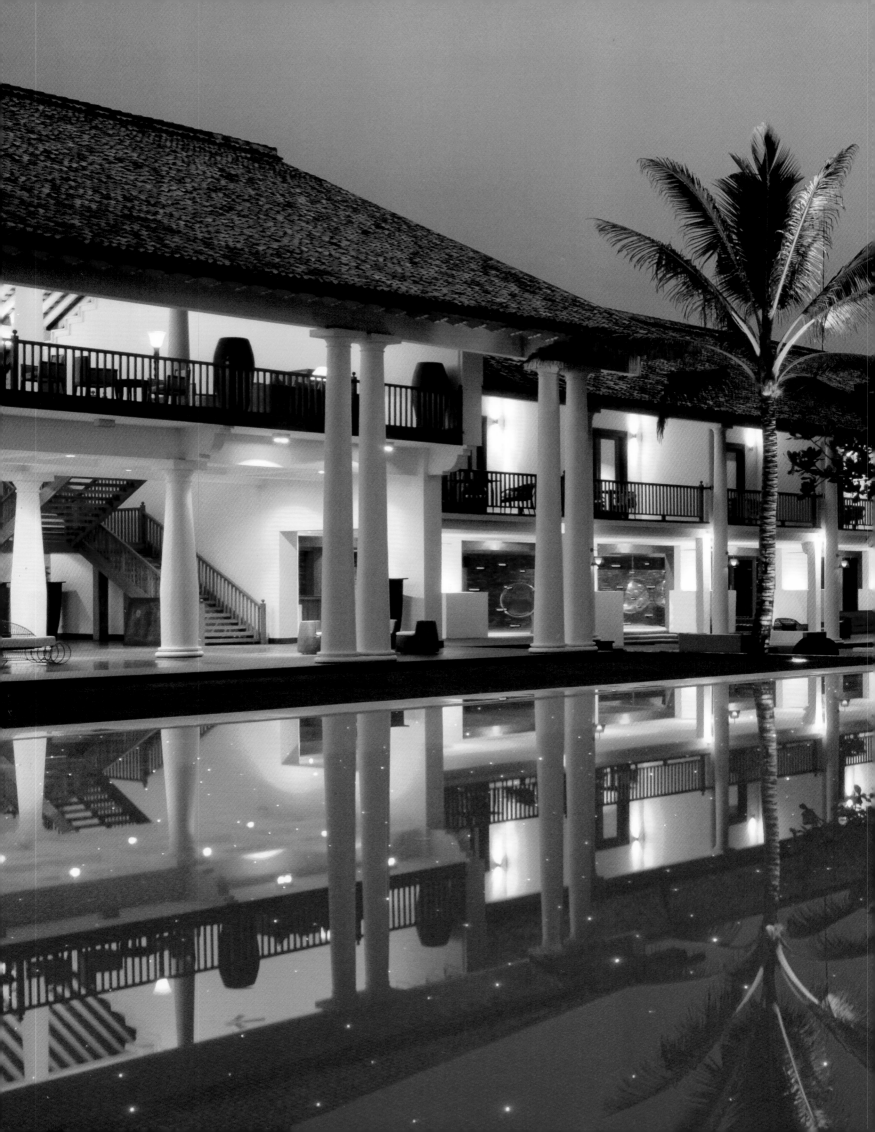

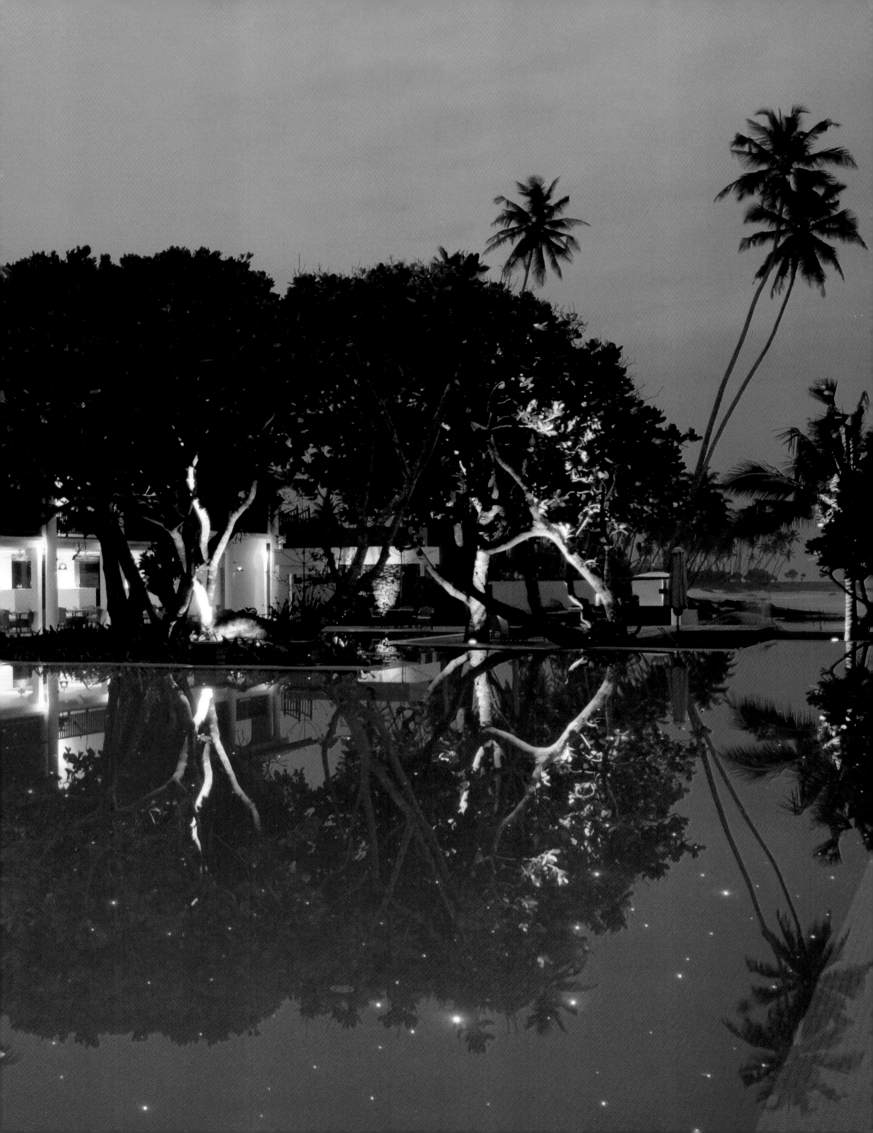

Park Hyatt Goa Resort and Spa

Goa, India

This hotel embodies exclusivity, generosity, and comfort. It is built in the style of a Goan village. The accommodation is spread throughout the large complex located right next to the sea with lagoons reaching into its luscious gardens. The large pool with its water slide guarantees fun for the family. Kids can enjoy the many activities on offer in the supervised club, while the parents can make use of the spa. Archery, bowling, cinema and aquatic sports are also on offer.

Exklusivität, Großzügigkeit und Komfort prägen das Resort, das einem goanischen Dorf nachempfunden ist. Die Unterkünfte sind über die weitläufige Anlage verteilt, die in einem üppigen Garten direkt am Meer liegt und von Lagunen durchzogen wird. Der große Pool garantiert mit seiner Wasserrutsche vor allem Familien viel Spaß. Kinder vergnügen sich im betreuten Club bei vielfältigen Aktivitäten, während die Eltern das breite Spa-Angebot genießen. Auch Bogenschießen, Bowling, Kino und Wassersport gehören zum Angebot des Resorts.

Distinction, espace et confort caractérisent ce complexe hôtelier bâti sur le modèle d'un village de Goa. Les suites sont réparties sur tout le domaine de cette vaste station, située directement au bord de la mer, dans un jardin luxuriant, et traversée de lagunes. La grande piscine, avec son toboggan nautique, promet de nombreuses heures d'amusement, surtout aux familles. Les enfants trouvent leur bonheur dans les diverses activités encadrées du mini-club, pendant que les parents profitent d'une formule spa étendue. Tir à l'arc, bowling, cinéma et sports nautiques font également partie des activités proposées par le complexe.

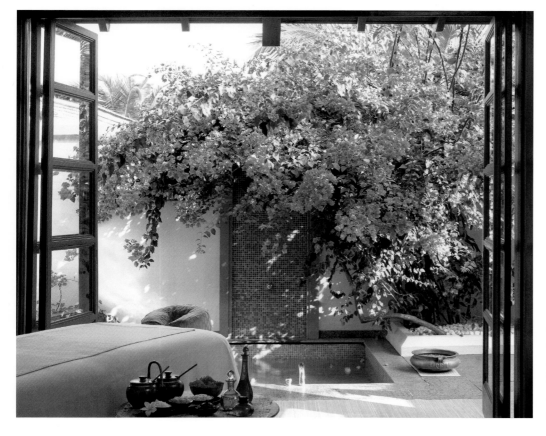

The hotel with its elegant rooms has a village-like ambiance.

Das Hotel mit dörflichem Charme hat elegante Zimmer.

L'hôtel, au charme villageois, possède d'élégantes chambres.

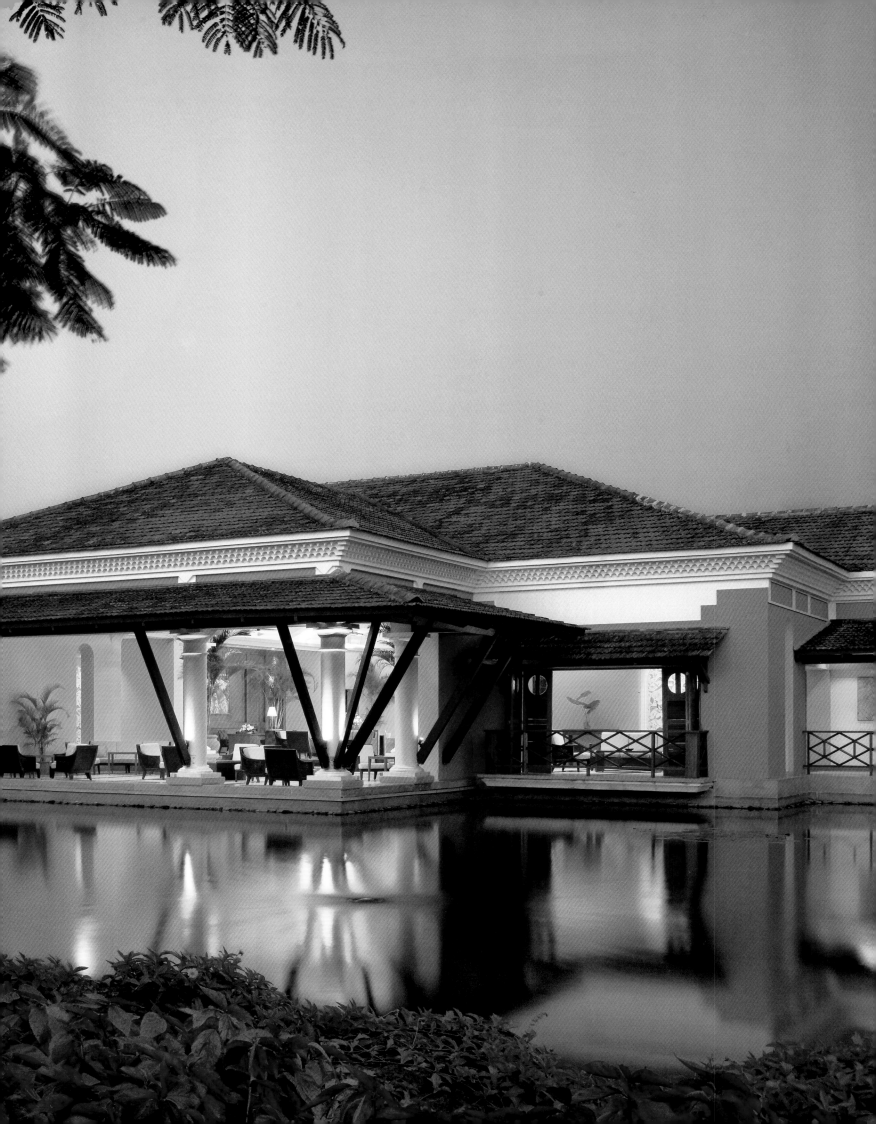

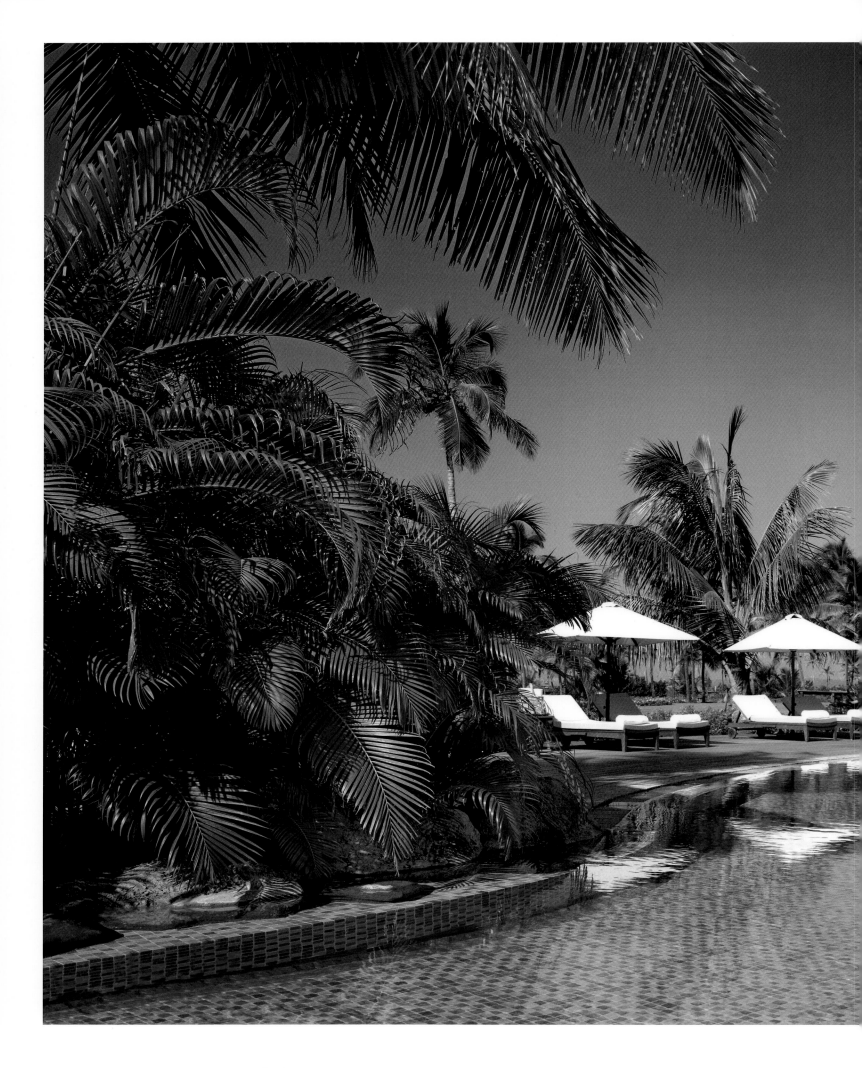

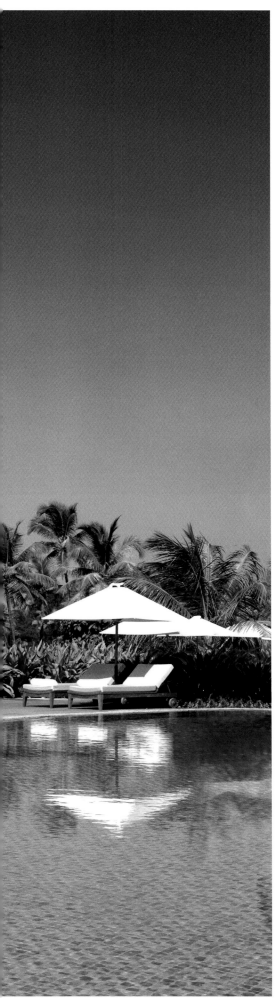

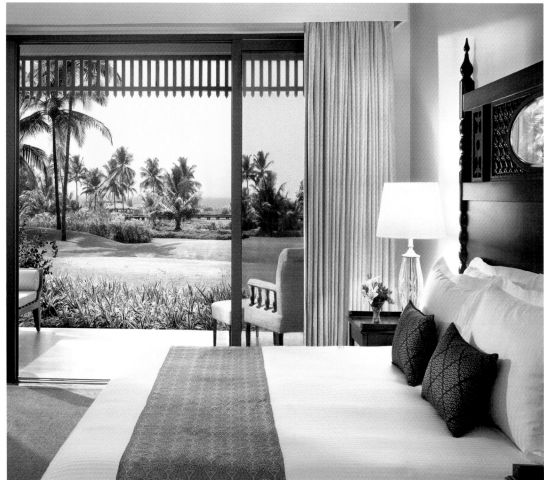

The large poolscape forms the heart of the complex.

Die große Badelandschaft ist das Herzstück des Strandhotels.

Le vaste espace baignade constitue le cœur de cet hôtel bâti en bord de plage.

Commune by the Great Wall Kempinski Beijing

Beijing, China

An avant-garde building and luxurious hospitality reach a spectacular climax in the valley of Shuiguan: modern architecture of international pedigree designed by twelve Asian architects next to the Chinese Wall. The villas are reminiscent of an architectural exhibition rather than a hotel. Guests have private access to part of the Wall that has not yet been renovated. The club house boasts a large pool, gallery, cinema, and library, while the kids' club caters for smaller guests.

Avantgardistische Architektur und luxuriöse Gastfreundschaft erreichen im Shuiguantal einen spektakulären Höhepunkt: Nahe der Chinesischen Mauer erstreckt sich moderne Baukunst von Weltrang, entworfen von zwölf asiatischen Architekten. Die Villen gleichen eher einer Architekturausstellung als einem Hotel. Gäste haben privaten Zugang zu einem unsanierten Teil der Mauer. Im Club House sind ein großes Schwimmbecken, eine Galerie, ein Kino und eine Bibliothek untergebracht; für die Kleinen wird im Kinderclub gesorgt.

Architecture d'avant-garde et hospitalité somptueuse atteignent un spectaculaire point culminant dans la vallée de Shuiguan : non loin de la Grande Muraille de Chine s'étend en effet une construction moderne de classe mondiale, œuvre de douze architectes asiatiques. Les villas qui la composent tiennent d'ailleurs davantage de l'exposition architecturale que de l'hôtel. Les clients ont un accès privé à une partie non restaurée de la Muraille. Le Club House abrite une grande piscine, une galerie, un cinéma et une bibliothèque. Le club enfants prévoit pour sa part des activités pour les petits pensionnaires.

Straight lines form a stark contrast to the rolling countryside.

Die geradlinige Architektur steht in Kontrast zur hügeligen Landschaft.

L'architecture rectiligne contraste avec le paysage vallonné.

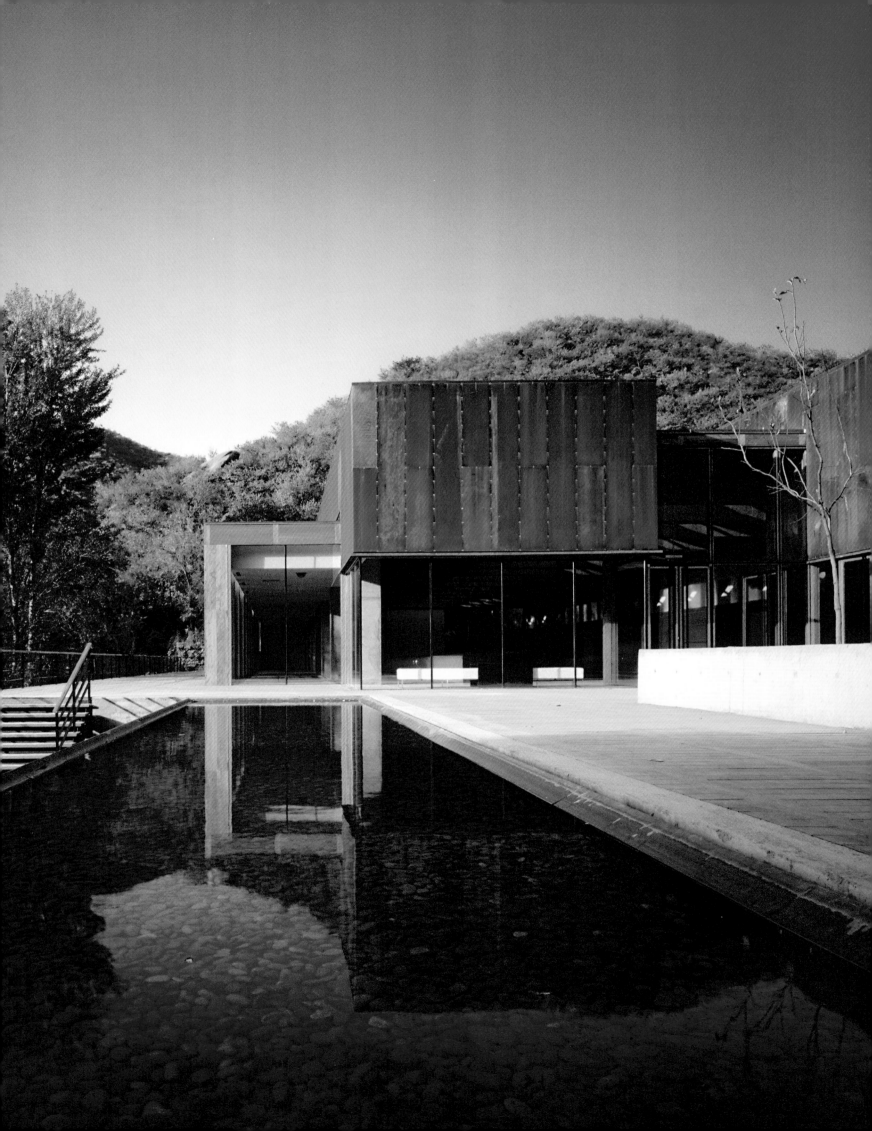

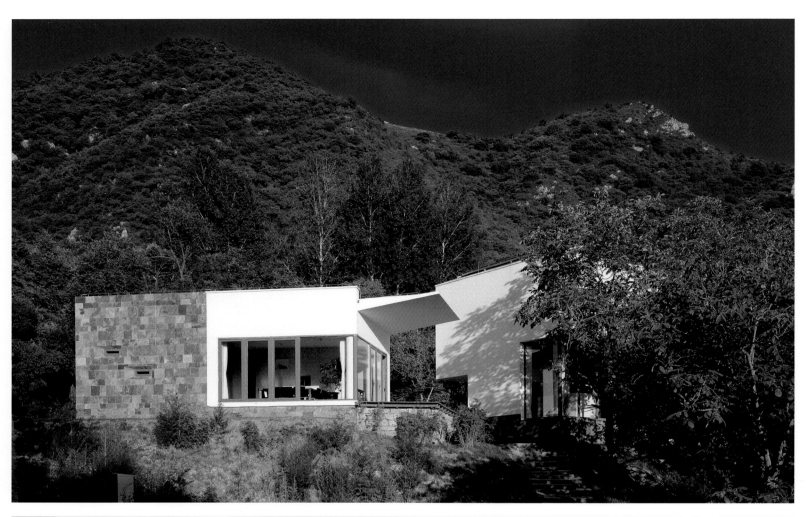

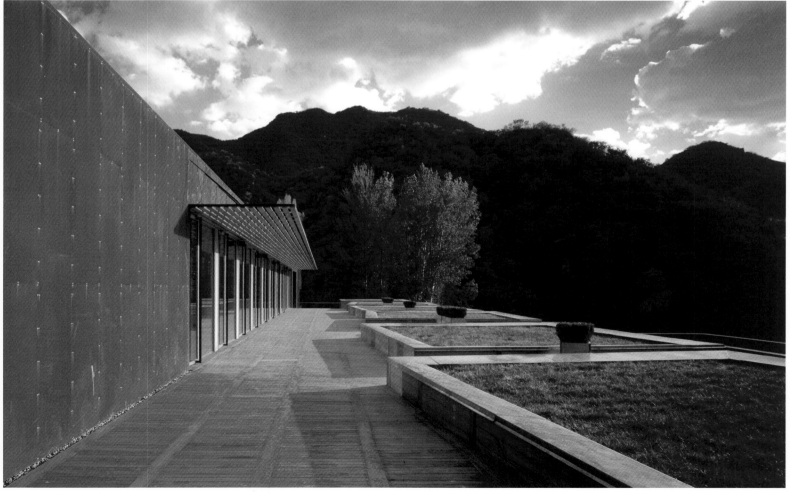

Cooking, gardening, astronomy, and camping feature in the program of the kids' club.

Kochen, Gärtnern, Basteln, Sternbeobachtung und Camping gibt es im Kinderclub.

Au club enfants, on peut cuisiner, jardiner, bricoler, observer les étoiles et même faire du camping.

Large windows, elegant design, and muted colors dominate.

Große Fenster, elegantes Design und gedeckte Farben bestimmen die Einrichtung.

De grandes fenêtres, un design élégant et des couleurs neutres donnent son caractère à l'aménagement intérieur.

Ramada Resort
Karon Beach Phuket

Phuket, Thailand

Here everything is geared for families: a variety of facilities and activities for kids of all ages including a dinosaur pool with water slide and the kids' club with its colorful program. The resort organizes excursions and entertainment from a dance show all the way to an island safari. Children enjoy staying in one of the 14 individual theme rooms. Favorites include the "space," "underwater," or "castle" themes. The other rooms are rustic and comfortable, yet functional. The beach is only minutes away; many rooms offer a view of the sea.

Hier ist alles auf Familien ausgerichtet: Ein großes Angebot an Anlagen und Aktivitäten wartet auf Kinder jeden Alters. Ein Dinosaurier-Pool mit Wasserrutsche und der Kinderclub mit buntem Programm gehören dazu. Das Resort organisiert Ausflüge und Freizeitspaß von der Tanzshow bis zur Inselsafari. Kinder übernachten gern in einem der 14 Themenzimmer wie zum Beispiel „Weltraum", „Unterwasser" oder „Schloss". Die übrigen Zimmer sind rustikal, komfortabel und funktional eingerichtet. Der Strand ist wenige Minuten entfernt; viele Zimmer haben Meerblick.

Ici, tout a été conçu pour les familles : un large choix d'espaces et d'activités attend les enfants de tous âges, y compris une piscine-dinosaure avec toboggan nautique et un mini-club au programme pour le moins varié. Outre des excursions, le complexe organise également des activités distrayantes, du spectacle de danse au safari dans l'île. Les enfants aiment passer la nuit dans l'une des 14 chambres thématiques, comme par exemple la chambre « espace », la chambre « monde sous-marin » ou la chambre « château ». Les autres chambres sont rustiques, mais confortables et fonctionnelles. La plage n'est qu'à quelques minutes, et beaucoup de chambres ont vue sur la mer.

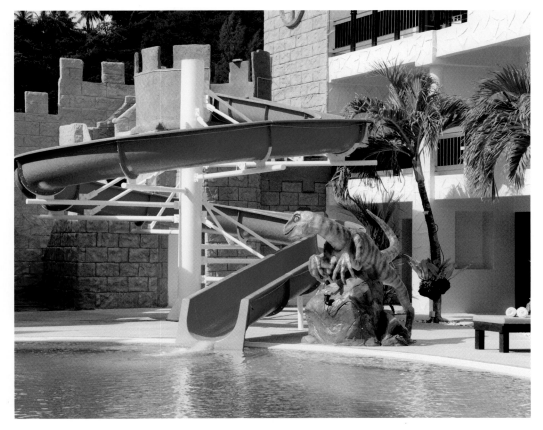

Dino pool and castle restaurant are part of the family program.

Dino-Pool und Schloss-Restaurant gehören zum großen Familienangebot.

La piscine-dinosaure et le restaurant-château font partie de la large palette d'attractions proposées aux familles.

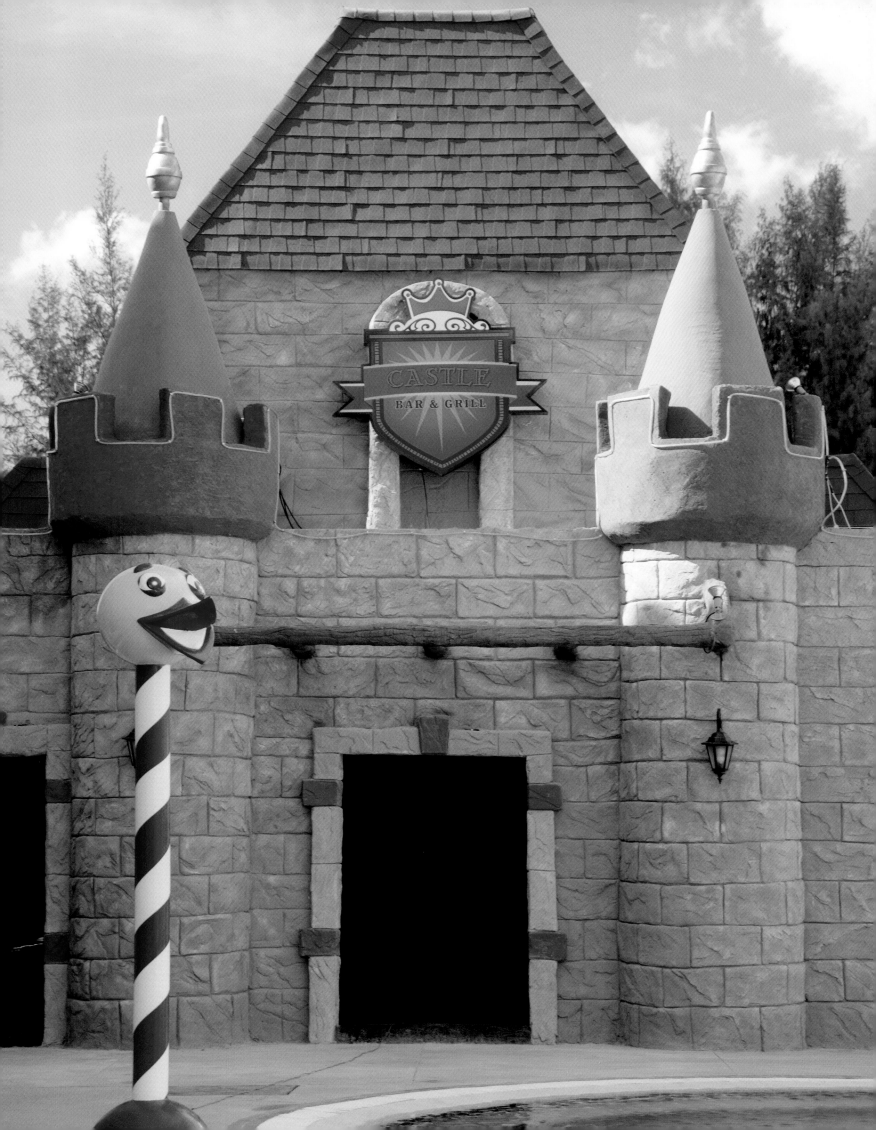

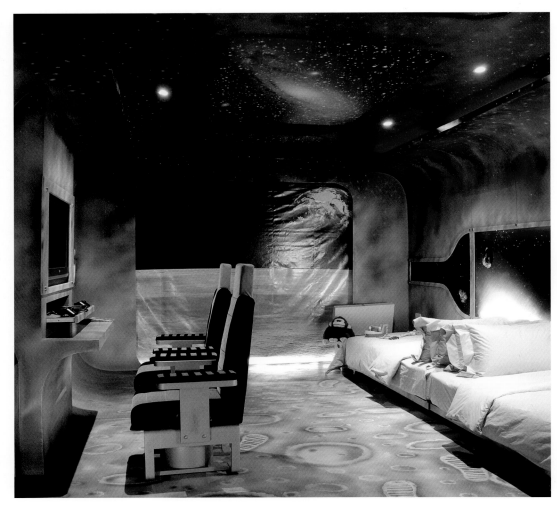

Astronaut or deep-sea diver? Exciting environments for kids.

Astronaut oder Tiefseetaucher? Spannende Wohnwelten warten auf Kinder.

Astronaute ou scaphandrier ? Des mondes thématiques captivants attendent les enfants dans les chambres.

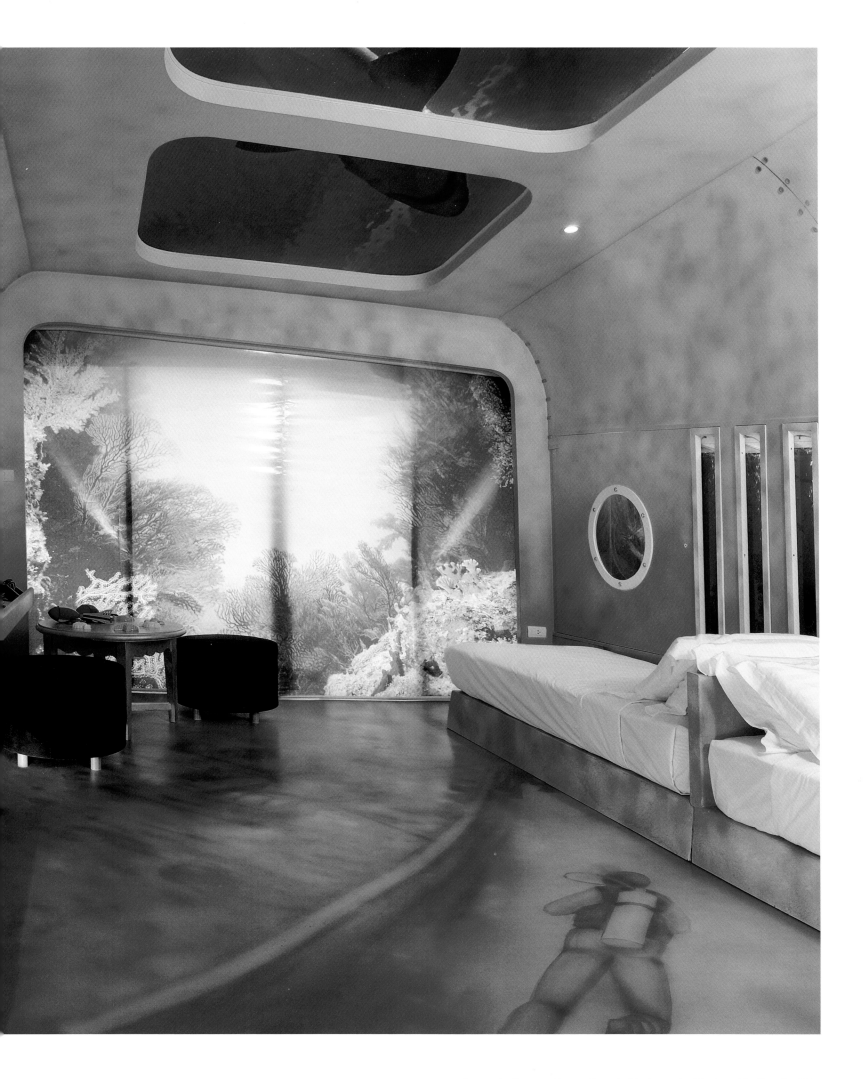

Shangri-La's Rasa Ria Resort

Borneo, Malaysia

Surrounded by well-kept tropical gardens, this resort is located on an almost untouched sandy beach. Golf enthusiasts have a classy 18-hole course at their disposal, nature freaks can explore the rain forest in the neighboring nature reserve. Next stop with the family is the orang-utan reserve, where young primates are trimmed for life in the wilderness. Catamaran tours and horseback riding are also on offer. The large pool boasts a separate kids' pool, while the kids' club has plenty to offer, too.

Umgeben von gepflegten tropischen Gärten liegt das Resort direkt am fast unberührten Sandstrand. Golf-Enthusiasten finden einen renommierten 18-Loch-Platz vor, Naturliebhaber erkunden im benachbarten Naturreservat den tropischen Regenwald. Mit der Familie geht es in das Orang Utan Reservat des Resorts, in dem junge Affen für das Leben in der freien Wildbahn trainiert werden. Katamaran-Touren und Reiten gehören ebenfalls zum Angebot der Anlage. Das große Schwimmbad hat ein separates Kinderbecken. Der Kinderclub bietet kleinen Gästen Spaß und Vergnügen.

Entouré de jardins tropicaux entretenus, ce complexe touristique est situé juste au bord d'une plage de sable presque vierge. Les fans de golf y trouveront un parcours 18 trous réputé, les amoureux de la nature pouvant explorer la forêt tropicale de la réserve naturelle voisine. En famille, on peut aller visiter la réserve de rééducation d'orangs-outangs du complexe, dans laquelle on prépare de jeunes singes à être relâchés dans la nature. Virées en catamaran et équitation sont également au programme de l'hôtel. La grande piscine dispose d'un bassin enfants séparé. Le club enfants offre quant à lui plaisir et amusement aux petits pensionnaires.

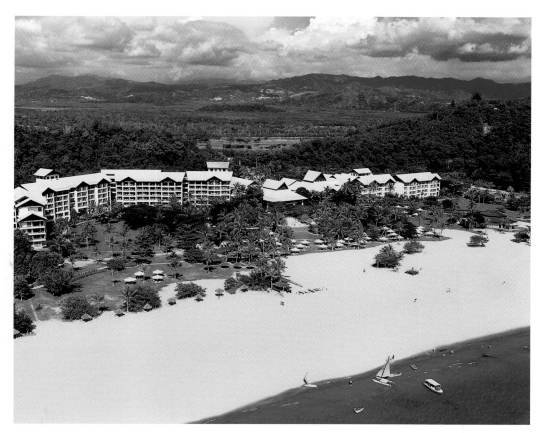

The hotel, situated on a broad beach, has a varied program for kids.

Das Hotel am breiten Strand bietet ein abwechslungsreiches Programm für Kinder.

Cet hôtel situé au bord d'une vaste plage propose un éventail d'activités variées pour les enfants.

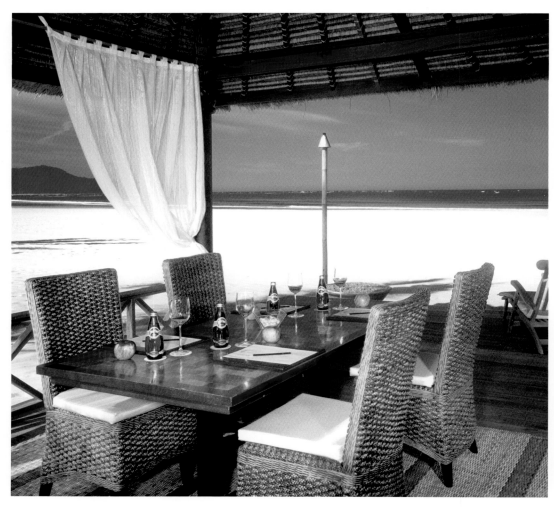

Both pool and restaurant proffer fantastic views of the ocean.

Vom Restaurant und vom Schwimmbecken hat man einen weiten Blick aufs Meer.

Depuis le restaurant et la piscine, on a vue belle vue sur la mer.

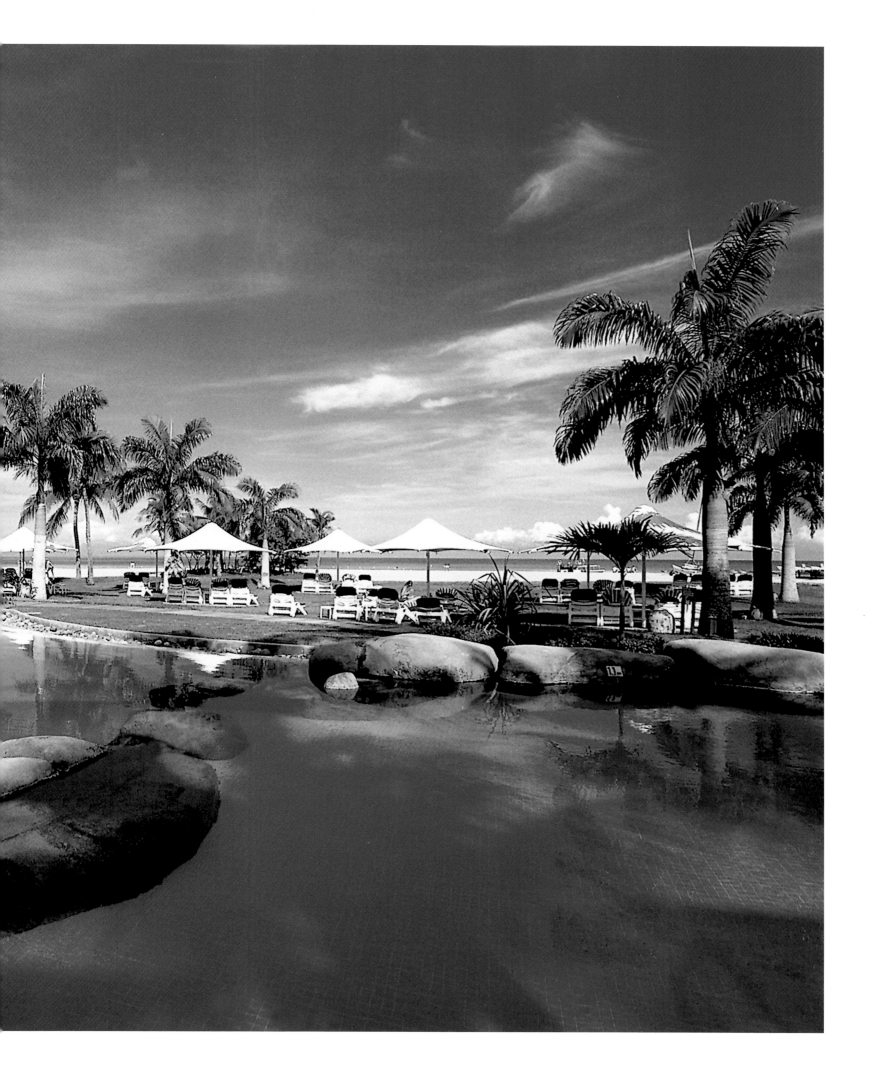

Voyages Dunk Island

Great Barrier Reef, Australia

The mountainous island with exotic flora, luscious rain forest, and gorgeous beaches is a real find for families who enjoy untouched nature and varied sports, games, and leisure programs. The luxurious complex next to the sea offers catamaran sailing, guided jungle tours, banana boats, horseback riding, excursions to the Great Barrier Reef, and much more. Kids will enjoy the Kids Club with treasure hunts, arts and handicrafts. Night hikes, disco, and videos form the evening program for the smaller guests.

Die gebirgige Insel mit exotischer Blütenpracht, wucherndem Regenwald und traumhaften Stränden ist eine Entdeckung für Familien, die urwüchsige Natur und ein breites Angebot an Sport, Spiel und Freizeit schätzen. Die komfortable Anlage direkt am Meer bietet Katamaran-Segeln, geführte Regenwaldtouren, Bananaboatfahren, Reiten, Ausflüge zum Great Barrier Reef und mehr. Kinder erleben im Kids Club Schatzsuche und Basteln. Nachtwanderungen, Disco und Filme gehören zum Abendprogramm für die Kleinen.

Cette île montagneuse aux fleurs magnifiques, à la forêt tropicale luxuriante et aux plages de rêve est une belle découverte pour les familles qui apprécient la nature primitive, et le fait d'avoir le choix entre de nombreuses activités sportives, récréatives et ludiques. Ce confortable centre de vacances situé juste au bord de la mer propose des virées en catamaran, des excursions guidées dans la forêt tropicale, des sorties en pirogue, de l'équitation, des excursions vers la Grande barrière de corail, et plus encore. Pour les enfants, le Kids Club prévoit des chasses au trésor et des bricolages. Le programme de la soirée prévoyant pour sa part des promenades nocturnes, des soirées discothèque et des projections de films.

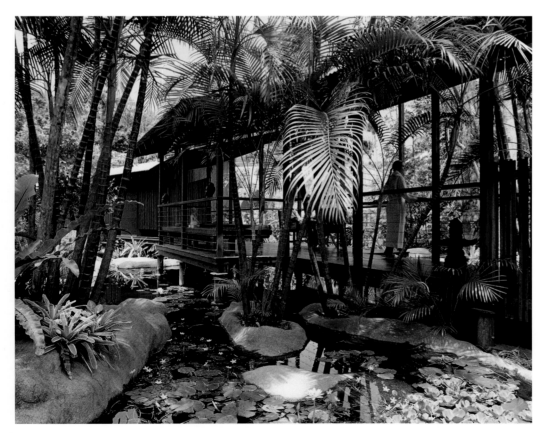

Tropical nature and quiet retreats are the resort's highlights.

Tropische Natur und stille Rückzugsorte machen den Reiz des Resorts aus.

Nature tropicale et lieux de refuge tranquilles font le charme de ce complexe.

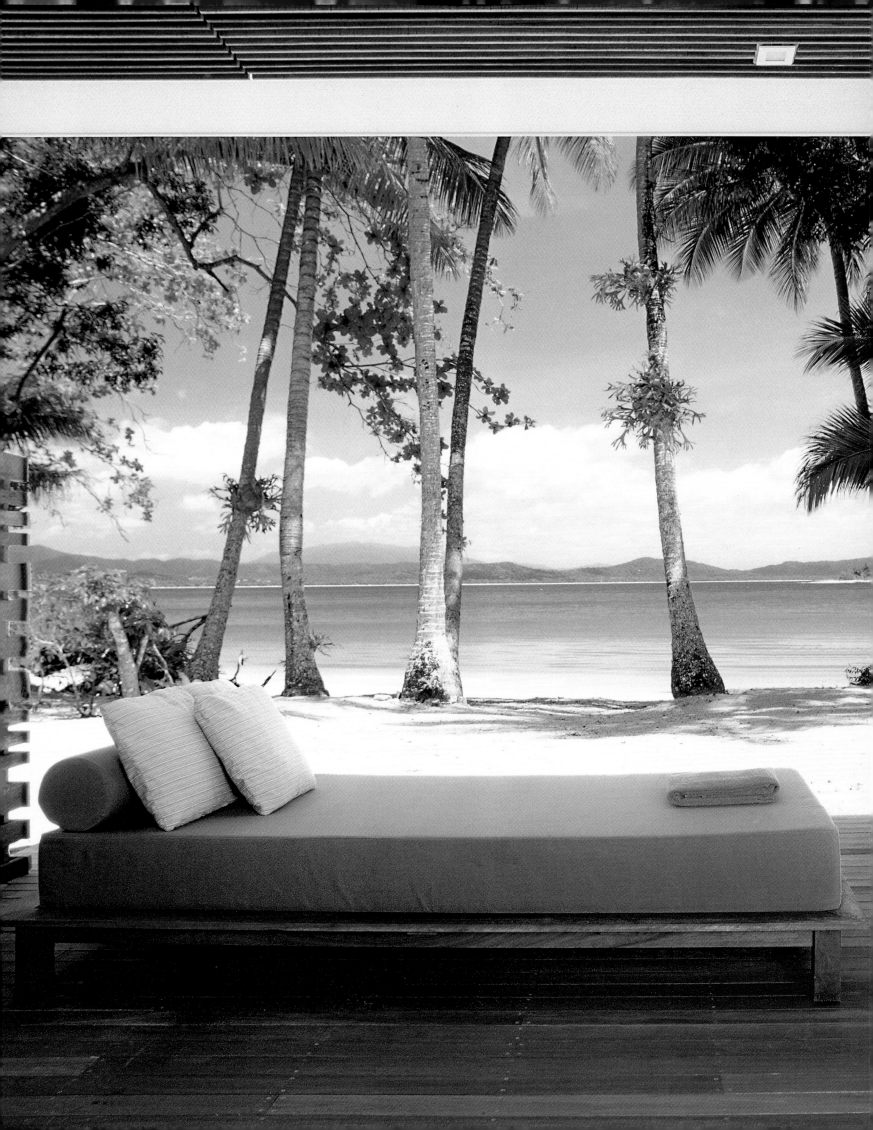

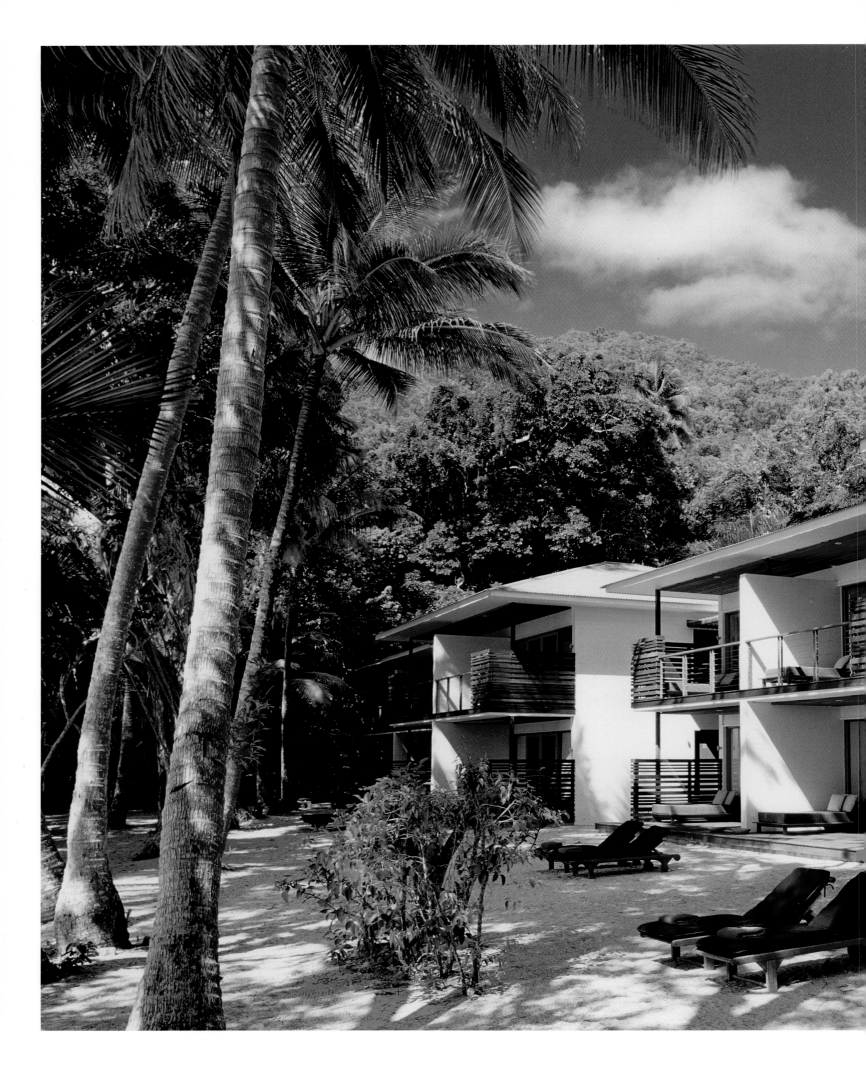

The holiday complex with its 160 rooms is located directly on Brammo Bay beach.

Die Ferienanlage mit 160 Zimmern liegt direkt am Sandstrand der Brammo Bay.

Ce centre de vacances de 160 chambres est situé juste au bord de la plage de sable de Brammo Bay.

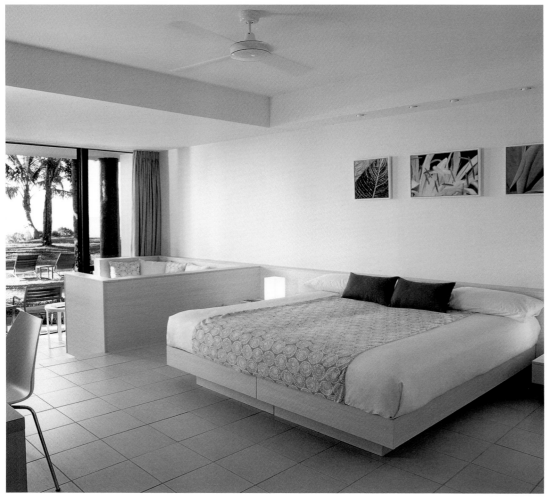

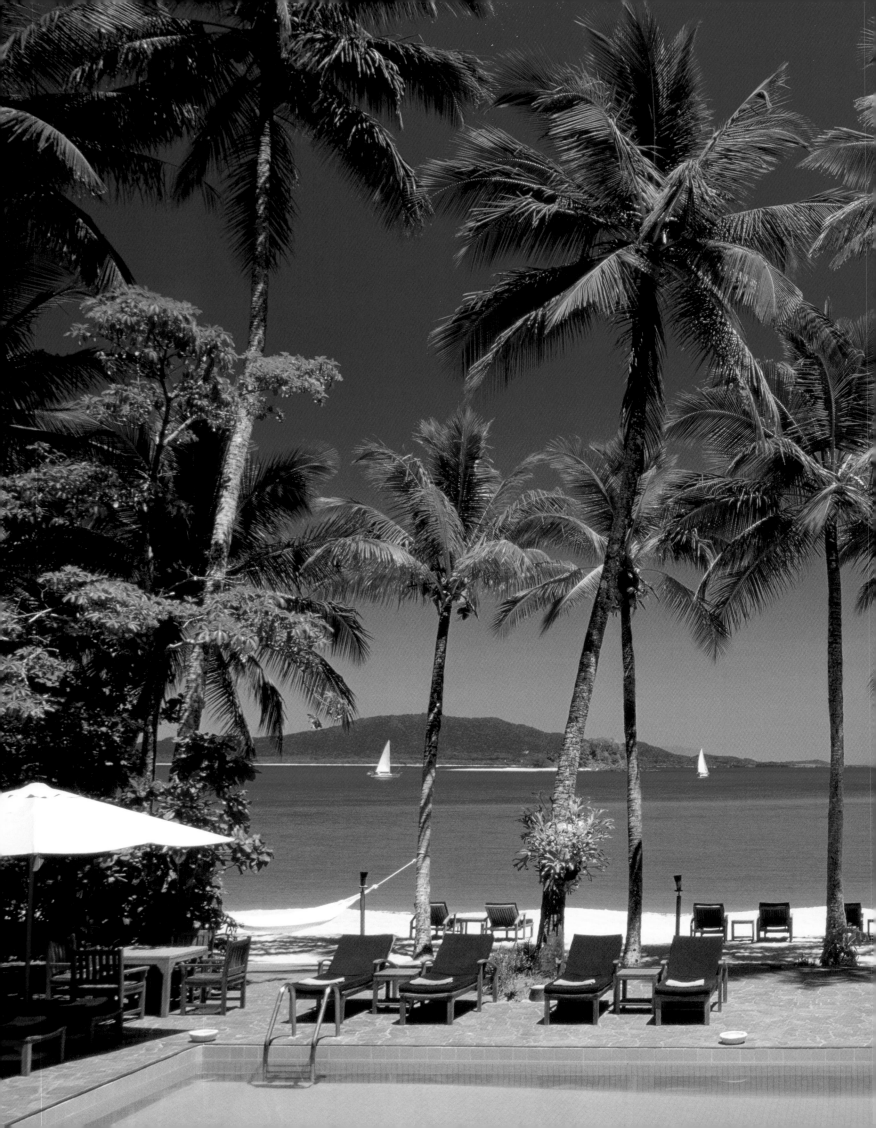

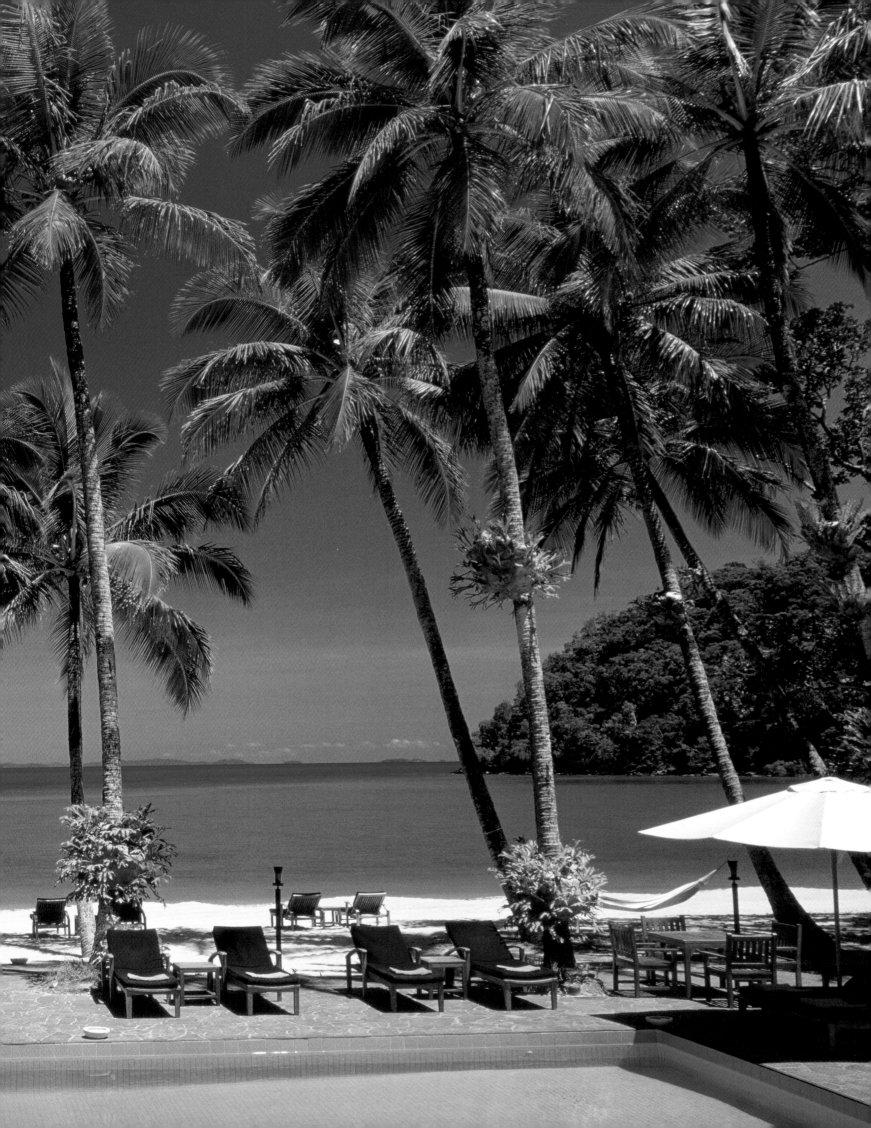

Index

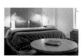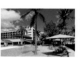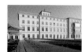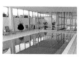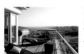

playground, wellness arrangements for kids and teens as well as discovery activities (pirate boat trips, mudflat hiking tours, promenades on the beach). Babysitter available on request.

Schloss Elmau – Cultural Hideaway & Luxury Spas
82493 Elmau, Germany
T +49 8823 180, F +49 8823 18177
www.schloss-elmau.de

130 rooms and suites. 6 restaurants for gourmets and families, offering breakfast, buffet, Italian, Thai and fusion cuisine à la carte, fondues. Smokers' lounge and bar, family lounge and tea room with winter garden. Several terraces with great vistas. 4 separate spas for adults and families covering more than 54,000 square feet / 5,000 square meters, a total of 4 lap pools (3 outdoor pools, 2 of them are heated year-round, 1 with salt water). 2 concert halls. 2 libraries. Big bookstore and lifestyle shop. Kindergarten. 2 playgrounds, adventure and edutainment programs for children.

Austria
Arlberg Hospiz Hotel

6580 St.Christoph, Arlberg, Austria
T +43 5446 2611, Fax:+43 5446 3773
www.hospiz.com

92 rooms and suites. One-star restaurant. Large collection of Bordeaux wines. All-day childcare in the hotel's own nursery and in the countryside. Great variety of animations, art activities, outdoor program, show evenings and lots more! Cots and children's beds, baby monitor equipment, children's menus and children's meals with the carers. Enrolment on skiing courses and best individual care from the age of 3 years! Babysitters on request.

Naturhotel Waldklause

Unterlängenfeld 190, 6444 Längenfeld, Austria
T +43 5253 5455, F +43 5253 54554
www.waldklause.at

48 rooms and 6 suites. Breakfast buffet, 5-course gourmet menu. Roof terrace. Vitality and relaxation area with sauna, vapour-bath, spa, massages and beauty. Fitness room. Gratis mountain bike and walking-stick loan. Gratis use of tennis court, free admission to the open-air swimming pool in walking distance. Gratis guided alpine hut hikes and Nordic walking sample courses. In winter: free admission to the ice-skating rink, gratis loan of ice skates, gratis ski bus to the Sölden skiing area, guided snowshoe hikes. Large playground. Climbing and rafting for children in summer. Situated in the heart of the Oetz Valley, in a forest area surrounded by the Tyrolean alps.

Avance Hotel – Reiter's Burgenland Resort

Am Golfplatz 1–4, 7431 Bad Tatzmannsdorf, Austria
T +43 3353 884 1607, F +43 3353 884 1138
www.reitersburgenlandresort.at

167 rooms, 2 suites. 1 restaurant, 2 bars. Spa. Lippizaner horse riding, tennis, golf, riding- and golf course for kids, Kasimir's Kidsworld, safari-lodge, kids restaurant, kids bar, all-embracing child care. Pets allowed. Located in the Burgenland, about 70 miles / 115 km from Vienna.

Unterschwarzachhof

Schwarzacherweg 40, 5754 Hinterglemm, Austria
Phone:+43 6541 6633, F +43 6541 663 325
www.unterschwarzach.at

38 rooms, suites and apartments. Childcare, baby-friendly facilities, indoor- and outdoor activities, mini farm, kids wellness, teen club, daily from 9 am. Survival training in the wild. Milking courses with "Kaiser-schmarrn" party. Large kids playground. Kids organic mini farm with ponies, dwarf ponies, llama, donkeys, goats, rabbits, guinea pigs, dwarf chickens. Located in the midst of lush green alpine meadows, only a stone's throw away from the village center.

Switzerland
CUBE Savognin

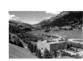

Veia Grava 15, 7460 Savognin, Switzerland
T +41 81 659 1414, F +41 81 659 1415
www.cube-savognin.com

76 rooms. Pinoccioclub, tabletop football, indoor climbing, billiard, singstar, PlayStation, fun sports, family rooms. Located 40 minutes from Chur and St. Moritz on a plateau, only 10 minutes within walking distance from restaurants, shops, next to mountain railway.

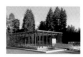

Waldhaus Flims Mountain Resort & Spa
Via dil Parc 3, 7018 Flims Waldhaus, Switzerland
T +41 81 928 4848, F +41 81 928 4858
www.waldhaus-flims.ch

150 rooms and suites. 6 restaurants, 4 bars. Large spa center with hammam, saunas, wellness suites. Own hotel museum. Full-time child care free of cost, playrooms, playgrounds, petting zoo, wellness program for kids, kids restaurant with kids menu, youth camp in July/August, tightrope adventure garden. Located in the wood of Flims, a 60-minute drive to Zurich, in the midst of the mountains of Flims/Laax.

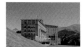

Hotel Castell
Hotel Castell, 7524 Zuoz, Switzerland
T +41 81 851 5253, F +41 81 851 5254
www.hotelcastell.ch

68 rooms including family rooms. Restaurant, bar with fireplace. Wellness area with hammam and rock water sauna. Garden. Billiard table. Bicycle rental. Art events. Special prices for kids. Playground, kids club, hammam for kids, babysitting, kids menu, bed for children 6 or younger free of charge, table for children. Nestled in the natural landscape of the Engadine in the triangle of Zurich, Milan and Munich close to the ski lift and the golf course, $^2/_3$ mile / 1 km from the railway station of Zuoz.

Beau-Rivage Palace
Place du Port 17–19, 1000 Lausanne, Switzerland
T +41 21 613 3333, F +41 21 613 3334
www.brp.ch

169 rooms and suites. Each child is greeted with a personalized welcome. Orchestrated around the hotel's new mascot, Bori, each child's stay is planned according to age and any particular needs articulated by the parents. The room are equipped with a crib, chest of toys, DVD's, etc. Various learning and discovery activities like floral workshop, pastry class, treasure hunt throughout the hotel or supportive services (special menus, babysitting, skiing trips…) are available. The hotel caters for babies through to teenager. Babysitting. Children's playground. Water sports, boat excursions. Situated on the shores of the Lake Geneva.

France
Dream Castle Hotel

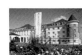

40, avenue de la Fosse des Pressoirs,
77703 Marne-la-Vallee (Paris), France
T +33 164 179 000, F +33 164 179 010
www.dreamcastle-hotel.com

386 rooms, 14 suites. "Musketeers" restaurant, Excalibur-Bar. Spa and beauty center, quiet surroundings with gardens and lake. Fitness center. 6 meeting rooms. "Dragoon Lagoon," Children Fun & Splash Pool. A room full of video games. Play areas in the lobby, indoor and outdoor play areas. Outdoor playground in the beautiful French garden. Service concierge. Located next to Disneyland® Resort Paris 35 minutes from Paris.

Château de la Couronne

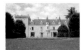

16380 Marthon, France
T +33 545 622 996
www.chateaudelacouronne.com

5 Suites, with 4 more bedrooms included when the entire chateau is hired. Dining Hall. 3 guest salons. 48-feet / 14.5-meter heated pool in 5 acre / 2 ha private park. TV/DVD in every room. In-house cinema. Table tennis room. Billiard room. PlayStation and games. Located at the Dordogne/Charente border.

Italy
Fortevillage Resort

ISS 195 Km 39,600, 09010 Santa Margherita di Pula Cagliari, Sardinia, Italy
T +39-070 921 71, F +39-070 921 8002
www.fortevillageresort.com

732 rooms and 33 suites. 21 restaurants with Italian and international cuisine. More than 10 swimming pools. Various fitness and technogym machines. Thalasso therapy at the Thaermae del Forte. Catamaran, kayaking, windsurfing, pedalo riding, water skiing, sailing, diving, tennis, football. Mini Club for children aged 3 to 11 years, 24 hours babysitting service for children under 3 years, Mini Restaurant for kids with special menu and small furniture. Leisure Land with go kart-track, modern nightclub, trampolines, bowling and an open-air ice rink. Located a 45-minute drive away from Cagliari Airport, admidst a great tropical garden at the bay of Santa Margherita di Pula.

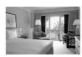

Spain
Hyatt Regency La Manga
La Manga Club, Los Belones, Cartagena 30385, Spain
T +34 968 33 1234, F +34 968 33 1235
lamanga.regency.hyatt.com

192 rooms, 6 suites and 1 "King Suite." Several restaurants and bars.
Spa with pool, sauna, Jacuzzi. 3 golf courses, 28 tennis courts, 8 football
grounds. Children's play area, swimming pool with separate babies' and
kids' pool. Experience family holidays at La Manga Club with the Hyatt
Touch™ with free nights, half-price kids rooms and many other summer
benefits. Situated on the Costa Calida, in a privileged location at the heart
of Europe's leading golf resort (La Manga Club). Located 15 miles / 25
km from Murcia San Javier Airport and 75 miles / 120 km from Alicante
Airport.

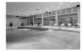

Blau Porto Petro
Avda. des Far, 12 Porto Petro, 07691 Mallorca, Spain
T +34 97 164 8282, F +34 97 164 8283
www.blau-hotels.com

210 rooms, 99 suites, 10 villas with private pool or Jacuzzi. 4 restaurants.
3 pools. Spa. Water sports. Convention center. Mini&Maxi Club, special
pool, mini club, children area, children menus, babysitters. Located on the
coast, by the Blaudi beach.

Malta
The Westin Dragonara Resort
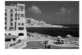
Dragonara Road, St. Julian's, STJ 3143, Malta
T +356 21 381 000, F +356 21 381 347
www.westinmalta.com

340 rooms including 27 suites and 29 luxury suites. Westin Kids Club®
from Monday to Sunday. The private beachfront setting offers dozen of
ways to delight and entertain the kids—all in secure surroundings.
Children can run, jump and play to their heart's content. Children can build
sandcastles, search a treasure, go swimming, paint pictures or have a
great time playing ball games. Special kids menu, babysitting services,
parties are organized for kids aged 1 to 8 years. Nestled on a private
peninsula in St. Julian's just steps away from downtown Malta.

Greece
Porto Sani Village & Spa
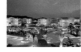
63077 Kassandra, Chalkidiki, Greece
T +30 23740 99 500, F +30 23740 99 509
www.saniresort.gr

103 rooms. 2 restaurants including 1 à la carte gourmet restaurant. The
Spa Suite with indoor pool, Jacuzzi, hammam, sauna and fitness studio,
private beach awarded EU Blue Flag for cleanliness, free umbrellas and
sun beds. Melissa Miniclub & Crèche (from 4 months to 12 years),
Teenagers' Club for teenagers 13 to 16 years (high season only), specially
organized activities during high season, baby watch program (30 minutes
complimentary babysitting on the beach), children's pool, kids menu. Dine
Around program. Located around Sani Marina part of the Sani Resort.

Cyprus
Almyra
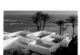
Poseidonos Avenue, 8042 Paphos, Cyprus
T +357 26 888 700, F +357 26 942 818
www.thanoshotels.com

158 rooms. Restaurants, bars. Freshwater pool especially for children.
Almyra Spa. Children's playroom and playground, babysitting, Smiling
Dolphin Kiddies' Club, Crèche. Located directly on the beach, guests have
the advantage of direct access to extensively landscaped gardens and the
sea, while also being within walking distance of the shops, castle, the
house of Dionysos with its unparalleled Roman mosaics and many other
attractions in and around the Paphos area.

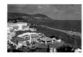

Anassa
Latchi, 8840 Polis, Cyprus
T +357 26 888 000, F +357 26 322 900
www.anassa.com.cy

177 rooms. 2 outdoor, freshwater multi-level swimming pools with
waterfalls and a 3rd pool featuring mosaic tiling. Indoor gym. 2 tennis
courts, squash court, table tennis, pool table. A year-round Children's
Club, babysitting and children's meals upon request. Children's animator
available during the summer season and other major school holidays.
Babysitting services available. A wide range of water sports including
scuba diving (Golden Palm five-star award) and sailing. 45-minute drive
from Pafos airport and 2 hours from Larnaca airport.

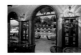

Turkey
Club Orient Holiday Resort
Ören at the Bay of Edremit, 10700 Ören-Burhaniye, Turkey
T +90 266 416 3445, F +90 266 416 4026
www.club-orient.de

60 rooms. Daily care, children's only dinner, mini club, children's pool,
beach with gradual slope into the sea. Table tennis/ping-pong, volleyball,
tennis, canoes, bikes and wonderful walking routes. Located at the Turkish
west coast, directly at the Aegean Sea, surrounded by famous antique
sites, at the center of the wide Bay of Edremit (Olive Riviera), just vis-à-vis
the Greek island of Lesbos.

Hillside Beach Club
Kalemya Koyu, P. O. Box 123, 48300 Fethiye/Mugla, Turkey
T +90 252 614 8360, F +90 252 614 1470
www.hillsidebeachclub.com

330 rooms. 3 restaurants, 9 bars. Swimming pool. Windsurfing,
catamaran, canouing, sailing, tennis, water polo, tabletop soccer, extra
room for handicrafts, archery. Internet café. Kid Side for children aged 4 to
12 years, kids holiday village with heated pool, small houses, bridges and
water playground, babysitting service, professional multilingual staff for
kids, baby phone. Located in the Kalemya bay, a 45-minute drive from
Dalaman International Airport and 2 ½ miles / 4 km from the city center
of Fethiye.

Africa & Middle East

Morocco
Villa Vanille
Douar Bellaaguid, 40000 Marrakesh, Morocco
T +21 26 440 0465, F +21 22 431 0123
www.villavanille.com

5 family suites and 2 rooms for up to 26 people total. 2 pools, one of
them heated and 2,000 square feet / 200 square meters large,
hammam, gym, massage. Exterior games for children, board games, baby
cot available, babysitting, house adapted to children. Located in the heart
of a vast garden in the "Palmeraie" of Marrakesh.

United Arab Emirates
Beit Al Bahar
P. O. Box 11413, Dubai, United Arab Emirates
T +971 4 348 0000, F +971 4 301 6800
www.jumeirah.com

19 villas. 5 star resort, located at the Jumeirah Beach Hotel. Over 20
restaurants and bars, breakfast at Villa Beach restaurant, afternoon tea or
coffee. 5 swimming pools, gym, health suite, Jacuzzi, sauna. Privilege
access to the Club Executive Pool with exclusive use of private Majilis
tents. Sindbad's Kids Club, babysitting services, family pool, unlimited
complimentary access to Wild Wadi Waterpark. 6 tennis courts, 1 multi
court, 3 squash courts, climbing wall, water sports, private beach,
National Geographic Dive Center, golf.

Oman
Shangri-La's Barr Al Jissah Resort & Spa
P. O. Box 644, Postcode 113, Muscat, Sultanate of Oman
T +968 2477 66 66, F +968 2477 66 77
www.shangri-la.com

640 rooms, 43 suites. Located between a backdrop of mountains and the
waters of the Gulf of Oman Shangri-La's Barr Al Jissah Resort & Spa is
home of three hotels. 19 restaurants, bars and lounges. CHI, the Spa at
Shangri-La is the largest and most luxuriously appointed spa in the
Sultanate of Oman. Little Turtles Kids Club, children's pool, games such
as Treasure Hunt, henna painting, sand city competition. Children can play
in safe, supervised environments. Lazy river.

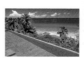

Seychelles
Frégate Island Private
Frégate Island, Seychelles
T +49 69-8600 4298 0, F +49 69-8600 4298 1
www.fregate.com

16 villas with private pools for a maximum of 40 guests. Castaway
Clubhouse, 2 villas nestled in private gardens for families with children.
2 restaurants, 2 bars, wine cellar. 7 beaches, 2 swimming pools, The
Rock Spa, fitness center. Library. Private butler. Island museum. Chapel.
Island marina. Located 20-minute flight from Mahé.

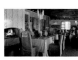

Tanzania
Hatari Lodge
Arusha National Park, Momella, Tanzania
T +255 27 255 3456, M +255 754 510 195
www.hatarilodge.com / www.uniquesafarilodges.com

9 rooms with ensuite bathrooms, 2 basins, shower (2 rooms have a bath tub). 2 honeymoon rooms. All rooms have a private fireplace and terrace. European cuisine mixed with African ingredients, breakfast and lunch terrace (seasonal), bar. Living and dining room, library and movie corner. Wooden walkway for game and scenic viewing. Mt. Meru Crater walk, Ngurduto crater walk (New). Guided game safari in Arusha National Park. Canoeing. Forest picnics. Individual excursions around the lodge, historical tours, cultural experience within the village and Arusha town. Located on the foot of Mt. Meru at the northern edge of Arusha National Park. Airport transfer.

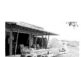

Namibia
Wolwedans Dunes Camp
NamibRand Nature Reserve, Namibia
T +264 61 230 616, F +264 61 220 102
www.wolwedans.com

The Private Camp is in the middle of nowhere at the end of a valley and offers an intimate atmosphere for maximum 4 guests. The Dune Camp on the edge of a 820-ft / 250-m high dune are 6 tents on wooden platforms, furnished with standard beds, veranda, private bathroom. Located in the heart of NamibRand Nature Reserve, 37 miles / 60 km south of Sossusvlei. Intimate atmosphere, unperilous adventure of nature. Malaria free. Namib Desert Environment Education Trust nearby offering programs for children (www.nadeet.org). Hot-air ballooning, dune boarding. Only the Private Camp is appropriate to families with small children.

Kenya
Alfajiri Villas
Diani Beach, Kenya
T +254 403 202 630
www.alfajirivillas.com

12 rooms in the 3 villas. The house has been designed with children's need in mind. Alfajiri Cliff Villa is most suitable for families with small children and features absolute privacy. 2 English speaking ayahs (nannies) available 24 hours a day. Games, TV and video. Inclusive of 15 staff, all food and drinks, massage, and 18-hole golf course.

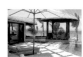

Mauritius
Beau Rivage
Belle Mare, Mauritius
T +230 402 2000, F +230 415 5020
www.naiaderesorts.com

74 suites. The Mini Club (9 am to 10 pm) has a lovely atmosphere, with a large room for activities and a fenced garden play area outside. Qualified hostesses look after and entertain youngsters from 3 to 12. A babysitting service is also available on request, for a fee. Children's dinner is served from 6 to 7 pm. The Teens Club arranges a whole range of activities for those aged 12 and over, including a number of optional excursions outside the hotel. The club is open during school holidays. Located on a superb beach at Belle Mare in the east of the island.

Constance Belle Mare Plage
Poste de Flacq, Belle Mare, Mauritius
T +230 402 2600, F +230 402 2626
www.bellemareplagehotel.com

235 rooms and suites, 21 villas. 7 restaurants and 5 bars. 4 pools. "Le Spa de Constance" with Shiseido Pavilion, fitness center. Golf club, two 18-hole golf courses. 4 tennis courts. Kakoo Club for children aged from 4 to 12 years with games room and a playground, indoor and outdoor activities are organized daily under supervision, lunch and dinner in buffet style available for children, babysitting available on request. The resort is situated directly on a 1-mile / 2-km long white sandy beach, set in tropical gardens of almost 37 acre / 15 ha.

Asia

Maldives
Island Hideaway Spa, Resort & Marina
Boduthakurufaanu Magu, Henveiru Malé, Maldive Islands
T +960 650 1515, F +960 650 1616
www.island-hideaway.com

43 villas, directly located at the beach. The Tender Hearts Club at Dhonakulhi is open to all kids. It offers various activities, a playground of 544 square feet / 50.5 square meters, a small library, board games and bicycles to ride. The 815-square-feet / 75.7-square-meters Meridis offers a safe and enjoyable diving experience for children over 10 years of age,

and has special kids diving equipment for this. Children can carry out the PADI Open Water Junior course. Crab race, dance parties, balloon race, treasure hunt. Located in the north of the island.

Sri Lanka
The Fortress
P. O. Box 126, Galle, Sri Lanka
T +94 91 438 9400, F +94 91 438 0338
www.thefortress.lk

49 rooms located on the golden southern coast of Sri Lanka. Restaurants, wine cellar. Lime Spa featuring Ayurvedic treatments. Wedding and yoga pavilion. Little Adventurers Zone. Free flow swimming pool with kid's bathing area. Boutiques. Located minutes away from Sri Lanka's most historically interesting living city, Galle.

India
Park Hyatt Goa Resort and Spa
Arossim Beach, Cansaulim, Goa 403712, India
T +91 832 272 1234, F +91 832 272 1235
goa.park.hyatt.com

250 rooms. North and South Indian restaurant, Goan restaurant, Italian restaurant, beachside sea food restaurant, lounge bar, and pool side bar. 36,000-square-feet / 3,350-square-meter Sereno spa, India's largest outdoor swimming pool. Meeting facilities. Babysitting services. Bicycles available for hire. Camp Hyatt programs for children aged between 3 to 12 offering fun and educational activities. Located in South Goa, a 15-minute drive from Goa's Dabolim airport.

China
Commune by the Great Wall Kempinski Beijing
Exit at Shuiguan, Badaling Highway, Beijing, 102102 P. R.C.
T +86 10 8118 1888, F +86 10 8118 1866
www.kempinski-thegreatwall.com

42 villas designed by 12 Asian architects, ranging in size from 4 to 6 bedrooms, which are dispersed along the steep slope of the serene valley. Each House offers dramatic views of the sinuous landscape or The Great Wall, which is accessible by a path on the property. The Walnut Valley includes 11 presidential villas with 46 guest rooms and 1 Commune club which opened in October 2002, and the Rock Valley includes 31 new villas with 190 guest rooms, which opened in September 2006.

Thailand
Ramada Resort Karon Beach Phuket
Karon Beach Phuket, 568 Patak Road, Phuket 83100, Thailand
T +66 7639 6666, F +66 7639 6444
www.ramadaphuket.com

121 rooms and suites. 2 restaurants, 2 bars. Gym/fitness center. Multi activity station KidzClub, 14 special kids rooms, Siam adventure club, dino pool, corner store, babysitting. Handicap facilities. Situated on Karon Beach.

Malaysia
Shangri-La's Rasa Ria Resort
Pantai Dalit Beach, 89208 Tuaran, Sabah, Borneo, Malaysia
T +6088 792 8 88, F +6088 792 7 77
www.shangri-la.com

420 rooms including 10 suites. 4 restaurants, 2 bars including pool bar, lounge, in-room dining. Spa. 400-acre / 160-ha tropical setting. Pristine beach. Business center. Sailing, windsurfing, cat boat tours, waterskiing, fishing, diving, horse riding, cycling and nature walks. Orang-utan sanctuary. Access to Dalit Bay Golf Club, a 18-hole par 72 championship golf course. Children's Club, babysitting, children's pool, affiliated own nature reserve for baby orang-utans. Located on the unspoilt Pantai Dalit beach whithin 400 acres / 160 ha of tropical vegetation.

South Pacific

Australia
Voyages Dunk Island
Great Barrier Reef, Australia
T +61 2 8296 8010, F +61 2 9299 2103
www.dunk-island.com

160 rooms. 4 restaurants, 2 bars, barbecue dining. 2 swimming pools, gym-nasium. Spa. 3 floodlight tennis courts, squash courts. 9-hole golf course. Snor-keling, many other water sports. Kids Club with fun and educational activities for kids from 3 to 14. Children 12 years and under stay free using existing bedding. Children eat free when dining with a paying adult at buffet restaurants or from the children's menu. Family horse rides along the beach at sunset. Located 3 miles / 5 km off Mission Beach in Far North Queensland, Australia.

Photo Credits

Roland Bauer	Aparthotel Bommelje	44
	Villa Vanille	142
Andrew Bordwin	Le Parker Méridien New York	14
Herbert Breuer Stephan Brückner Andreas Burz	Wolwedans Dunes Camp	164
Gregoire Gardette	Commune by the Great Wall Kempinski Beijing	196
Philippe Giraud Michel Hasson	La Créole Beach Hôtel & Spa	38
	back cover (bottom left)	
Eduard Hueber	CUBE Savognin	82
Gavin Jackson	Hotel Diva	10, 11, 13
Nikolas Koenig	Le Parker Méridien New York	16
Martin Nicholas Kunz	Beit Al Bahar	148
	Frégate Island Private	156
	Constance Belle Mare Plage	178
Rien van Rijthoven	Hotel Diva	12
Mark Selwood	Château de la Couronne	102
Jurgen Shriber	The Fortress	186

Other photo courtesy

Alfajiri Villas	Alfajiri Villas	168
Arlberg Hospiz Hotel	Arlberg Hospiz Hotel	66,
	back cover (top right)	
Beau Rivage	Beau Rivage	94, 172, Cover
Blau Porto Petro	Blau Porto Petro	114
Club Orient Holiday Resort	Club Orient Holiday Resort	134
Dream Castle Hotel	Dream Castle Hotel	98
Fährhaus Sylt	Hotel Fährhaus Sylt	58
Floris Suite	Floris Suite	34
Forte Village	Fortevillage Resort	106
Frégate Island	Frégate Island Private	156

Hatari	Hatari Lodge	160
Hillside Beach Club	Hillside Beach Club	138
Hotel Castell	Hotel Castell	90
Hotel Punta Islita	Hotel Punta Islita	20
Hyatt Hotels & Resorts	Park Hyatt Goa Resort and Spa	192
Hyatt Regency La Manga	Hyatt Regency La Manga	110
Island Hideaway	Island Hideaway Spa, Resort & Marina	182
Kempinski Grand Hotel Heiligendamm	Kempinski Grand Hotel Heiligendamm	48
	back cover (top left)	
Naturhotel Waldklause	Naturhotel Waldklause	70
One&Only Resorts	One&Only Palmilla	30
Porto Sani Village	Porto Sani Village & Spa	122
Ramada Resort Karon Beach	Ramada Resort Karon Beach Phuket	202
Reiter's Burgenland Resort	Avance Hotel – Reiter's Burgenland Resort	74
	back cover (bottom right)	
Schloss Elmau	Schloss Elmau	62
Shangri-La Hotels and Resorts	Shangri-La's Barr Al Jissah Resort & Spa	152
	Shangri-La's Rasa Ria Resort	206
Thanos Hotels	Almyra	126
	Anassa	130
The Ritz-Carlton Hotel Company	The Ritz-Carlton, Cancun	24
The Westin Dragonera Malta	The Westin Dragonera Resort	118
Unterschwarzachhof	Unterschwarzachhof	78
Vier Jahreszeiten	Vier Jahreszeiten Zingst	54
Voyages Dunk Island	Voyages Dunk Island	210
Waldhaus Flims	Waldhaus Flims Mountain Resort & Spa	86

Editor Patricia Massó

Editorial Coordination Elke Roberta Buscher, Katharina Feuer

Hotel Texts by Ann Yacobi

Text coordination Sabine Scholz

Layout Katharina Feuer, Anke Scholz

Imaging, Pre-Press Jan Hausberg

Translations by Zoratti studio editoriale, Trierweiler (English, French)

Editorial project by fusion publishing gmbh, stuttgart . los angeles
www.fusion-publishing.com

Published by teNeues Publishing Group

teNeues Verlag GmbH & Co. KG
Am Selder 37, 47906 Kempen, Germany
Tel.: 0049-(0)2152-916-0, Fax: 0049-(0)2152-916-111
E-mail: books@teneues.de

Press department: arehn@teneues.de
Tel.: 0049-(0)2152-916-202

teNeues Publishing Company
16 West 22nd Street, New York, NY 10010, USA
Tel.: 001-212-627-9090, F 001-212-627-9511

teNeues Publishing UK Ltd.
P.O. Box 402, West Byfleet, KT14 7ZF, Great Britain
Tel.: 0044-1932-403509, F 0044-1932-403514

teNeues France S.A.R.L.
93, rue Bannier, 45000 Orléans, France
Tel.: 0033-2-38541071, Fax: 0033-2-38625340

www.teneues.com

© 2008 teNeues Verlag GmbH + Co. KG, Kempen

ISBN: 978-3-8327-9269-5

Printed in Germany